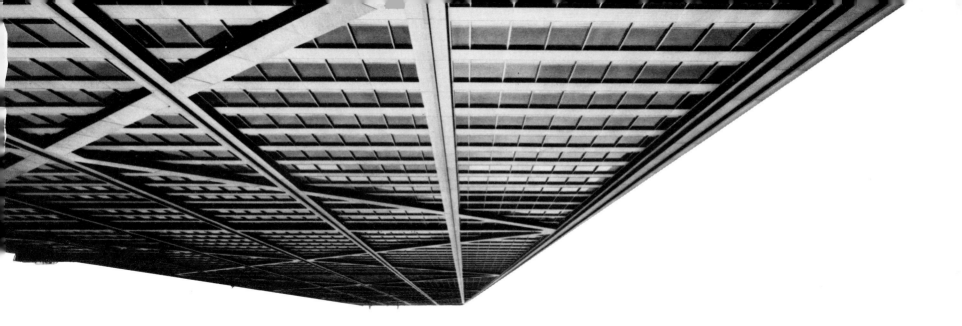

Architectural
Photography

Architectural Photography

John Veltri

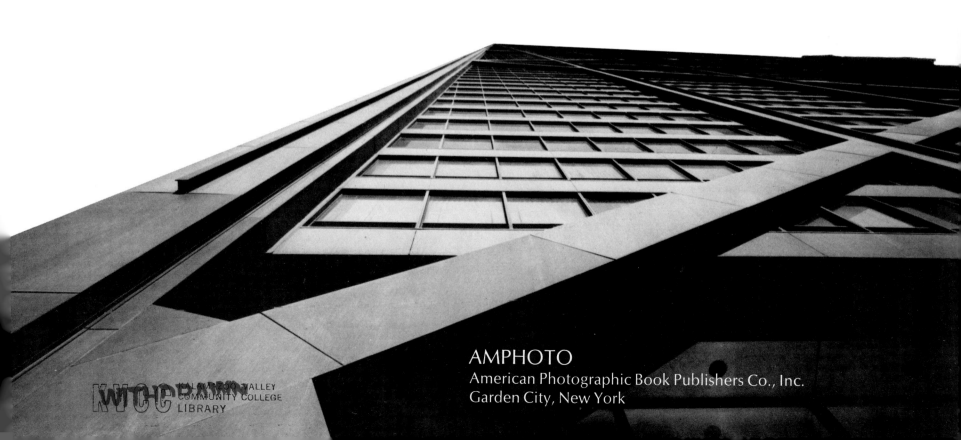

AMPHOTO
American Photographic Book Publishers Co., Inc.
Garden City, New York

Copyright © 1974 by American Photographic Book Publishing Co., Inc.

Published in New York by American Photographic Book Publishing Co., Inc. All rights reserved. No part of this book may be reproduced in any form without the written consent of the publisher.

Library of Congress Catalog No. 72-91033
ISBN 0-8174-0556-9

Manufactured in the United States of America

CONTENTS

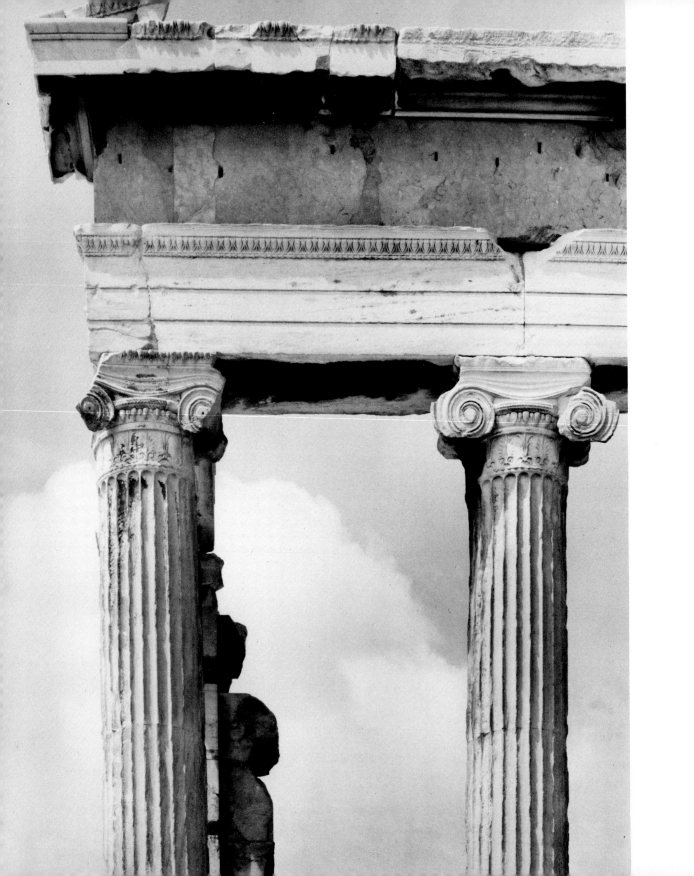

Introduction

Photography deals in images. By definition, the image is not the reality itself, but an impression, a symbol, or a representation of that reality, which is the subject photographed. The photograph is then, a selection of the physical or phenomenal reality of the subject. By inclusion and exclusion of certain aspects of that reality, the photograph becomes a representation which can give special impact, and make memorable the desired qualities of the architectural subject as intended either by the architect as author or the photographer as interpreter of that architectural work.

Architectural photography is quite simply, portraiture. Portraiture, it must be admitted, whether of persons or buildings, is a service art. It must, as architecture itself, perform a service, otherwise it has no purpose, no content, no value. In addition, portraiture in painting, photography, and buildings themselves must perform this service in such a way as to speak to our psyche; to strike some response from our sensibilities, from what has been our awareness and experience.

The severe task of the single, still image or representation, is that it sum up explicitly or implicitly, what in the case of the living subject is a cumulative impression. Human portraiture is a static recording of a living, moving subject; while architectural photography is a static recording from a fixed station point of a static subject made alive and kinetic as it were, by the movement of living beings coursing through it. The skill and often genius of the artist is in knowing his or her subject so well that the cumulative experience is made vivid. The concern then is not for the specific or the momentary truth, but for the conglomerate of impressions.

There have been moving camera recordings of sequences of movement through architectural space. There have been blow-ups as large as to give the illusion we are actually in architectural space. And there may be possibilities of multi-projections which can bombard the viewer with trip hammer simultaneity. However, the still photographic image is surely the common and most serviceable method of recording works of architecture, and I believe will be for some time.

To know the architectural subject well, the photographer must live with and study it in various conditions of occupancy and service as well as its purely visual aspects. To know a building is to see it not only in form, but more importantly in process. Only then can a photographer speak of a building in the sense that we speak of people whom we know well or love. We speak of their shortcomings as well as their successes, of their peculiar qualities as well as their conventional outward appearances, their essential quality rather than their specious appeal. In this task, the photographer might and in fact should turn down a commission involving a

building of no significance to him. However, once having accepted a commission he or she is professionally obliged not to produce a competent set of prints, but morally obliged to search out the truth of that building whatever that may be.

Architecture should of course be experienced for itself, as people should be known for themselves. But this is less and less apt to be so in an age in which we deal in symbols and images; when in this electronic age anything can be made real in any place at any time by retrieval from knowledge banks, or even as extrapolations for the future. The implosion of knowledge, experiences, and recorded events is the essence of our time as McLuhan has made known to us. The impact is stunning and inescapable. It is more likely that, in spite of more efficient transportation to the architectural work itself, we will know and remember buildings through images. Surely the buildings which have had impact upon us and are memorable to us, are so, because some skilled and sensitive photographer made a patient and dedicated search for this essential quality in these buildings; and in doing so has fulfilled a rather large historic responsibility to the architectural profession and to society as a whole.

John M. Johansen, April 11, 1973

Foreword

In this book of thoughts and techniques, it has been my intention to give the reader a complete, concise approach to the photography of architecture. The book is designed both for the architect who wants to broaden his technical understanding of photography and for the photographer who wishes to expand his knowledge of architectural problems.

Although information basic to the problems of photographic communication is provided throughout this book, I have not written a step-by-step primer on photography. To get the most out of the following pages, some experience with architecture and/or photographic practice is necessary.

In my discussion about technique, I have posed several theories about visual perception that remain to be proved by the reader's own experimentation with the medium of photography. Any theoretical discussion, no matter how concretely tied down to illustrations, must be translated into the reader's own experience.

It is my hope that this book will prove to be a challenging and stimulating experience and will provoke the reader to inquire more deeply into the way a photograph communicates.

I would like to take this opportunity to express my appreciation to the following people: to Rolf Myller, Abe Geller, Julian Whittlesey, and Andreas Feininger for their encouragement and significant help in my photographic career; to all my clients for their understanding and faith in my ability as I learned my craft by photographing their buildings; and finally to Robb Smith for his editorial assistance in the preparation of this manuscript.

John Veltri, New York City

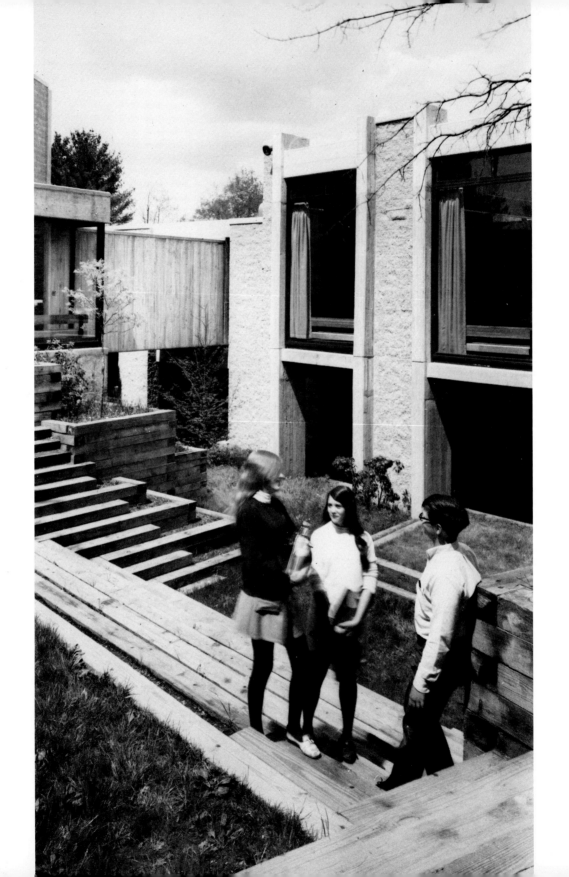

1

The Photographic Approach To Architecture

There are many approaches to photographing architecture, and the thoughtful photographer must search to find the right one for each assignment. The purpose of this chapter is to describe how different assignments can be handled and to illustrate the different approaches to the photography of a building.

A meaningful architectural photograph must not only document the architecture in an interesting manner, but it must say something about the point of view that architecture represents.

Each building is a particular solution to problems of space and organization. Each architect will solve these problems in a different way. It is the job of the architectural photographer to discover the reasoning behind the specific architectural statement and translate that statement into photographic terms.

By looking carefully at the reasoning and point of view expressed by an architect through his building, the photographer can analyze the requirements for a specific assignment. By thus de-

fining the requirements for any given assignment beforehand the photographer has a better chance of satisfying his client's needs.

There are four main types of assignments, depending on the client and the use to which the photography wil be put:

1. Client: The architect or architectural office. Use: Photos for brochures or portfolio illustration to show the design decisions, philosophy, and point of view expressed by the work of that office.

2. Client: A magazine or book publication. Use: To illustrate a written text.

3. Client: Building owner, or developer. Use: Fund raising or publicity.

4. Client: Educational institution or library. Use: Classroom instruction, individual reference and study.

Each type of assignment will determine the particular emphasis of the photographic coverage.

PHOTOGRAPHY FOR THE ARCHITECT OR ARCHITECTURAL OFFICE

The most complete, in-depth assignment given to the architectural photographer will come from the architect himself. An architect will want to see expressed all those aspects of design he fought so long to achieve. To the architect, the finished building represents a tremendous investment in time and energy, and very often the photo series will be the major means he will have (outside of the finished building itself) of communicating his design decisions to future clients. It is therefore imperative for the photographer to know as much about the building as possible prior to photographing it.

In the first meeting with the architect or job captain it is useful to look at and discuss in detail a building plan, and perhaps elevations. Renderings and construction photos are also useful in visualizing the project and helpful in analyzing problems that might be encountered. The more concrete information the

photographer has, the better he is able to handle all aspects of the assignment.

When the architectural photographer goes out on a job, he should take a copy of the building plan with him. On this plan should be marked the important spaces, angles, and details that the architect feels it is necessary to cover. These notes form the skeleton around which the photographer will develop his shooting schedule.

It is wise, although not always convenient or possible, to discuss a building at firsthand with the architect, particularly if the photographer is new to an office. By walking around the project with the photographer, the architect can point out the elements to emphasize and to avoid. Also, the architect has the opportunity to get direct feedback from the photographer. Frank and honest discussion about the problems and methods of photographing a building can proceed directly from the experience of that building. In this situation both architect and photographer have a better chance of getting involved in the process of translating the actual building into photographic terms.

The more familiar the photographer is with the design philosophy and working methods of a particular office, the less necessary this firsthand approach will be. However, it must be remembered that each building presents new and often unique problems of interpretation and photographic handling.

The following topics can profitably be discussed with the architect; this list can also be used to help structure the first meetings with a new client:

1. Type of building: private house, school, community center, church, office building, factory, and so on.
2. Ways the function of the building (building program) shape the design: The building type and function should influence the photographic approach. A school, for instance, is designed to facilitate the educational process, and people are the essential factor in that process. To photograph a school without students

would be to tell only half the story. The building's function would not really be illustrated unless the people who use the building were included in the photographs. Photographing a factory space, on the other hand, requires a different approach. In a factory where heavy machinery is housed, the machinery is the essential factor of the design program. Unless people are needed to operate this machinery, the assignment could be handled adequately without people.

3. Orientation of the building to the movement of the sun: By determining which direction is north and knowing how the sun moves across the sky at the time of year when the photo coverage is done, the photographer can note on the architectural plan where on the building the sun will be shining at different times of the day.

4. Relationship of the building to the site.

5. Relationship of the building to surrounding buildings and community.

6. Special design considerations, details to emphasize, and special materials used.

7. Problems either of construction or obstruction. How to avoid incompleted areas or incompleted landscaping.

8. Major interior spaces to cover, and specific treatment of floors, walls, lighting fixtures, and furniture. What must be emphasized or de-emphasized.

9. Additional elements to be considered to complement the building: landscaping, playgrounds, fountains, sculpture, and so on.

10. Additional information that is available: Is there a printed explanation of the design philosophy of the office or building to be photographed? How could the photographer gather additional research material to enhance his photographic documentation?

The preceding ten-point list can be added to or subtracted from depending on how familiar the photographer is with the assignment and/or the architectural office.

PHOTOGRAPHY FOR MAGAZINE OR BOOK PUBLICATION

Illustrations for a preconceived text are fairly simple, especially if the magazine article or book text is complete before the photographer begins his assignment. A completed text can be used as a guide to structure a shooting session, and the point of view of the article or book can determine the photographic interpretation.

Of course, the thoughtful photographer should not stop when he has expressed the point of view of the manuscript, especially if he sees other aspects of the building not mentioned in the text. Within the time span allotted him, the photographer should explore all aspects of a building, keeping in mind that the editor can benefit from the photographer's experience. Very often a photographer and an editor-writer can work together to develop a magazine story. Moreover, since most assignments are commissioned on a one-time-use-only basis, the photographer is free to resell his pictures after the original article or book has been published. And, the more material the photographer has on a given subject the greater are the possibilities for future sales.

PHOTOGRAPHY FOR A BUILDING OWNER OR DEVELOPER

An essential part of the documentation of a project can be the use of photos to help raise money to keep a project expanding. For example, a school, church, or resort hotel will very often be built in stages as money is made available. Thus, the photography becomes an essential means for communicating present accomplishments and future plans.

Very often the architectural photographer is called upon to photograph a model of a proposed project. From the photos of that model the architect's client can raise the necessary funds to begin construction. The job for the photographer is then to make a model look as life-like as possible, so that the investors or community can fully appreciate the design and the implications of the completed building.

SLIDE PRESENTATIONS

If photos of a model are presented in front of a large group, communication is best facilitated by making either original color slides or copy slides from your black-and-white prints. When slides are projected on a wall, the project takes on added emphasis, and the large scale helps to convey the impression of a life-like completed building. If the architect is leading the discussion for the developer, he can carefully lead his audience through all the design stages by the juxtaposition of model slides and copy slides of plans, sketches, and renderings.

PUBLICITY

All categories of architectural photography have elements of publicity attached to them, but what is meant here is a photograph taken to show a specific aspect of the finished project or architectural model. The photographs are taken to convey only one impression and not to document the entire project.

PHOTOGRAPHY FOR AN EDUCATIONAL INSTITUTION OR LIBRARY

Architectural photography plays an important part in the training of the architectural student. Every college design department has (or should have) a slide library of important buildings for the use of its staff and students in lectures, seminars, and research projects. The 35mm or 2¼" x 2¼" slide in color or black-and-white is best suited for this purpose. The instructor can group the slides in a series to talk about one building or in juxtaposition to illustrate his lecture notes. Many architecture departments build their slide libraries by giving students assignments in photographic documentation. The discipline of translating a three-dimensional object onto a two-dimensional photographic plane is an excellent opportunity for practice in objective seeing. In photographing a finished building, a model, or an interior space, the architecture student is forced to look at only one aspect

of the building (one point of view) at a time. If the student is given an assignment to photograph his own model he can quickly see all the indecisions, false moves, and disproportional spaces. Details previously overlooked can loom prominently in a photograph. No other instrument can be so objective, so accurate, and so unfeeling as a camera when used as a recording instrument only, and this aspect should be stressed when the camera is being used as a teaching tool. To the architecture student, clarity is the key word in this photographic assignment. An understanding and evaluation of the project is the purpose of this type of photography.

A similar use of architectural photography can be implemented by an architectural office, particularly in photographs made for site studies, monitoring construction, and documenting small study models. The concerned architect should be able to use the camera as a tool to help him be discriminating in regard to design problems and hopefully help him to enhance his creativity.

From the preceding brief discussion it should be evident that the architectural photograph has many different uses and can play an important role in the design process itself. Architectural photography used in the hands of a skillful photographer can be the chief means for communicating the concepts and concerns that a finished building represents.

ANALYZING THE ASSIGNMENT

In this section five typical assignments are analyzed. Each combines one or more of the photographic approaches previously discussed. Taken together, they demonstrate methods of handling a great many of the problems that the architectural photographer is likely to encounter. The first two examples show building types that were designed as a series of interrelated structures, each of which reflects the activities occurring within. The third example covers a building that is built on the modular concept. The last two examples show how the architectural model is handled.

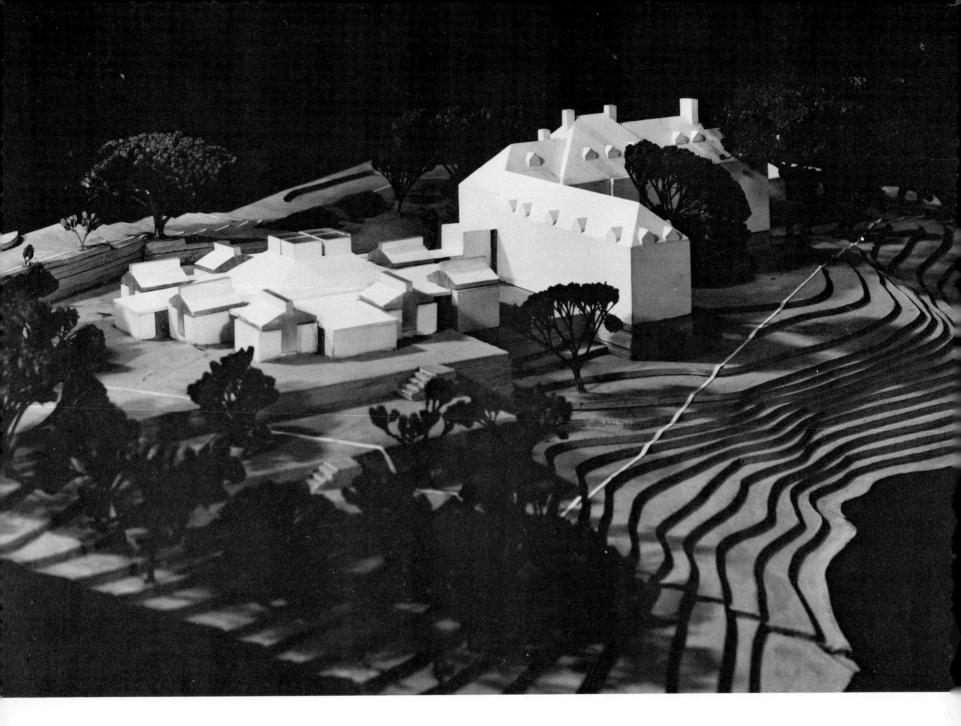

18

1. HENRY ITTLESON CENTER FOR CHILD RESEARCH, A. W. GELLER, ARCHITECT.

In this instance the photographer had the opportunity of working with the architect on each phase of the design process, from model through construction to completion and occupancy of the building. It is of interest to note that the architect's concern for the way the building was to be used dominated the whole process of design and construction. Mr. Geller and his staff spent countless hours studying the problems of emotionally disturbed children in an attempt to find a design solution that could be of positive help in therapeutic treatment. The final resolution was a design that, in Mr. Geller's words, "provides definitive spaces for [the children's] varied activities, ordered means of going from one place to another, and identity for each child as an individual, as part of his unit, and as part of the entire group."

The first phase of my photographic documentation began when I was asked by Mr. Geller to photograph two study models. The first was a small-scale model that showed the Ittleson Center in its site context. The second model was a larger-scale study model designed to explore the interior spaces of the building. Both models and their corresponding photographic documentation provide a clear understanding of the design and final execution of this distinctive project.

As the building neared completion I was asked to do some additional photo studies. From the experience gained by photographing the two models I accomplished this with ease. Although the building was not fully completed, I was able to get several usable photographs, one of which (the elevation shot of the building in the snow) was used as a final key picture when photographs of the building were published. All the photographs taken thus far formed the basis for the final picture presentation when the building was completed and occupied.

The following series of photographs shows the three phases of the photo coverage: model photography, construction photos, and finally the complete photo coverage for presentation. The captions accompanying this photo essay are the words of the architect, A. W. Geller and his design associate Michael Rubenstein.

"The intention, from the beginning of our involvement, was that the form of the building should be a positive help in the treatment of the children by providing definitive space for their varied activities, ordered means of going from one place to another, identity for each child as an individual, as part of his unit, and as part of the entire group."

Contrast and relationship were the key words behind the design philosophy. From the research done by the architect and his design associate they learned that a structured environment, yet one free of conventional spacial organization, was needed to increase the awareness of autistic children. The following pictures demonstrate the complexity of their solution.

20

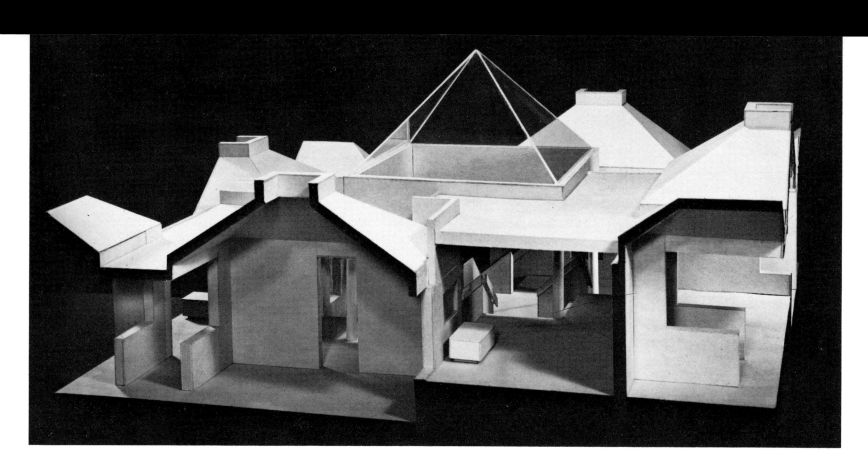

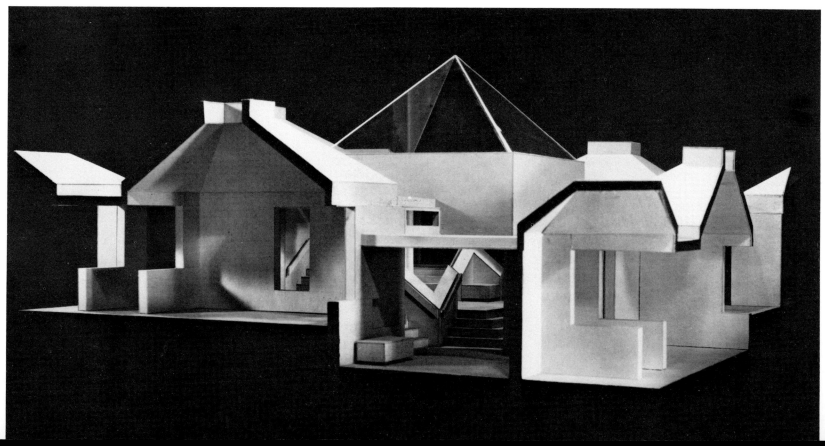

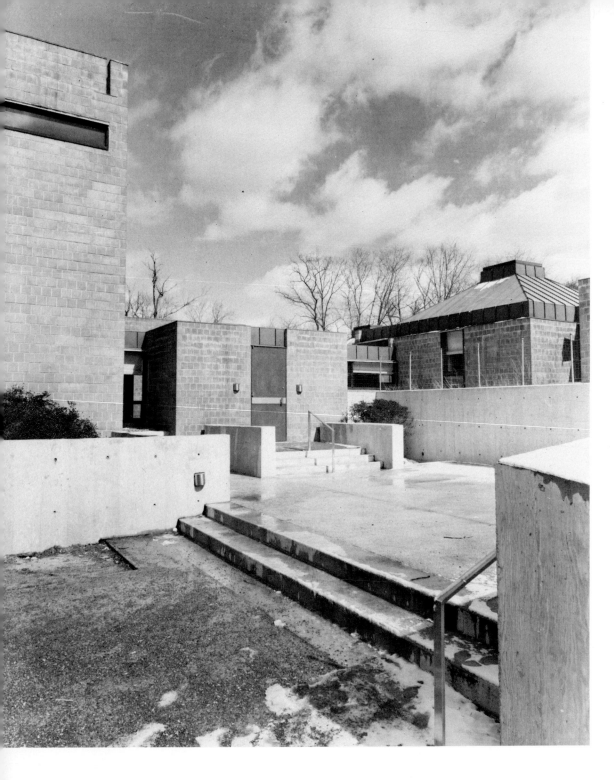

"As to the outside appearance, the attempt has been made to express clearly what is going on inside. The bedrooms, with their pyramid roofs and low supporting walls, contrast with the living rooms, high with flat roofs; outside light sources are low horizontal, middle rectangular, or high clerestory openings; highest of all is the central court with its pyramidal skylight. It was hoped that the children would be able to identify easily the different spaces."

Two pictures were taken of the main entrance of the residence complex, the first just after the building was occupied (above) and the second, on the opposite page, two years later.

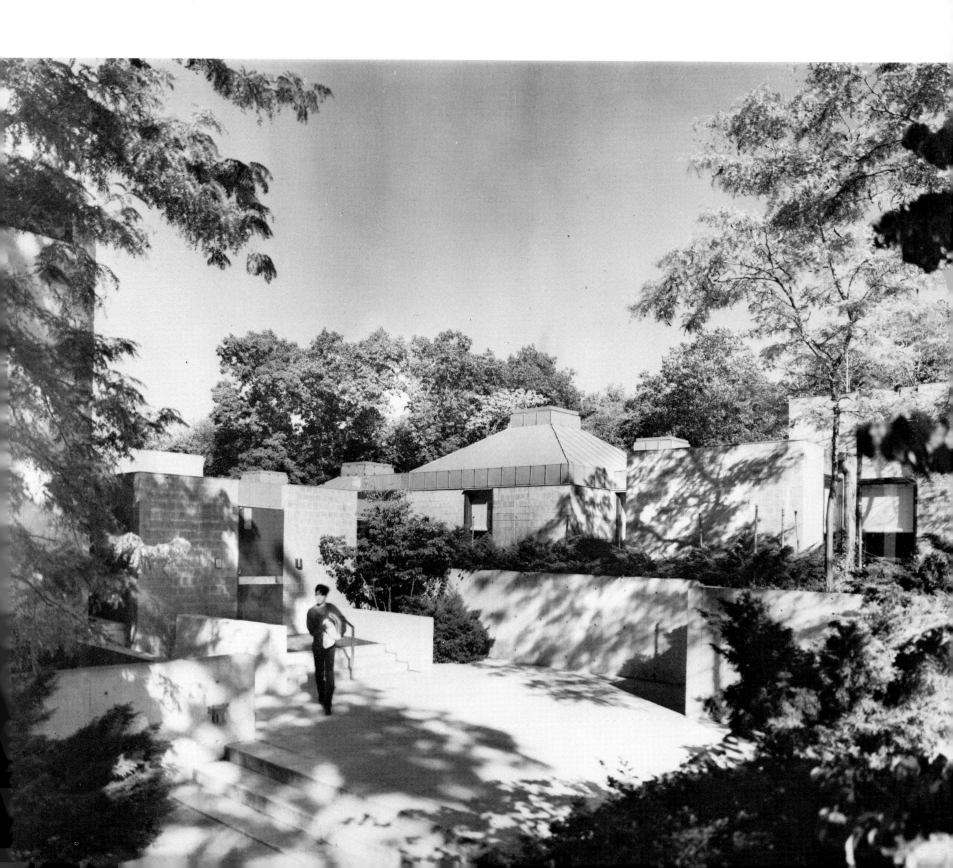

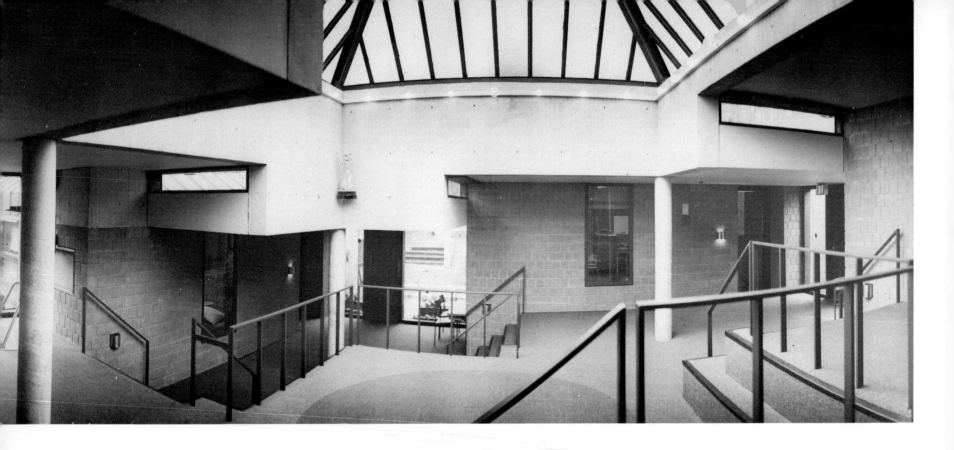

"The four home units of eight children were placed as close as possible, around the central court. The court was not in the program; it was provided as circulation space and as a bonus, a playspace during inclement weather. The four units were clustered together not only because of the tight site but so that the night nurse could be central to the sleeping children. It was the intention that the central court would be an anchor that the children could relate to; it was therefore given a dramatic spatial form."

The final photographic solution emphasizes the spatial drama because of the use of a wide-angle Panon camera that covers 140 degrees and shows how the space is experienced.

24

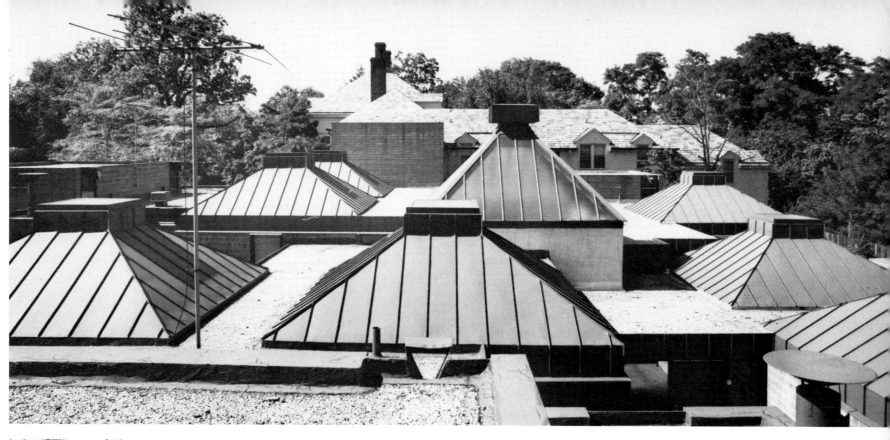

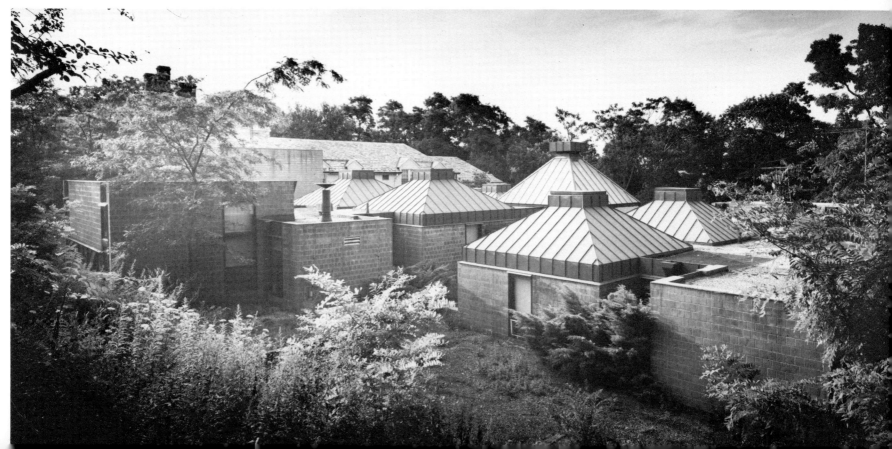

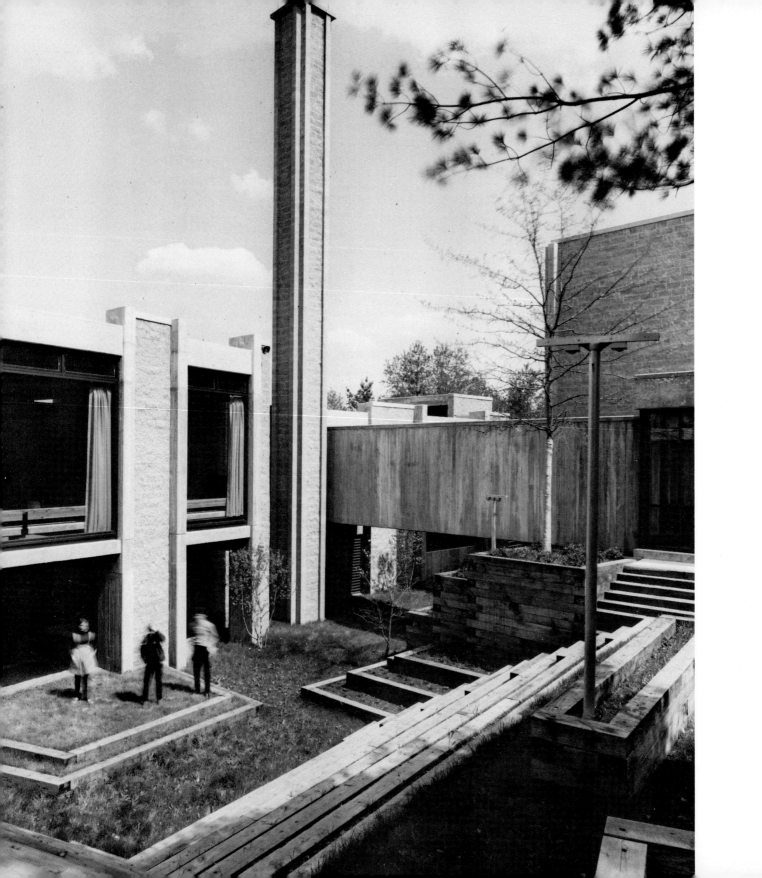

2. LITCHFIELD JUNIOR HIGH SCHOOL, JOHN M. JOHANSEN, ARCHITECT. CLIENT: PROGRESSIVE ARCHITECTURE MAGAZINE.

This assignment illustrates another approach to the photography of architecture. The main job of the photographer here is to illustrate the point of view of the magazine article. The photographer therefore should begin his preparation for the assignment by reading the article itself and discussing it with the writer or story editor. From this discussion the photographer develops a shooting approach that will illustrate the central points of the text.

The title for this magazine article suggests elements to photograph: "Litchfield Junior High: Bridges, Blocks, and Railroad Ties." The article begins in the following manner: "Architect John Johansen developed the organization of his Litchfield Junior High School as a model for the truly flexible system in which parts could not only be addable, but disposable or interchanged."

This opening statement suggested to me that I photograph the many different elements that make up the school's design rather than try to get an overview that would tell the whole story.

Two additional paragraphs describe the specific elements to explore photographically:

"The four major parts of the building (administrative entry block, auditorium, gymnasium and classroom wing) are clearly articulated and linked together by concrete bridges, or tubes, that are free in space."

"Materials are heavy and lasting, but non-institutional. Split-face concrete block walls between exposed concrete columns are particularly handsome."

From this brief account it should be obvious that a well-written and organized text is of enormous help to the photographer, particularly when he is unfamiliar with the architect or the building to be photographed.

Depending on the amount of time available (many assignments are rush jobs to meet approaching publication dates) and the extent of the article, three other

sources for research can be explored: (1) the primary source for additional information, that is, the architect himself; (2) book or other magazine articles; and of course (3) a walk through the building, although this may not always be possible.

In handling the Litchfield Junior High School assignment, I arranged a meeting with the architect and got some additional comments about his philosophy. I also met several times with the architect's associate on the project, Ashok M. Bhavnani.

The following is an account of the initial meeting with Mr. Bhavnani. I carefully went over the building plan with Mr. Bhavnani and learned something about architect Johansen's design approach.

"Litchfield Junior High School represents a non-frontal approach to architecture," Mr. Bhavnani said. (What is meant by non-frontal architecture can be explained simply as architecture that can not be understood by any single view of the building, and particularly not the front

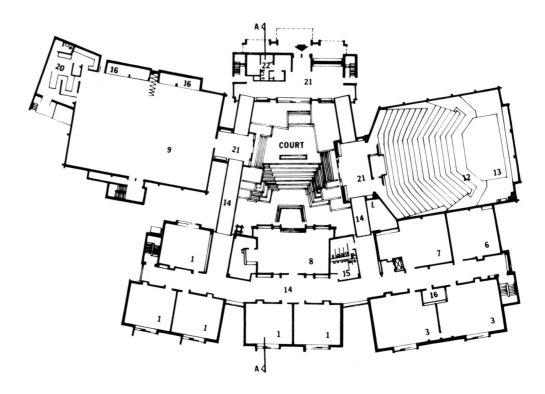

SECOND and MAIN FLOOR PLAN

SCALE 0 15 N

SECTION A – A

SCALE 0 15

view.) "Litchfield," Mr. Bhavnani went on to explain, "is a cluster of buildings of distinctly different shapes that house different functions. Each building block forms its own system to promote the energies within, and each block is connected in the most direct way possible by tubes that bridge one building to another. Perhaps the inner, central court could be considered a unifying element in this design. This court certainly gives the arrangements of building parts their focus. Actually the inner court is part of the original site, which was further defined by placing railroad ties down the natural slope. With the railroad ties forming seats, this courtyard becomes an amphitheatre."

Discussion with Mr. Bhavnani helped to develop my approach: Since the central courtyard is the main feature relating the various elements, it seemed obvious to start the photographic documentation by exploring as many aspects of this courtyard as possible.

Another source for research was Paul Heyer's excellent book, **Architects on Architecture.** From Mr. Heyer's account of an interview he had with Johansen I learned more about Johansen's architectural approach: "I am interested in a return to basic fundamental experiences and processes—not caring whether they are modern or not," said Johansen. "My design begins with an analysis of functions, and it grows; and if there is an order to the life, and its accommodation, in a building, it will result nearly always in workable organization. The architect must be interested in the physical and psychic human processes that are to take place in his building, because it is a precise accommodation of these processes that makes a building come alive."

One final statement of Johansen's (as quoted by Paul Heyer) seemed applicable, although it was made to describe Johansen's Goddard Library: "The building itself expresses the several stages of the design process, and in seeing the final form one will feel as though one has come upon the various parts of the building in process of assembly or attachment."

From the preceding examples of research material it should be obvious that many avenues are open to the photographer who wishes to make his photo essay as meaningful as possible. In any assignment, the more the photographer knows about the subject the better he is able to control the final result.

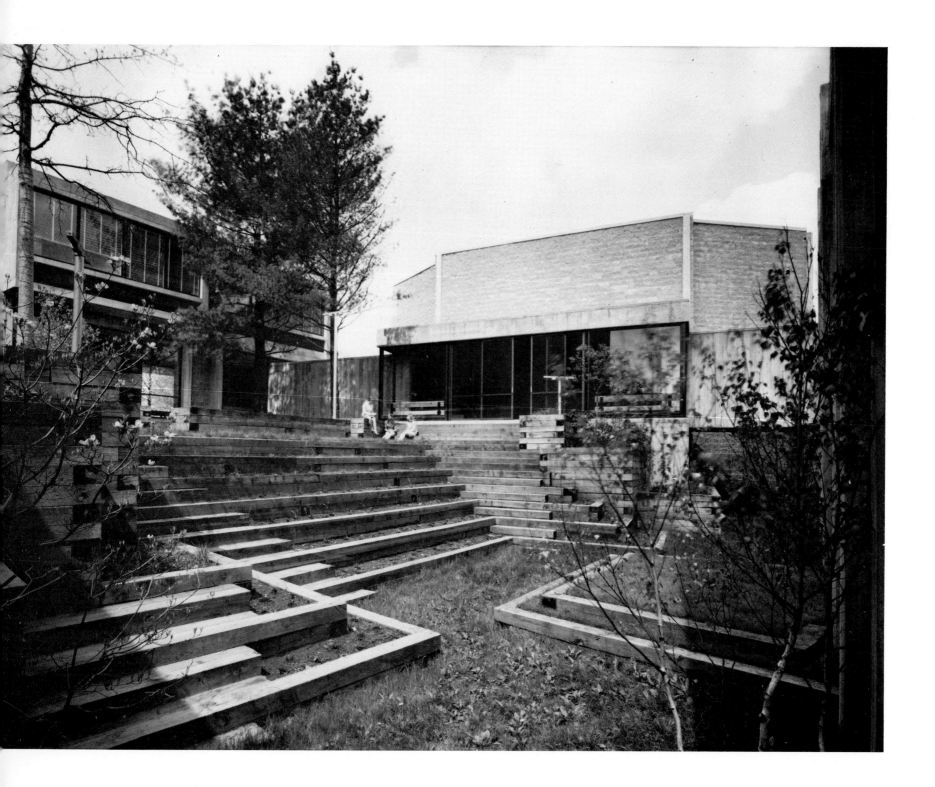

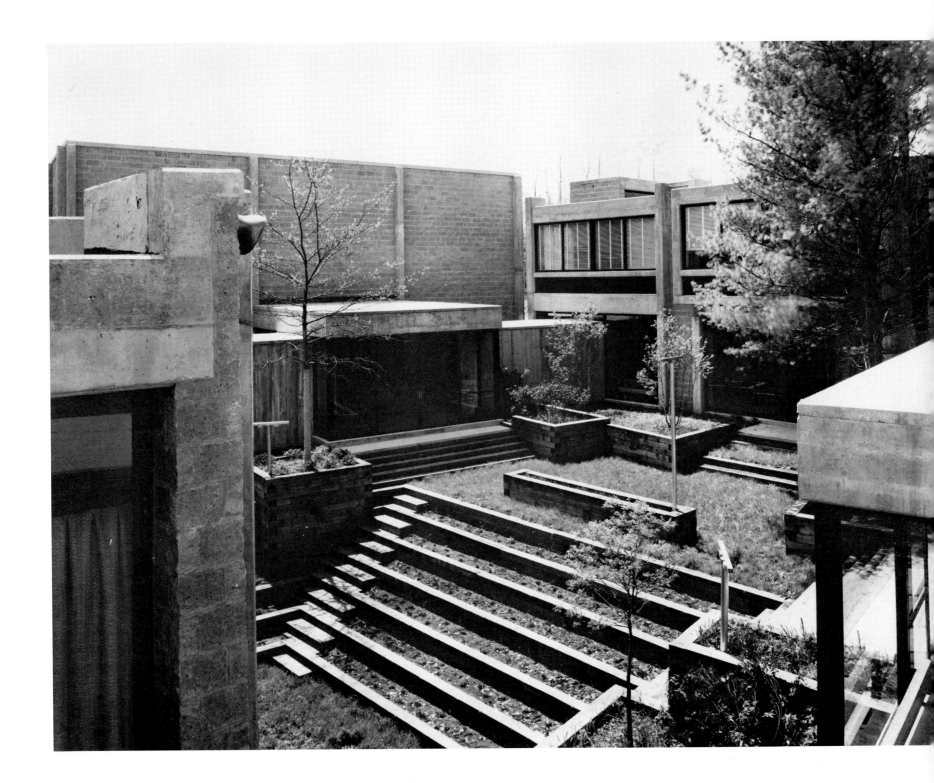

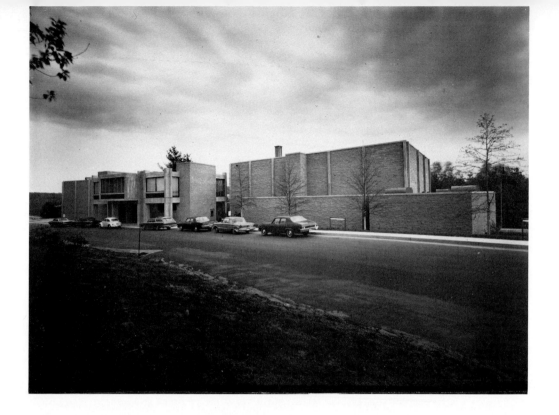

View of the front of the building complex facing the street.

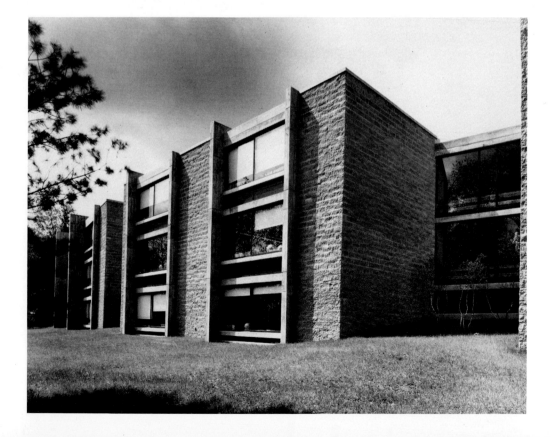

View from the back of the building showing the relationship of the classrooms to the environment of the site.

3. SEAGRAM BUILDING, LUDWIG MIES VAN DER ROHE WITH PHILIP JOHNSON, ARCHITECTS.
BOOK ILLUSTRATION.

A striking contrast to the expressionistic, personal approach of John Johansen is the architecture of Ludwig Mies Van der Rohe. For Mies, whose primary interest has been with the high-rise skeleton structure and the clear-span open-space structure, design reflects a concern for universal solutions rather than a personal involvement with function.

According to Paul Heyer in his book **Architects on Architecture,** "Mies says that while form cannot change, function does; 'We do not let the function dictate the plan. Instead let us make room enough for any function' ...Mies creates a flexible space capable of continual modification and thereby designs to counteract obsolescence."

Clarity, simplicity, nobility are some adjectives used to describe the architecture of Mies Van der Rohe. Keeping these words in mind, the approach to photo-

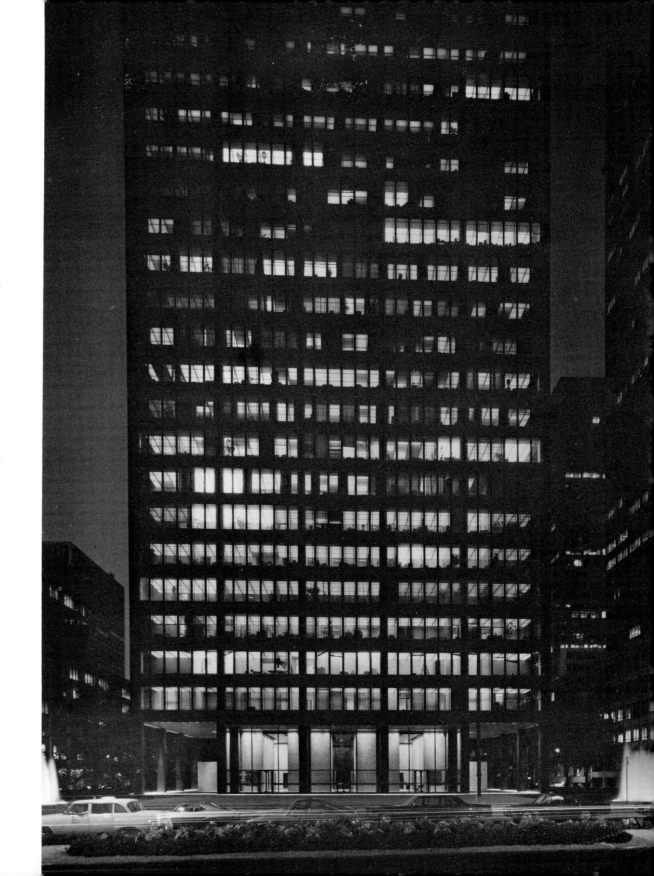

graphing the historically important Seagram building becomes obvious. The assignment requires one well-chosen photograph. The text makes the choice obvious:

"Set back from Park Avenue so that the purity of its 38-story shaft can be appreciated, it is approached formally across a granite plaza flanked by fountains. The plaza is actually a podium, elevated three steps above the level of the principal approach from Park Avenue, and up a short flight of steps beneath glass-roofed canopies on both side approaches. Here, Mies kept the structure within the skin of the building, but the structure is still clearly expressed as it forms a colonnaded entrance to a lobby that is an unusually noble 24 feet high. The structure is sheathed in brown-tinted glass, and with its millions of bronze spandrels, it gives an impression of warm durability and quiet unity. It is particularly dramatic at night when its entrance lobbies and travertine-sheathed elevator shafts are bathed in a white light, contrasting with the deep brown tone of its bones, while its windows emit a warm muted glow that emphasizes its elegant proportions."

Both the architect's philosophy and the writer's description suggest straightforwardness and directness as touchstones. The photograph should be straightforward, direct, well chosen, and simple. In this case the photograph was taken from a position directly across the street, elevated sufficiently to give a feeling of height, yet low enough to record the podium and entranceway. It was made at a time of evening when the interior light dominated, and yet there was sufficient skylight to allow recording of exterior details. It was an easy shot to visualize, but a most difficult shot to accomplish.

Lack of sufficient open space in front of the building was a principal shooting problem. Available cameras were not equipped to handle such a wide angle of view, and the solution became a compromise. The 5" x 7" format was used with a 65mm lens, which was not designed to cover this format completely. The final picture is a success because of careful timing and printing.

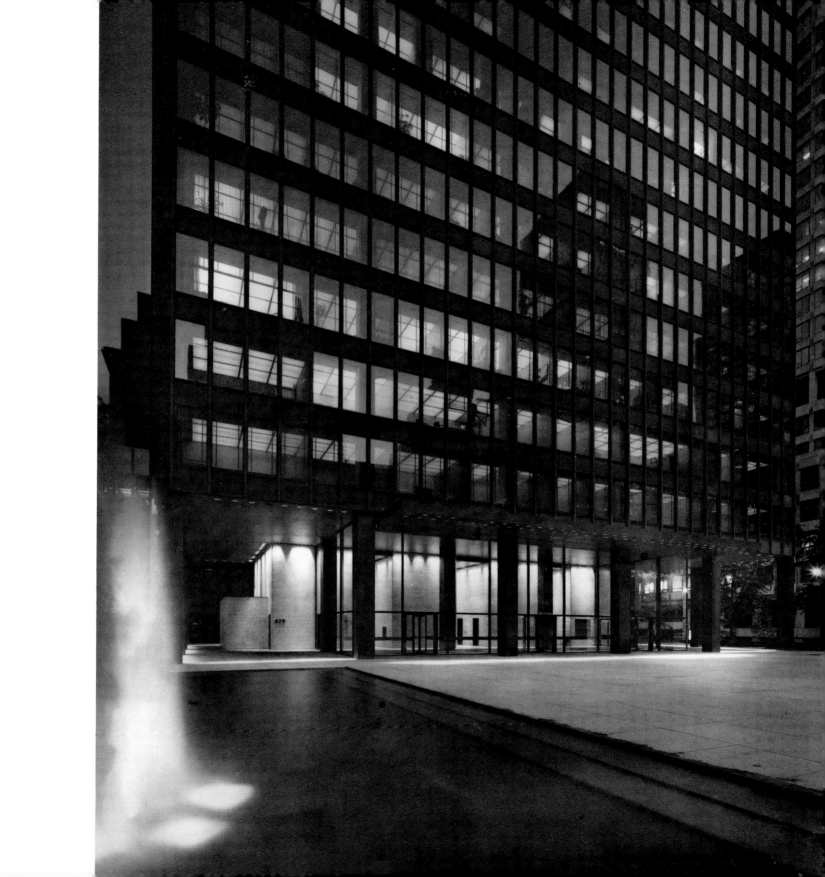

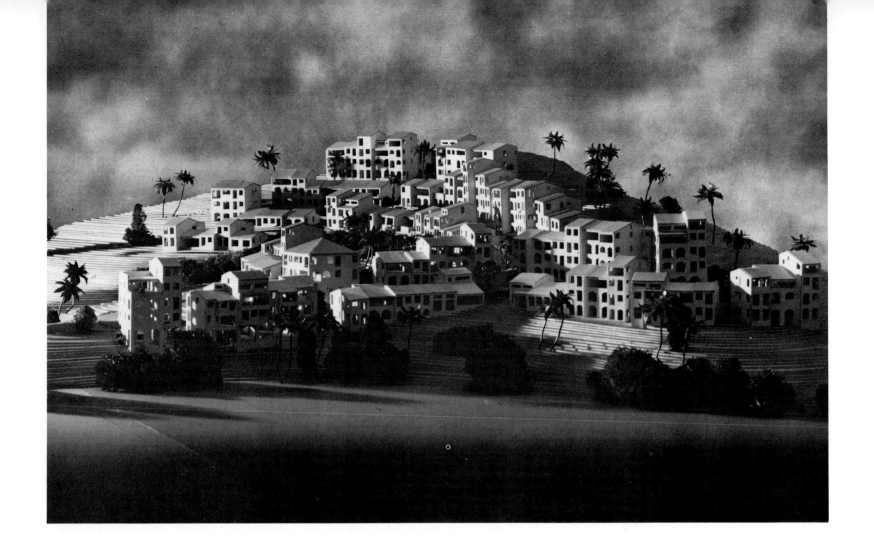

4. PALMAS DEL MAR. STUDY MODEL.

The photography of Palmas del Mar offers us an opportunity to examine how an architect develops a final design, and how photography can aid that development by helping the architect gain perspective. Working closely with the architect, the photographer examines the model from many points of view. With the aid of a thorough photo analysis, the architect is able to see aspects of his design that he may have overlooked.

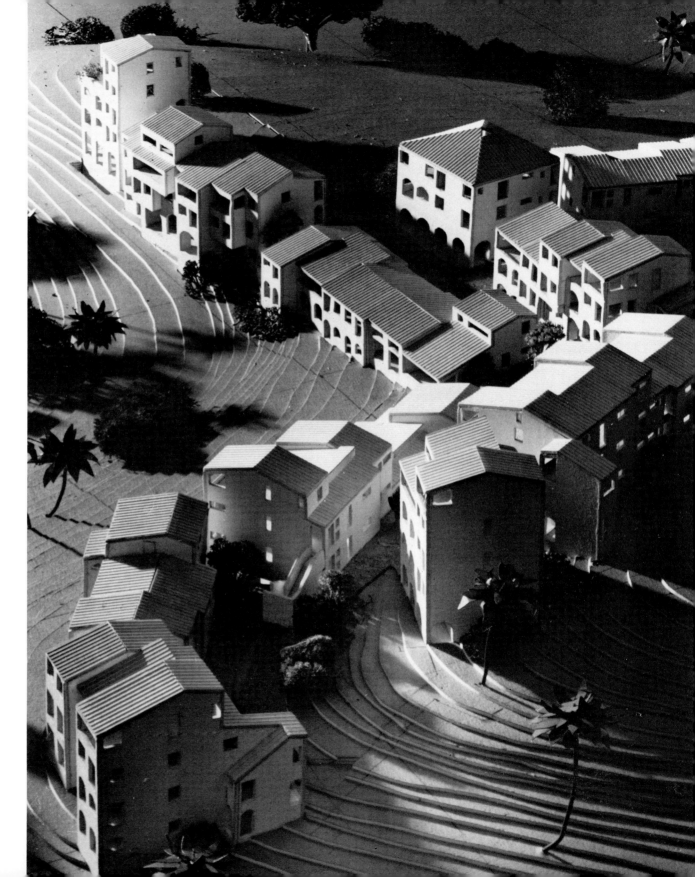

Two views show the character of this project. The photo on the opposite page shows the overall design of the resort complex while the photo on this page shows a small detail. Both shots are dramatically lit to give depth and mood to the image.

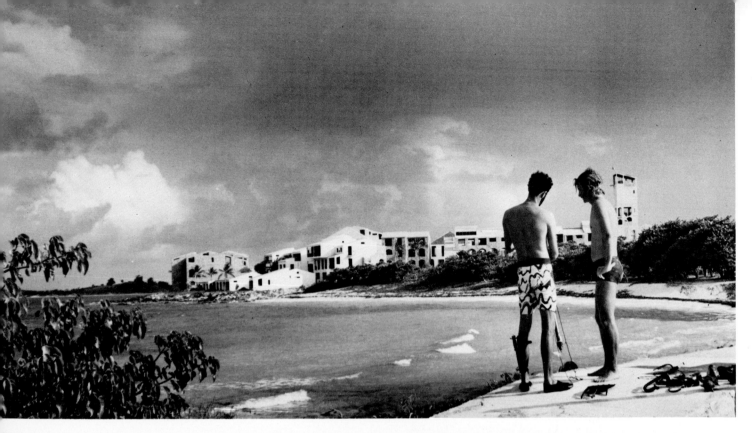

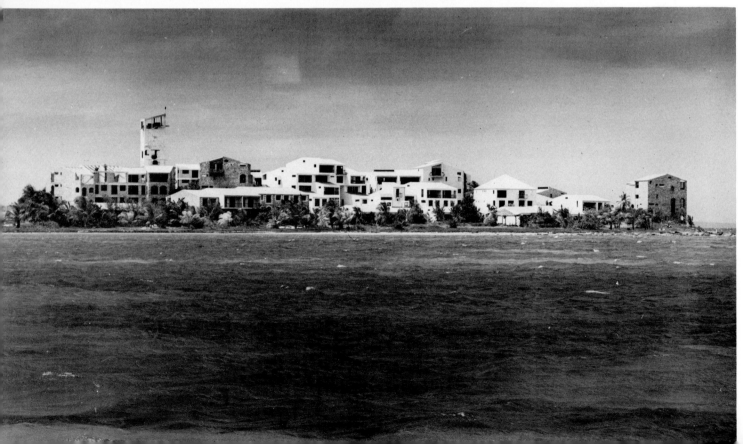

Two elevation shots were chosen to express the environment and character of La Belle Creole. The placement of some people in the foreground, in the top illustration, helps to personalize this project although it was still unoccupied at the time of the shooting.

5. (1) PALMAS DEL MAR
(2) LA BELLE CREOLE
(RESORT HOUSING,
ST. MARTIN),
DAVID TODD AND
ASSOCIATES, ARCHITECTS.
PRESENTATION MODELS.

The photographs of Palmas del Mar were not made for study but rather for presentation to the architect's client. Their intention here is to describe the architect's design philosophy. Other uses of these photographs were for fund raising and promotional advertising. The composition, use of background, and angle of view were chosen to give the photograph as life-like an appearance as possible.

The basic concept behind the Belle Creole development was to create a fluid, self-sustaining, village-type resort community, a full-service community with all the modern conveniences. Located near each apartment complex were to be boutiques, gift shops, pubs, and small restaurants; within the main first-phase complex were to be service and maids' quarters, a large restau-

rant, a casino, a central shopping mall, swimming pools, and a boat basin. Unfortunately, the Belle Creole project was stopped suddenly for refinancing, and the photo series was taken only two-thirds of the way to completion.

The photographs were used two ways: first, by the architect, as promotional material and record photographs, and second, by the architect's client. The photos were intended to make the development look as finished as possible, yet record those aspects that needed additional funding. Discussions with the designer, Bob Cabrera, defined the approach to the photographing of this complex project:

"The feeling of the project should be loose and fluid. It should give the impression of an evolved community, the organization not imediately recognizable. It is a series of well-chosen vignettes. The design was like an architectural jam session."

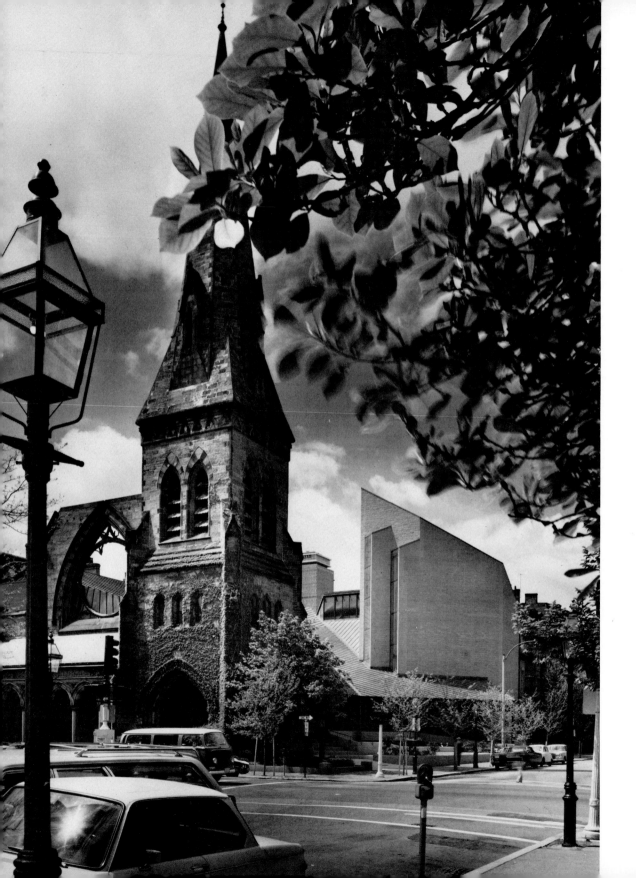

The following series of pictures was taken as a direct response to the sculptural/spatial quality of this beautiful church. The architect created a unique statement and my approach was to respond photographically to as many differing aspects as possible. This series, shot in black-and-white and color, was commissioned by *Progressive Architecture*. I did not discuss the project in any detail with the architect or the editor in charge of the story. The photographs therefore represent my subjective response to the textural elements and the quality of the interior spaces.

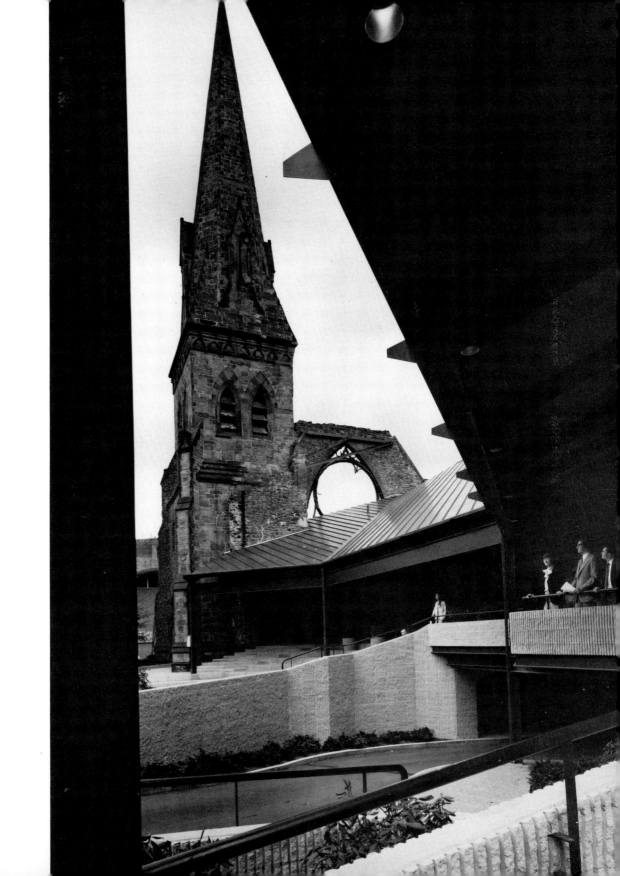

FIRST AND SECOND CHURCH,
Boston, Mass.
PAUL RUDOLPH, Architect.

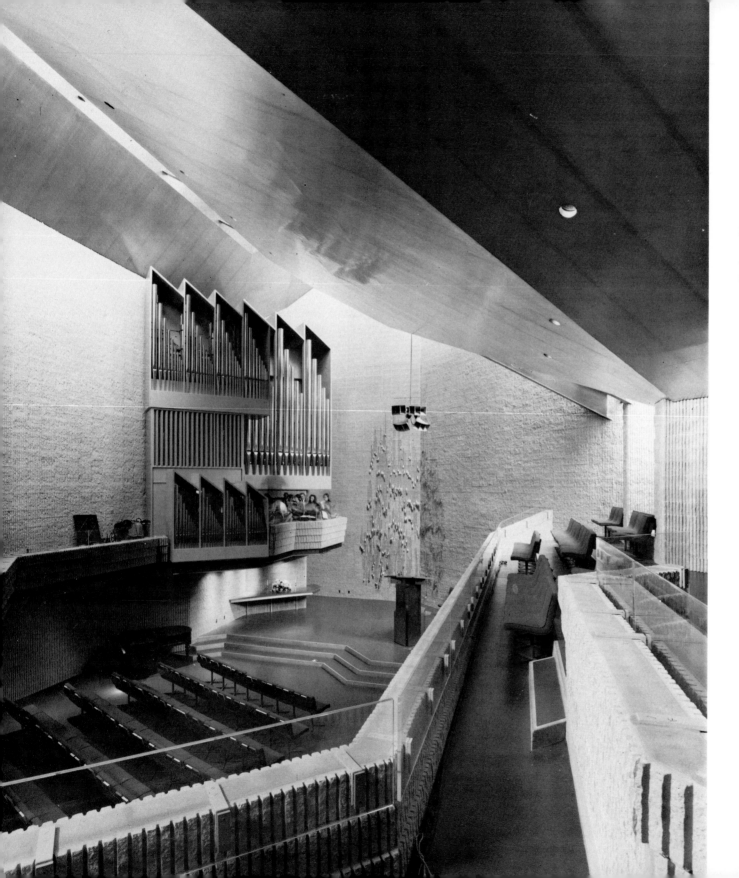

Two views of the chapel taken from the second-story balcony explain the design. The picture on the left was taken on an overcast day during an actual service with a Brooks Veri-Wide camera. The picture on the opposite page was taken on a 4" x 5" format the following day. Both pictures are interesting in different ways because of the subtle variation in light and camera position.

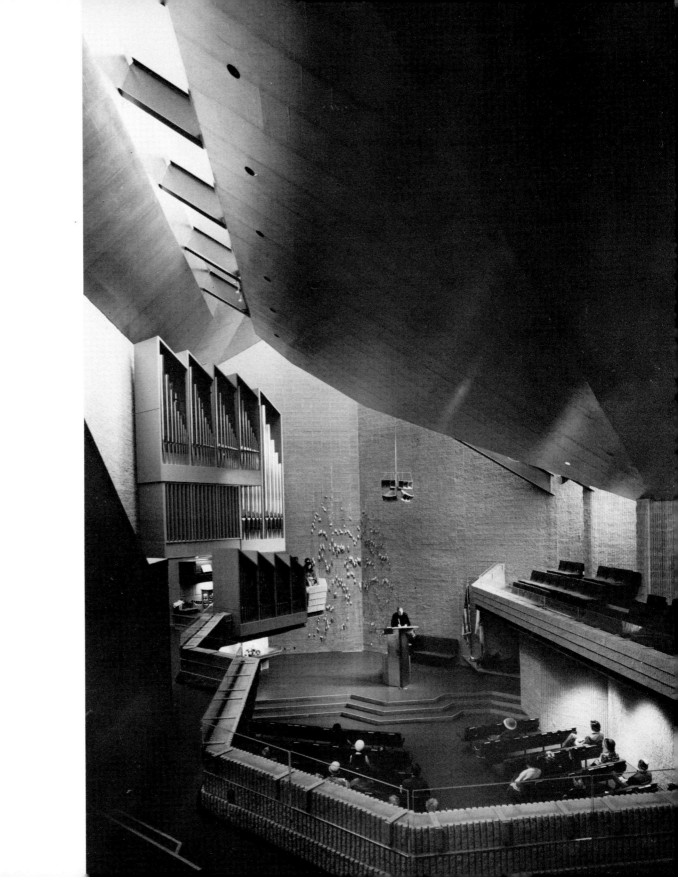

SUMMARY

From these five distinctly different assignments you can see how and why you should vary your photographic approach. Each building presents a new situation, and the "right" approach to that situation must grow out of the photographer's sensitivity and understanding of the way the design works. Knowledge about photographic technique is not enough to insure success in this specialized field.

As far as I know, there are no formal classes in architectural photography in any school, college, or university, although some design schools require a general course in photographic technique. The best training, particularly for an experienced photographer who wishes to specialize in architecture, is to work closely with a practicing architect. Frank and honest criticism from an architect is of enormous help in finding the right way

This shot was taken with the camera pointing directly upward from the pulpit. Many freewheeling vignette shots were taken to capture the spirit of the building as it is articulated through many varying details.

to photograph his building. By learning the way an architect "sees" his project, the photographer can begin to visualize how the design elements must be represented photographically.

Magazine publications on architectural design are of additional help both for researching an assignment and for studying photographic approaches. By careful analysis of the way other photographers handle architecture, further insight can be gained into the how and why of architectural photography; and by comparison of the work of different photographers many techniques can be seen. It is particularly interesting and informative to compare magazine photographers from different countries.

Here are some magazines that can be recommended for study and as potential markets for future sales: **Architectural Forum; Architectural Record; Progressive Architecture; Architectur Pluss; Interiors; The AIA Journal** (national and local). In England: **Architectural Design** and **Architectural Review;** in France; **L'Architecture D'Aujourd'hui; Techniques et Architecture;** in Italy: **Dolmos;** in Canada: **The Canadian Architect.**

Other sources for study materials are the libraries of schools of architecture, public libraries, historical societies, and many museums. To the industrious student many resources are available for expanded study.

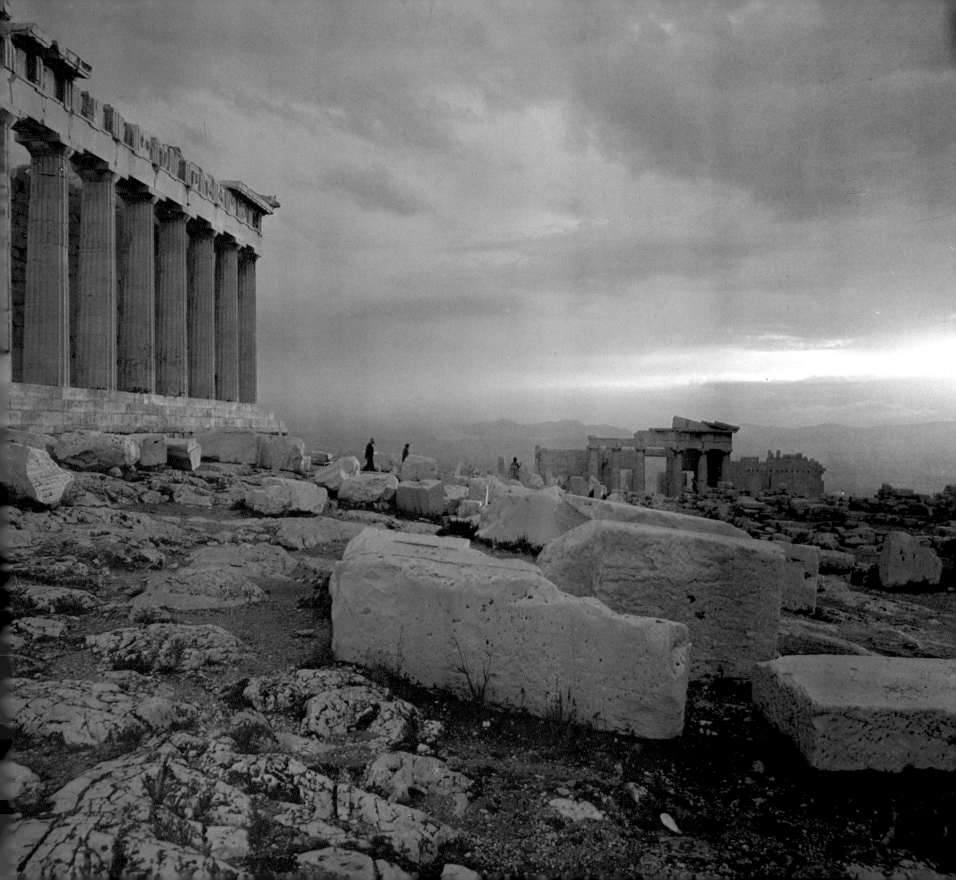

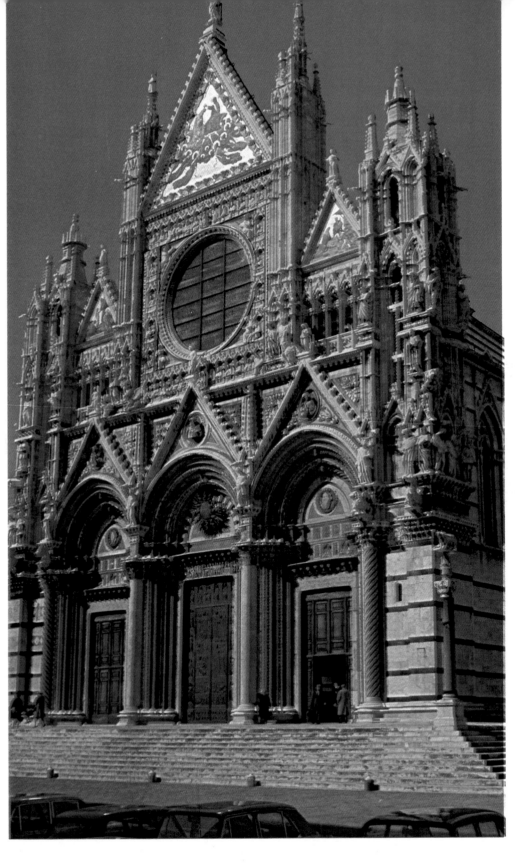

Underexposure, Ektachrome Film Type B, and an extremely blue sky create the moody quality of this beautiful Church in Orvietto, Italy.

FORD FOUNDATION BUILDING, New York City.
KEVIN ROCHE, Architect.

COMPLEX A, State University of New York at Old Westbury.

ALEXANDER KOUZMANOFF,
VICTOR CHRIST-JANER, JOHN M. JOHANSEN,
Architects.
Two examples (opposite page) of composition in color photography. The top picture expresses the dynamic aspect of the design; the bottom picture, though static, renders the subject more realistically. Each picture serves a different purpose.

FORSTER CHEMICAL COMPANY, New Jersey.
JOHN M. JOHANSEN, Architect.
Two examples of composition in color photography. Both pictures are a direct response to the color inherent in the architectural design.

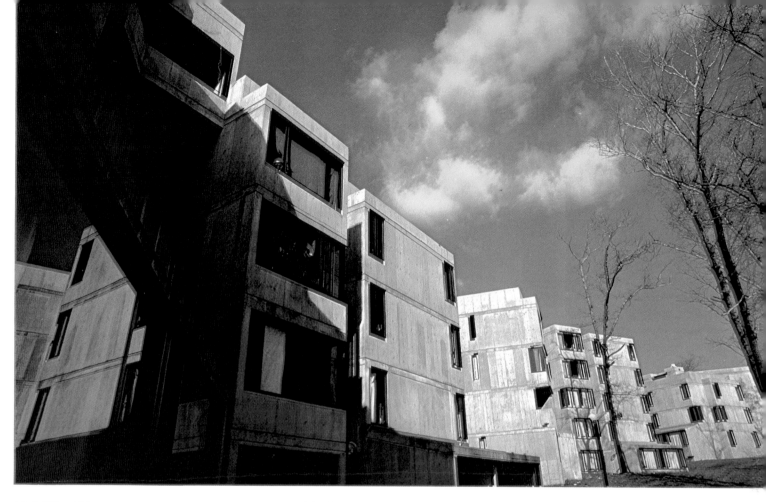
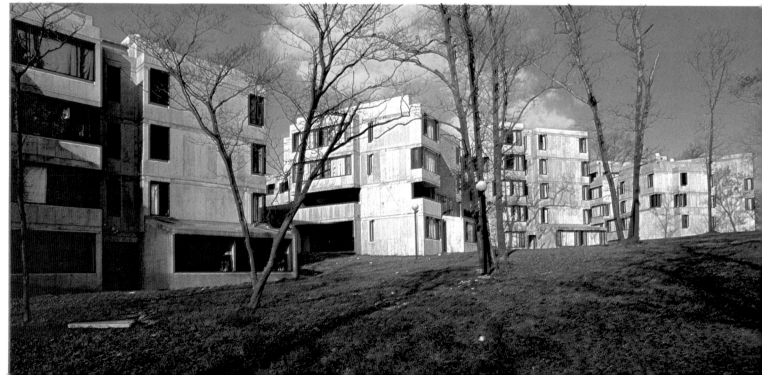

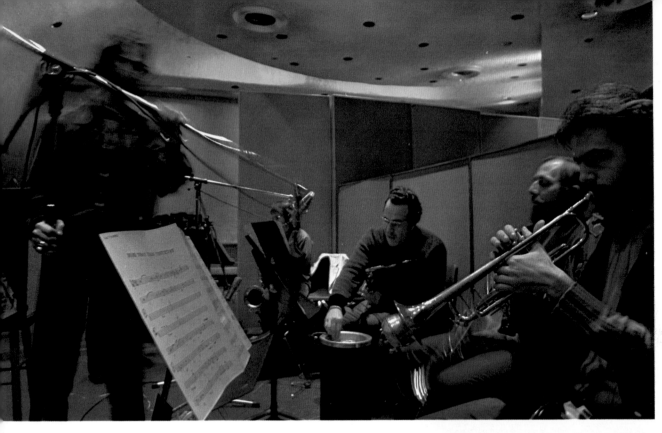

ELECTRIC LADY RECORDING
STUDIO, New York City.
CEREBRUM NIGHT CLUB,
New York City.
JOHN STORYK, Designer.

Two examples of how a mixture of
colored lights, an essential part of the
architectural design, can be rendered
photographically.

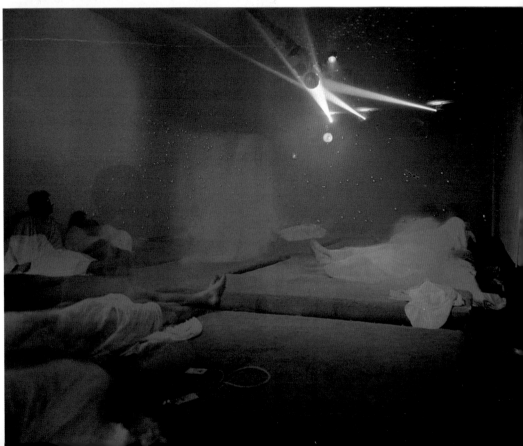

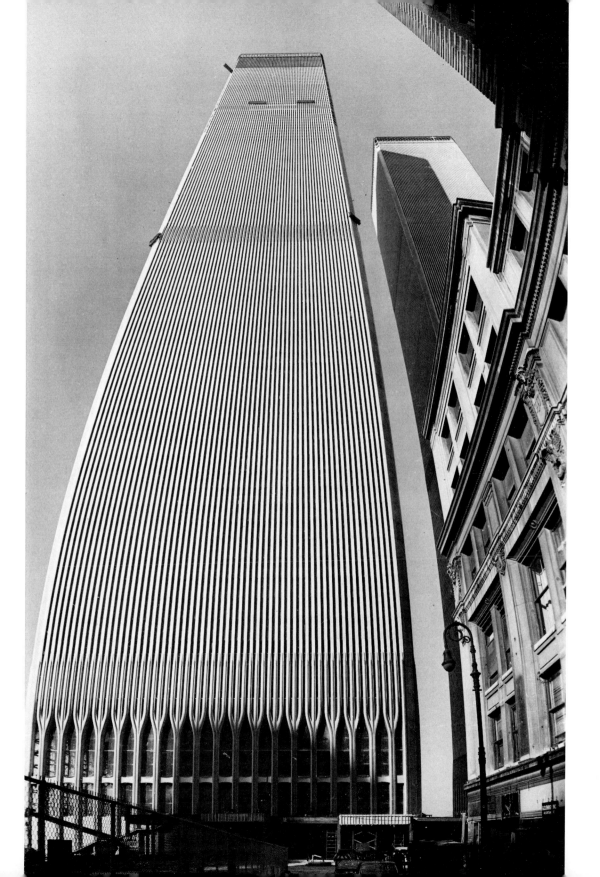

2

WORLD TRADE CENTER,
New York City.
MINORU YAMASAKI, Architect.

Taken with a Panon camera.

Equipment And Its Uses

The selection of equipment is always a difficult one for a beginner in a specialized field. A knowledge of that field's requirements is necessary before an appropriate choice can be made. The purpose of this chapter is to survey the available equipment that can be applied by the architectural photographer and to describe how this equipment can be used in specific situations.

The following is a list of the types of equipment discussed in this chapter: (1) cameras and lenses; (2) light meters; (3) artificial lights; (4) the tripod; (5) filters; (6) the polaroid back; (7) carrying cases.

Equipment for the architectural photographer need not cost a lot. Cost is not always a clear indication of quality; and it is often possible to purchase good equipment inexpensively from a used-camera dealer, if he is reliable and will give a reasonable guarantee. Also, throughout the following discussion it should be remembered that equipment should be purchased as the need arises. It is better to have a few

reliable pieces to begin with than to own a fancy array of unusable objects. Each piece of equipment —even a simple camera, for example—requires experimentation and practice before its potential can be fully utilized. It is advisable to explore that potential before going on to a more complex and more costly piece of equipment.

THE CAMERA

The selection of a suitable camera for the beginning photographer is difficult, as this first camera must serve many purposes. For the photographer who wishes to specialize in architecture, the selection should be based on two factors: (1) the experience you have in seeing photographically; and (2) the degree of flexibility the camera has in controlling perspective.

Only one camera type, the view camera, has the ability to handle nearly all situations an architectural photographer is likely to encounter. This camera, however, is complex and difficult to handle, particularly for the beginner. If you have difficulty visualizing the way a normal camera-lens system "sees," then the view camera is not a wise first choice. If, on the other hand, you are coming to architectural photography with experience in seeing photographically, then the view camera will help to extend your vision, and will expand your ability to control the final picture in a way that is unsurpassed by any other camera type.

For the nonspecialized photographer, the 35mm single-lens reflex camera with interchangeable lenses has become most popular. With this camera type it is possible to view the subject directly through the lens with the aid of a prism viewfinder that reverses the image so that it appears upright and laterally correct. This camera type is easiest to use and perhaps the best for teaching the beginner to see photographically. With the invention of the perspective control lens (PC Nikkor) for the Nikon, the 35mm single-lens reflex camera became a highly usable tool for the archi-

tectural photographer. The PC lens is a specially designed lens with a wide covering power, allowing an 11° shift of the optical axis in any direction. This shift, particularly upwards, makes it possible to photograph a tall building without the effect of vertical lines converging. This convergence is apparent when the film plane is not parallel with the subject, that is, when the camera is tilted upwards in order to include the whole building. Other cameras applicable to architectural photography are the wide-angle cameras such as the Brooks Veriwide 100 and the Hasselblad Super Wide C. Both of these cameras have the advantage of a larger negative than the 35mm, an extremely wide angle of coverage, which is of particular use in photographing small interior spaces, and lightweight design, which is useful in hand-held work. The disadvantage of these two cameras lies in their non-reflex viewing and non-interchangeable lenses.

Twin-lens or single-lens reflex cameras with interchangeable lenses are available in formats larger than 35mm; they are, however, relatively heavy (compared with the wide-angle or 35mm cameras) and do not use extremely wide-angle lenses. Cameras like the standard Hasselblad, the Rolleiflex and the Mamiya C offer a wide selection of lenses and accessories. These camera types are useful when photographing architectural details, small buildings, large interior spaces, and architectural models.

Highly specialized cameras that are useful to the architectural photographer when he needs to record the site or entire environment surrounding a building or a proposed project are the panoramic cameras.

There have been a number of panoramic cameras, some still in use—The Panon Widelux is still in production and widely available. The Widelux uses 35mm film and produces an elongated 1″ x 2⅓″ format equivalent to almost two frames of a standard 35mm camera. When an exposure is made, the lens moves in an arc from left to right and the film, curved in a corresponding arc, is exposed through a narrow slit.

The overall coverage for this camera is 140° and the perspective is cylindrical.

Before we get into the discussion of the view camera, which is the most useful and versatile camera for the architectural photographer, let us look at the standard procedure for setting up and leveling a camera.

To be able to work quickly when photographing a building or interior it is necessary to adopt a standard working procedure. This is of utmost importance when working with a heavy, large-format camera and a tripod. The following is a step-by-step approach:

1. Decide the angle of view. This is usually done without a camera by experienced photographers, but for the beginner the hand-held camera and lens can be used to find the right angle.
2. Set up the tripod, adjusting it to the desired height.
3. Firmly attach the camera to the tripod with a locking screw and level it. This can be done easily by sighting down the side of the camera and aligning the vertical line of the camera body with a vertical line of the building.
4. Insert the lens in the front camera standard. This applies to the view camera only. When using smaller cameras, attach the lens before placing the camera on the tripod.
5. Set the horizontal level. This can be done easily by looking at the building through a gridded ground glass or viewing screen and aligning the horizontal lines on the grid with a horizontal line in the building. If the angle of view is oblique, you will have to imagine a horizon line running through the center of the building. The horizontal lines on the grid must be perpendicular to the vertical lines of the building.

Two other methods for leveling the camera can be used: (1) When your camera does not have a gridded viewing screen or ground glass, the sides of the viewfinder act as a rectangular frame, providing vertical and horizontal lines that can be aligned with the lines in the building to level the camera; (2) a small, round bubble level can be attached to the top of your camera. By centering the bubble, you will level both horizontal and vertical camera axes.

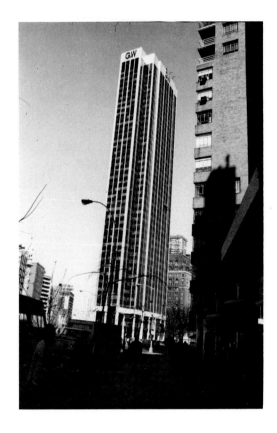

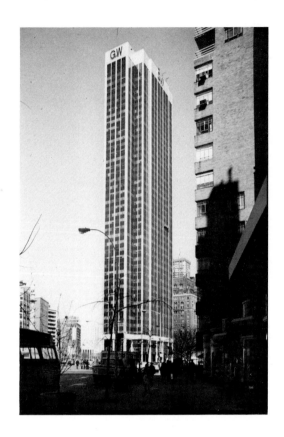

THE RISING FRONT ON A VIEW CAMERA

When you photograph a building with a "normal" camera, one in which the relationship between the lens and film is fixed, it is generally necessary to use a wide-angle lens to keep the camera parallel to lines in the build-

ing and at the same time include the entire building. This is a particularly serious problem when photographing a tall building from street level. When it is held level, the wide-angle lens will record an equal proportion of foreground can be cropped, but the effective size of the building in the negative is reduced. When

this negative is printed the foreground can be cropped, but the usable portion of the negative will be much smaller.

This is not the case if a view camera is used (or even a 35mm camera such as a Nikon F equipped with a PC [perspective control] lens). By raising the front lens board of the view camera,

The three pictures of the Gulf and Western Building on page 54 show how the PC-Nikkor 35mm lens can be used effectively. The left and center pictures were taken with the lens unaltered, while the third picture (of the entire building) has been corrected for the converging of parallel lines toward the top of the building, which occurs when the camera is pointed upward. The picture on the left was taken by tilting the camera upward. In the center picture the parallel lines remain parallel but the top of the building is cut off. The right-hand picture was taken from the same position as the center shot, but the lens was shifted to effect results similar to the raised front on the view camera. (See illustration of PC lens on page 67.)

(or the PC lens on the 35mm camera), the lens can be brought into a different relationship to the film plane. If the lens has sufficient covering power, this action alone eliminates that proportion of the foreground unnecessary to the composition, and it is not necessary to change the camera position. The accompanying series of demonstration photographs, made with a view camera, illustrates this method.

Another solution to the problem of covering an entire building is to tilt the whole camera upward, but then vertical lines appear to converge in geometric proportion to their distance from the film plane and create a different kind of perspective. This is disturbing, for we are accustomed to understanding a building as a series of vertically straight lines.

It is possible, if the upward tilt is not very great, to make a correction in the enlarger in a similar fashion as an adjustment with the view camera. In this case the paper easel or negative holder is tilted to make the necessary compensation.

If the horizontal and vertical axes of the camera back are correctly leveled, all vertical lines in a building will be parallel to each other and appear perpendicular to the horizontal line on the ground glass. If the camera back is parallel to the front of the building all horizontal lines will likewise be parallel to each other. On the other hand, if the horizontal lines appear in perspective, diminishing toward a point, you know the back is not parallel and the rear standard must be swung to the left or right slightly.

It is important to understand the above method of aligning the camera with the building; all further departures are based on this fundamental principle of perspective.

Distortion-free shots are photos taken of a flat surface in which the subject plane is exactly parallel to film plane. All other shooting positions utilize some form of apparent distorting perspective. What we are able to achieve with the use of a view camera is the minimizing of apparent distortion.

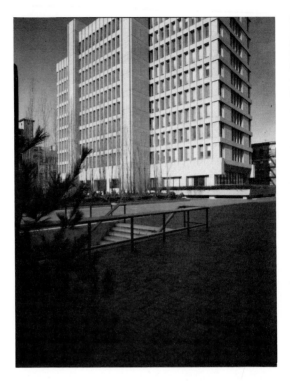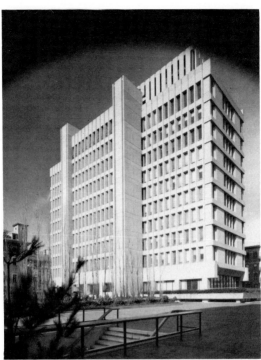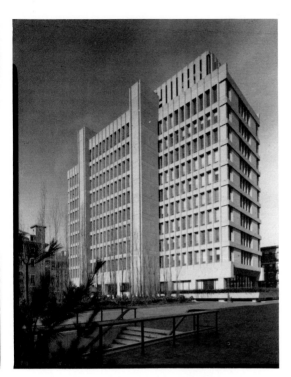
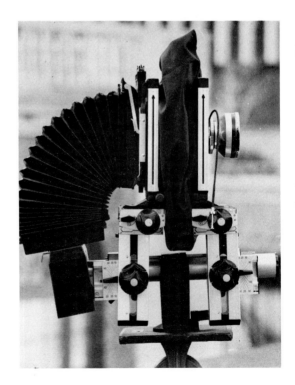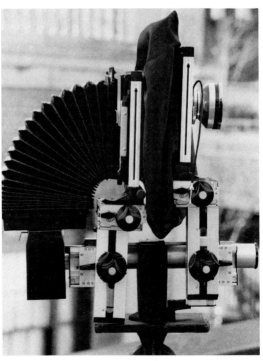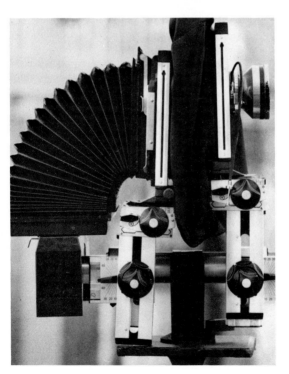

The illustrations on the opposite page demonstrate the effective use of the raised front on the Sinar P view camera. With the lens level, the wide-angle lens may not record the entire building (left pair). Raising the front slightly to include the entire building will noticeably cut down the angle of view if a filter is used (center pair). To avoid this vignette effect, either remove the filter or tilt the top of the lens board backward slightly (right pair). If this technique is used you will have to re-focus and use a smaller f/stop because the depth of field will be decreased.

The illustration on page 58 is a composite picture made by sandwiching the negative from the photo on page 59 with the photo on this page. It can be seen that the building appears wider and the severity of perspective diminution is lessened by the use of swinging the rear camera standard. The final interpretation of this building on page 59 is the result of careful manipulation of both front and rear parts of the Sinar P view camera. No other camera type could photograph this building in exactly the same way. The final picture realistically represents the design and at the same time (with the help of clouds and the proper timing of light as the day advanced) creates a mood and feeling about the architectural approach that this building represents.

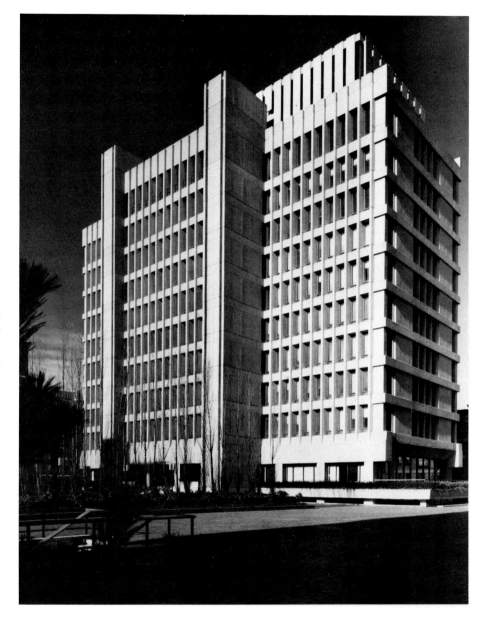

SCHOOL OF INTERNATIONAL AFFAIRS, Columbia University, New York City.
HARRISON & ABRAMOVITZ, Architects.

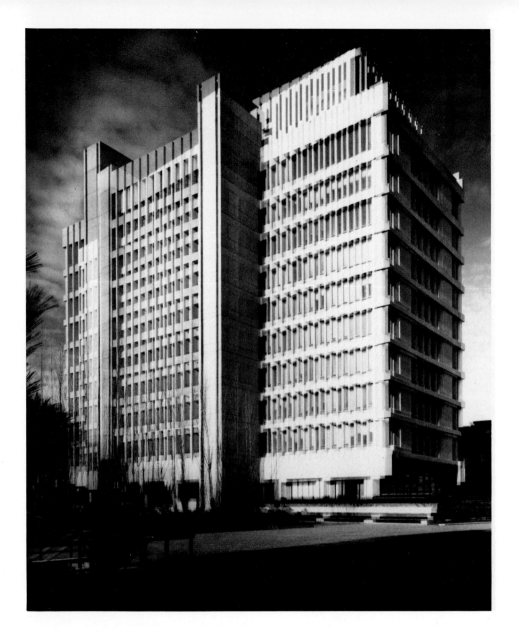

SWINGS AND TILTS

With the camera in this new position, you can observe another advantage of the view camera: It allows increased depth of field by rear-standard swings. This extension of the zone of sharpness will be noticeable on the ground glass. This is how to achieve it:

1. Position camera in proper relationship to the building so that all information you want to communicate appears on the ground glass.

2. Swing rear standard away from furthest point of building and observe how entire building comes into sharp focus. With a wide-angle lens a slight swing will create the desired effect. For extreme situations, however, the camera will have to be turned slightly in the opposite direction of the swing to keep the composition the same. When a great amount of swing is used, stopping down the lens will be necessary to bring all elements of composition into focus.

58

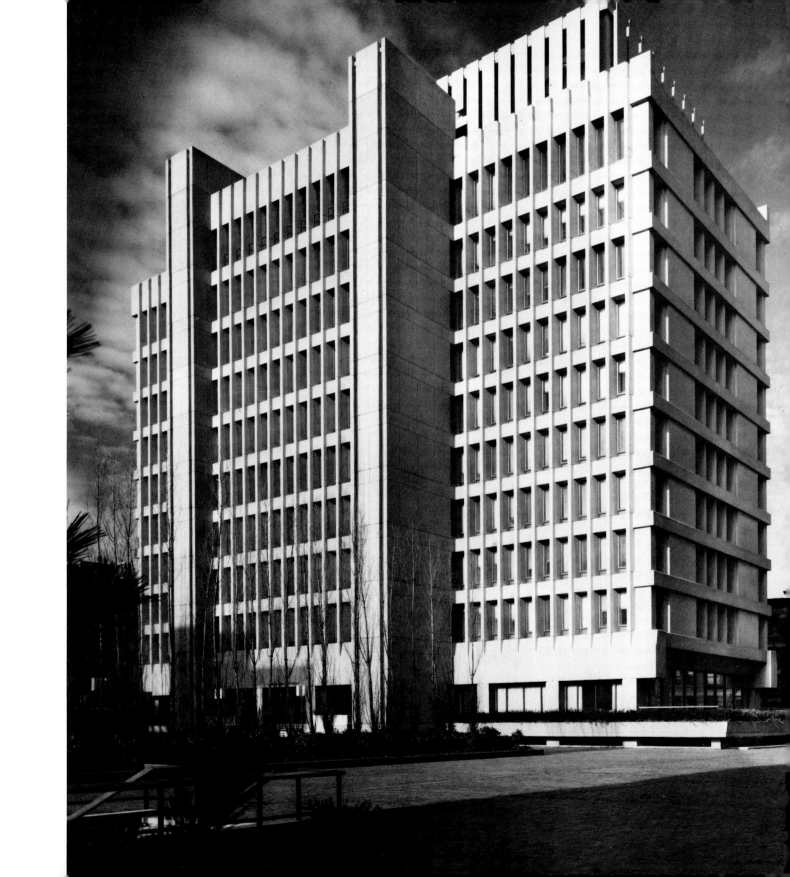

CHOOSING A VIEW CAMERA

There are many makes and designs of view cameras, and the decision to buy one brand or model over another should be well considered. The most flexible and, I might add, most costly of view cameras is the new Sinar P. This camera is not only an excellent camera, but it is an entire system. It is outfitted with a 4" x 5" rear standard, but is completely interchangeable with a 5" x 7" or 8" x 10" back. A different bellows is necessary for each format. For the architectural photographer who often uses wide-angle lenses, a special crushed bellows is provided, completely interchangeable with the standard bellows. The standard bellows can then be used as a focusing hood, thereby eliminating the traditional black cloth so often associated with photographers using large-format cameras.

The ground-glass screen for the Sinar P has four lines marking the swinging and tilting axes. This control, combined with accurate spirit levels on both front and back standards, allows for quick and easy user positioning of the camera. Another type of ground-glass viewing screen has etched lines forming a grid. However, with all the controls built into the Sinar P, this grid is not necessary.

The Deardoff view camera, designed in 1923 specifically for architectural photography, is a compact, light-weight camera that folds into a flat box, a feature that makes it highly desirable for the traveling photographer. The bellows are extremely flexible and compact, making it possible to use lenses from 65mm (with recessed lens board) to 240mm (and even greater focal lengths, when photographing distant buildings) without changing the bellows. Rugged and simple in design, this camera is an excellent tool for both the beginning and advanced photographer.

I personally use the Deardoff 5" x 7" camera with a 4" x 5" back for most of my out-of-town work or for situations where it is convenient to carry around a lot of heavy equipment.

When cost is a major factor the Calumet C-1 Camera should be considered. Similar in design to the Sinar, this camera is outfitted with soft bellows and a recessed front standard. It will handle lenses from 65mm to 165mm at regular distances and formats from 4" x 5" to 8" x 10".

CAMERA PURCHASE

For the photographer specializing in architecture, the best advice in choosing a camera is, shop around and look at several cameras before buying one. For controlled large-format work, the view camera is unsurpassed. It is possible to purchase a used view camera with an older, slow lens for a fraction of the cost of a new 35mm camera. This is advisable, as I said earlier, so long as you purchase used cameras and lenses from a reliable dealer who will give you a guarantee. I feel that high-quality used equipment is more desirable than inferior new equipment.

LENSES

The lens used on most occasions in architectural photography is a medium-wide-angle lens such as the 90mm Super Angulon used on a 4" x 5" format, or a 35mm lens on a 35mm camera.

Before we launch into a discussion of lenses it is important to understand three main factors about all lenses: their covering power, their focal length, and their speed.

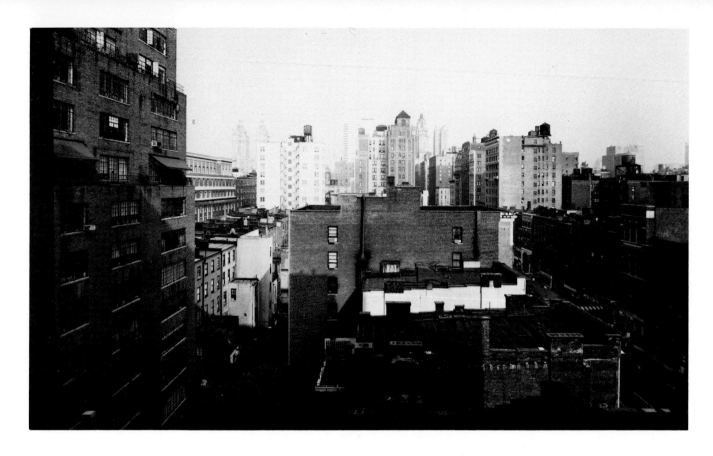

This shot was made with a 90mm Schneider Super Angulon lens used on a 5″ x 7″ format.

COVERING POWER

Covering power is perhaps the most important factor to consider when choosing a lens for a view camera. Most lenses produce a circular image of diminishing brightness from the center outward; therefore, when we speak of covering power we are talking always of a relationship of format to this circular image. Lenses designed for standard cameras such as the 35mm single-lens reflex or 2¼″ x 2¼″ reflex have covering power only for use with their, or a smaller, format. Lenses designed for the view camera have greater covering power than a standard, fixed lens, because the view-camera lens

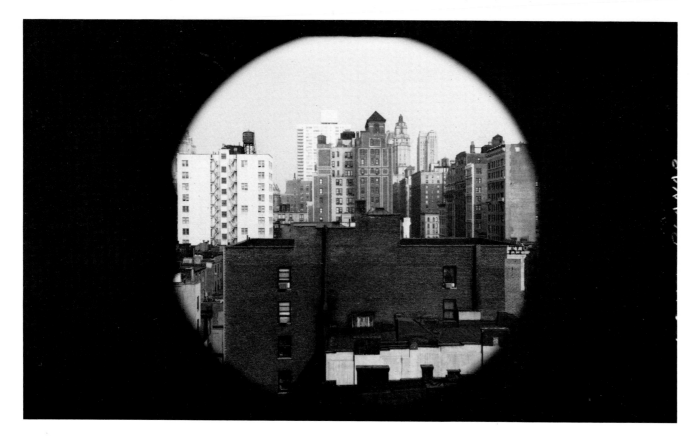

This shot, made with a 120mm Zeiss Planar lens, designed for a 2½″ x 2½″ format but here used on a 5″ x 7″ format, illustrates insufficient covering power even though the focal length is greater than the 90mm lens used for the shot opposite.

may be shifted off center. This principle is demonstrated by the accompanying examples.

For the view camera there is only one type of lens that offers the greatest amount of camera movement for its focal length, the wide field lens. The Schneider Super Angulon lens is both a wide-field and a wide-angle lens. What is meant by a wide-field lens is a lens so designed as to provide a circle far greater than the format on which it will be used. Usually this means that the lens will cover the next larger format. This can be demonstrated with the 90mm $f/5.6$ Super Angulon, designed for 4″ x 5″ format with maximum swing-tilt, but which can also be used for a 5″ x 7″ format.

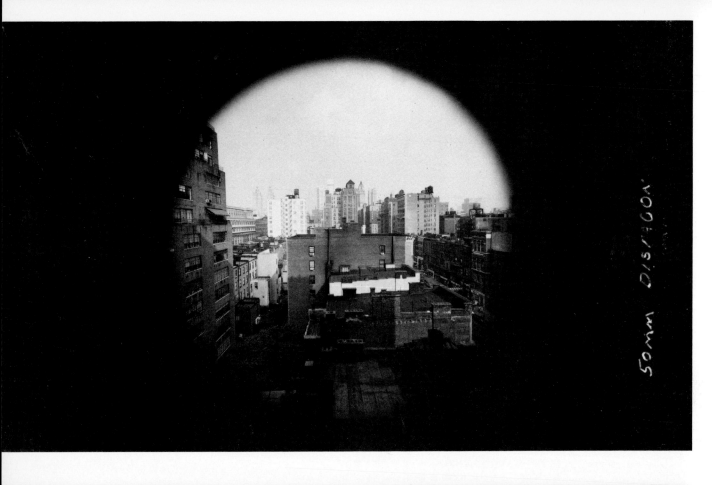

50mm Distagon.

Compare the size of the buildings and you will find that they are the same in both pictures, although the top picture, taken with a 50mm Distagon, appears to have been taken with a wider-angle lens. This is not the case, however; the 50mm Distagon merely has a greater covering power than the 50mm Nikkor lens used for the bottom picture.

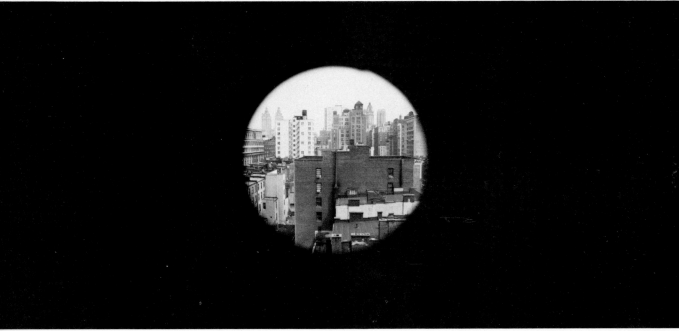

Two additional factors that affect covering power are diaphragm setting (f/stop) and distance from the subject. Covering power is increased slightly as the diaphragm opening is decreased, and there is a marked increase in covering power as the distance between the lens and film increases. This effect becomes quite apparent when objects 10 feet or less from the lens are shot.

Two types of lenses that can be recommended for architectural photography are Schneider Super Angulon and Schneider Symmar lenses.

FOCAL LENGTH

The focal length of a lens is usually inscribed somewhere on the lens mount and is designated in millimeters, centimeters, or inches. Technically, it is the distance between the node of emission, which normally lies slightly behind the center of the lens, and the film, when the lens is focused at infinity. The focal length determines the size of the image regardless of format. Take, for example, the image size of an object shot from a certain distance with a 50mm lens for a 35mm camera and measure the image size of the same object, shot from the same distance, taken with a 50mm lens designed for a 2¼" x 2¼" format (see page 64). Although the 50mm lens for the 2¼" x 2¼" format Hasselblad has a greater covering power, the object has exactly the same dimensions in both images.

The size of an image will increase or decrease in direct proportion to the focal length of lens. A subject, therefore, photographed with a 100mm lens will appear twice the size as the same subject photographed with a 50mm lens from the same distance.

LENS SPEED

What is meant by the speed of a lens—"fast" lens, "slow" lens— is the light-transmitting ability of that lens, which is measured in terms of its maximum effective aperture, i.e., its largest f/stop. Compare, for instance, a Nikkor 50mm f/4 to a Kodak 203mm Ektar f/8. The widest stop on this older design, f/8, is 2 stops slower than the fast 50mm f/4 lens, which makes it particularly difficult to focus in dim light because it transmits only ¼ the amount of light. The advantage of the slow lens is its great depth of field when stopped down to f/64.

For the architectural photographer a slow lens is no handicap, and in longer focal-length lenses, when increased depth of field is a major consideration, a slow lens usually can be stopped down much further than a fast lens. Moreover, a slow lens usually is less expensive, and in some cases of higher quality.

A SPECIAL LENS

The PC Nikkor lens, designed for the Nikon 35mm camera system, approximates the effect of the rising and falling lens board of the view camera. In the PC lens, a micrometer lead screw is turned to shift the optical axis off center as much as 11mm. The off-center shift can be set in any one of twelve positions, each related to a click stop, by rotating the lens on its mount through a 360° circle. An 11mm shift upward, for instance, creates the same effect as raising the lens board 3 inches with a 9½″ lens on a view camera.

It is also possible to use the PC for wide-field pictures. In its normal position the 35mm lens will cover 62 degrees; however, when using the 11mm shift to the left for one exposure, and then to the right for a second exposure, you are able to create, when joining the two photographs, an extremely wide coverage without the diminution in size of image rendition that a wider-angle lens would give.

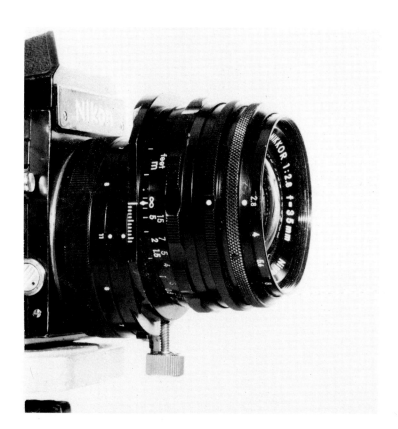

PC-Nikkor 35mm lens is shown above in the standard position. Below, the lens is shown with its elements divided by the manipulation of micro-screw to effect the same perspective-correcting results achieved by the rising front of a view camera.

67

EXPOSURE

The lens of a camera gathers and transmits light onto the film. The lens opening controls the amount of light transmitted, and the shutter controls the duration of that light. In all modern cameras a lens with f/stops is combined with a shutter that is calibrated so that the fractions of seconds bear the same relationship to each other as the f/stops.

The standard, international series of f/numbers is as follows: 2, 2.8, 4, 5.6, 8, 11, 16, 22, 32, 45, 64, and so forth. Each number in the series indicates that the lens, when set to that stop, will transmit exactly one-half the amount of light transmitted at the preceding stop. For example, f/5.6 transmits just one-half the light transmitted at f/4. Occasionally you will find lenses marked in the continental series—2.2, 3.2, 4.5, 6.3, 9, 12.5, 18, 25, 36, and so forth. These stops pass about one-third less light than the nearest corresponding numbers on the international scale, but again, each indicates a halving of the amount of light passed by the stop that precedes it. Today shutter speeds are calibrated according to the same principle, so that you can halve or double the shutter speed simply by moving to the next calibrated setting. Thus shutter speeds and f/stops can be used together in a variety of combinations, each of which will allow the same amount of light to strike the film, thereby providing equivalent exposures.

To understand this principle of equivalences simply look at the calculator dial of any light meter. Take an arbitrary setting—f/8 at 1/125 sec., say. We can see at a glance that opening up the lens to a greater diameter, say f/5.6, would require a shutter speed of one-half the duration, or 1/250 sec., to keep the exposures equivalent; and of course the reverse is true—stopping down to f/16 requires a slower shutter speed of 1/60 sec. to keep the exposures equivalent. This principle of equivalence is essential to the understanding of the lens-shutter system of exposure.

THE LIGHT METER

Light meters fall into two categories, reflected-light and incident-light meters. Reflected-light exposure meters measure light bouncing off the subject (reflected by the subject) and incident-light meters measure light falling on the subject.

A reflected-light reading is taken by pointing the meter at the subject from the position of the camera. An incident-light reading is taken by pointing the incident-light meter at the camera from the subject position. Incident-light meters are particularly useful when measuring continuous sources of artificial light, such as photoflood light. But for architectural photography, I feel that reflected-light meters are more useful.

ANGLE OF ACCEPTANCE

The angle of acceptance of a meter, its field of coverage, is an important consideration for the architectural photographer. When a meter with a wide angle of acceptance—50° or more—is used, reflected light from the sky, building, and foreground is gathered together by the light-sensitive cell of the meter and "read" as one subject. If such a meter is simply held at the camera position and pointed at the subject, the result can be a poor exposure, especially if an unusual amount of sky or foreground, or an exceptionally bright or dark subject, is included in the reading. When you use such a meter, it is usually better to measure selectively the lightest and darkest portions of your subject in which you want to record detail and then choose an exposure midway between the two readings. This, of course, means walking up to your subject and holding the meter so that it reads only the portions selected.

A spot meter, on the other hand, has a narrow angle of acceptance—30° or less—and allows you to measure selected areas of varying brightness more quickly and easily. The accompanying diagram shows the great range of exposures possible within one scene, and shows how an accurate exposure can be obtained under such conditions.

CHOOSING A METER

Many meters of high quality are now on the market and range in price from $25.00 to $300.00 and even higher. Honeywell Pentax offers a meter that measures a 1° spot from a 21° field of view. Minolta sells a fully-automatic spot meter with a 1° angle of acceptance. One of the most versatile light meters is the Gossen Luna-Pro, which measures both incident light and reflected light and has a spot attachment with an adjustable angle of view from 15° to 7.5°.

Several types of single-lens reflex cameras have a form of spot meter built into the reflex system. The angle of view in this case would depend on the lens used. All these meters employ a cadmium-sulfide (CdS) cell in their design, making them highly sensitive, particularly to low light levels. However, these meters have a "memory" for exceptionally strong light, and if the meter is inadvertently pointed at the sun,

or a bright light source, readings taken during the following 10 minutes or even two hours may be affected.

Other types of light meters use a selenium cell, and the Weston Master is the leading meter of this group. Although the Weston Master has a large angle of acceptance, it has been the standard for years. Its dependability, low cost, and ruggedness make it an excellent meter for the professional. If used carefully, this meter has many advantages over the cadmium-sulfide meters because it does not have a "memory" and does not require batteries.

ARTIFICIAL LIGHT

Some form of artificial light is usually necessary for photographing architectural interiors. The choice of a set of lights depends on two main factors, versatility and portability, and although several types of lights are applicable, some are more desirable than others.

This photograph appears natural although additional light was used so that all elements of the furniture could be seen clearly. Two 650-watt Colortram quartz lights were bounced off the opposite wall and corner of ceiling (not seen by the camera) to create a soft, diffuse light.

SHERMAN APARTMENT,
New York City.
LILA SCHNEIDER, Interior Designer.

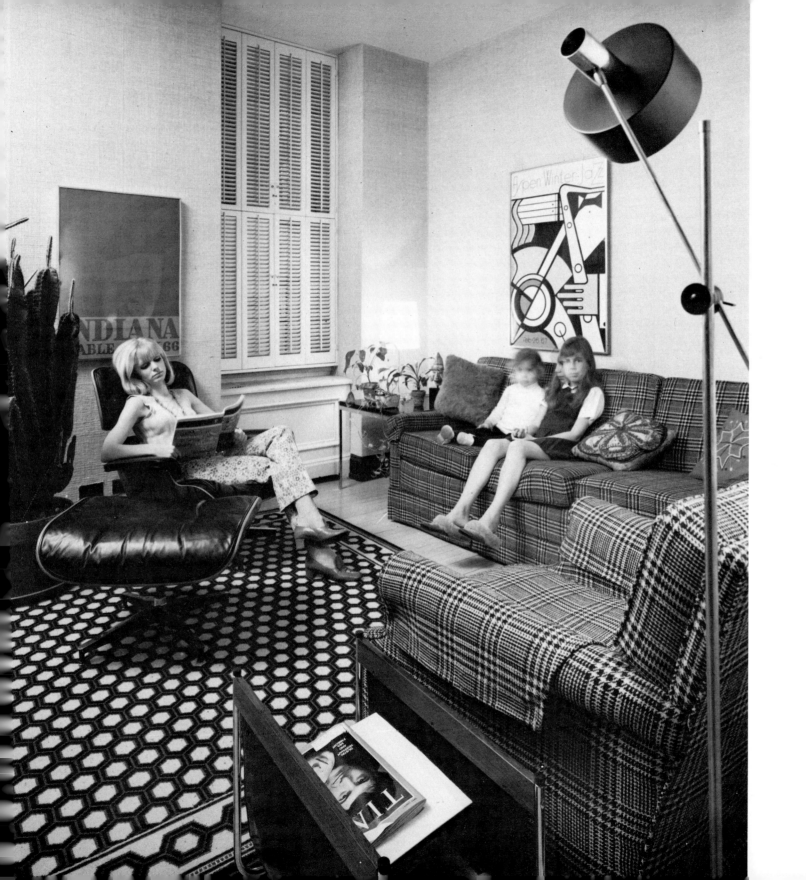

CONTINUOUS LIGHT SOURCES

Continuous sources of light, such as photofloods or quartz-halogen lamps, provide a constant illumination of subject that facilitates camera positioning and focusing. With a constant light source, you can readily see the effect of your lighting design and make changes in intensity and placement. Accurate exposure is easy with this type of light source because you can use a standard light meter in much the same way you would when exposing with natural illumination.

Photofloods and Studiofloods: These are tungsten-type bulbs designed to give maximum light output per watt. The blue type emits light with a color temperature of approximately 4800 K. The "K" stands for units Kelvin, which is the conventional means of designating how warm (reddish) or cool (bluish) a light is. The higher the K reading the cooler the light. These bulbs have a slightly warm effect when you use them with daylight color film, which is a desirable effect to have when

you need to photograph an interior that is partially illuminated by sunlight.

When exterior sunlight is not a factor, white frosted bulbs, balanced for either 3400 K or 3200 K can be used. These bulbs are inexpensive, lightweight, and can be used either as the main light or as fill-in illumination.

The 3400 K bulbs, designed to be used with Type A color films, can be used with Type B films if you use the appropriate light-balancing filter. The disadvantage of this type of lighting for color work is that the bulbs age rapidly and change color temperature (units Kelvin) as they age. They are quite useful for black-and-white work.

Quartz-Halogen Lamps: These lamps consist of a tungsten filament inside a vycor or quartz tube that is filled with a halogen, usually iodine vapor. The halogen prevents the lamp from changing color temperature with age and it preserves the life of the filament. This small, compact source of high-intensity light is excellent for architectural photography.

The picture on the opposite page illustrates the use of a fill-in flash to illuminate shadow details. The main light source is from the window at the left in the picture.

74

Several manufacturers sell lightweight, compact housings for use with these lamps. For example, Color Tran originated a very small unit called the Mini Light that is quite useful, especially when you want to bounce light from a ceiling, wall, or other reflector to create diffuse illumination. Portable quartz-lighting kits are available from a number of manufacturers.

DISCONTINUOUS LIGHT SOURCES

Sources of light such as electronic flash and flashbulbs offer some advantages over continuous sources of artificial light, but experience is the only way to guarantee results when you work with them. As exposure and flash are simultaneous, you cannot foresee the effect your lighting will have on your picture. The polaroid back, which allows for on-the-spot test shots, helps, and there are special light meters available designed to measure flash exposures.

CARLYN RESIDENCE, New York City.
ROLPH MYLLER, Architect.

Strobe (electronic flash) units large enough to illuminate architectural interiors are the most expensive and cumbersome type of lighting and have limited use for the architectural photographer. Color temperature of most of these units approximates daylight and is most consistent when the unit is powered through step-up condensers that draw power from a standard AC power supply, such as a normal room outlet. Although there are some good battery-powered units, their light output is normally too limited for use as a main light for a room.

Flashbulbs provide an intense, instantaneous source of light that architectural photographers often find convenient to use, since flash units are light and portable, and several can be fired at once. A small battery or current-booster box can be carried to provide sufficient power to fire a number of bulbs simultaneously.

THE TRIPOD

The choice of a suitable tripod depends to some extent on the type of camera used; however, it is advisable to purchase a tripod designed to hold a camera slightly heavier than the one normally used. This is particularly true if a small-format, lightweight camera is usually used.

A suitable tripod is one that shows no vibration at full extension. Stability should be the first consideration, portability, the second. Adequate extension is nearly as important as stability; actually, both qualities denote a well-made tripod. It is important to remember that photographing architecture often requires a camera position slightly higher than eye level, particularly when a wide-angle lens on a fixed-back camera is used. The tripod should offer complete stability to at least a height of seven feet.

The telescoping leg sections should have individual leg locks to insure positive tightening and rubber tips to minimize slippage. A pan or tilting head is advisable for quick positioning and fine adjustment. The entire tripod and head should have a non-corrosive finish to assure a long life.

Many beginning photographers feel that they can get away with a small, inexpensive tripod to start out with. For the photographer interested in architectural photography this is not advisable. A well-made, durable tripod is an essential tool for any critical photographic work. Nothing can be more frustrating than ruining a carefully composed, thoughtfully considered photograph through camera movement.

FILTERS

If you want to exercise greater control over the rendition of your subject, use the appropriate filter or combination of filters. In black-and-white photography filters allow you to change the tonal rendition of selected colors, making them lighter or darker compared with the rendition of other colors in the shot. In color photography, when an accurate rendition of color is needed, filters are often essential.

Filters are manufactured in a number of forms. Glass-mounted filters consist of a gelatin layer sandwiched between layers of

GULF & WESTERN BUILDING, New York City.
THOMAS E. STANLEY, Architect.

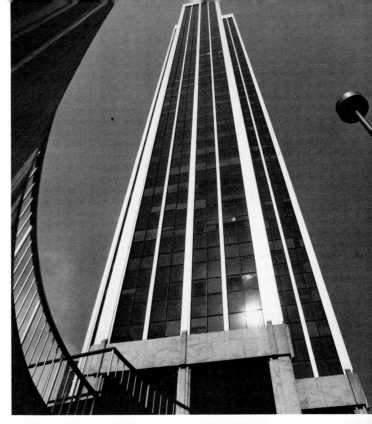

The top picture was shot without a filter and the bottom with a red filter. The sky was a deep blue and therefore the red filter absorbed enough blue to render the sky black in the final picture.

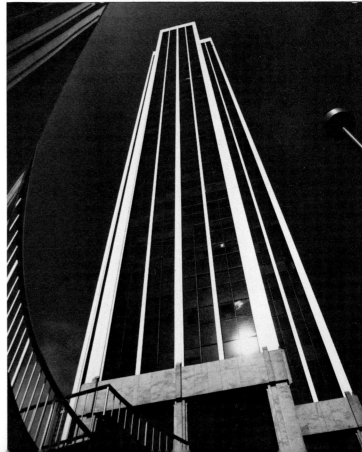

optically flat glass. These filters are designed to be mounted either directly on the lens or in an adapter ring and are available for use with a variety of mounts, including the screw-in and bayonet types. There is a popular, though limited variety of these filters available.

All-glass filters are expensive and only a few types are generally available. The most common all-glass filters are ultraviolet filters and filters used for duplicating.

Gelatin filters are manufactured in the widest possible variety by many American and European manufacturers. They are extremely thin (usually 0.1mm) and have excellent optical properties. For this reason, they are recommended for telephoto work or any highly precise photographic process. They are used with a special gelatin-filter mount that attaches to the lens. They have the additional advantage of being relatively inexpensive; however, they are also delicate and easily scratched,

which means they must be handled with great care. Fingerprints can ruin them permanently.

Filters are effective because they change the quality of light reaching the film: Neutral density filters change the intensity of the light; polarizing filters absorb rays of light vibrating in certain directions; and colored filters absorb, to a greater or lesser extent, some wavelengths (colors) of light and freely transmit others, creating subtle to drastic changes in the rendition of a subject. The most commonly used filters are contrast and correction filters, applied primarily in black-and-white photography; polarizing, neutral density, ultraviolet, and infrared filters, used for either black-and-white or color work; and color conversion, light balancing and color compensating filters, designed to create specific changes in color photographs. Filters for color are particularly important for the architectural photographer and should be studied carefully.

FACULTY CLUB, University of Connecticut.
JOSEPH STEIN, Architect.

The photo on the opposite page illustrates the use of a green filter to lighten the foliage of the surrounding landscape.

CONTRAST FILTERS

Contrast filters are used primarily in black-and-white photography and are normally used to lighten or darken specific colors. For example, a red filter may be used to increase contrast in a photograph of a building that has a blue sky behind it. The red filter absorbs the blue light of the sky, thus darkening its appearance in the final print. A deep red filter can absorb almost all the blue radiation and render the sky completely black. On the other hand, to lighten the foliage in an architectural shot that should emphasize the landscaping, use a green filter to increase the proportion of green transmitted to the film.

The basic filter colors, each manufactured in various densities, are red, orange, yellow, green, blue, and purple. The rule of thumb is that a filter will transmit light of its own color and absorb light of the complementary color. A filter also absorbs other colors, however, and precise data on the absorption and transmission characteristics for each filter are supplied by the manufacturer. The color density of a filter determines the degree of transmission and absorption.

CORRECTION FILTERS

Correction filters are used to create very slight changes in the composition of the light that strikes the film so that all colors are recorded with approximately the same brightness values as seen by the eye. Panchromatic film is almost, but not quite, similar in color sensitivity to the eye. In fact, it is slightly too sensitive to blue and ultraviolet radiation, which causes a slight overexposure in the blue to violet end of the spectrum. We have all been surprised and disappointed to see a white sky in a photograph taken of a building with a beautiful blue sky behind it. To correct for this blue bias in pan film, use a pale yellow correction filter, which holds back some of the blue light from reaching the overly sensitive film.

NEUTRAL DENSITY FILTERS

Neutral density filters are designed to reduce brightness without affecting the color balance of black-and-white or color films. Originally designed for motion-picture work, they are applicable in still photography to bring two different film speeds to the same ASA. If the film is too sensitive for the internal brightness values in the scene, these filters are used to uniformly reduce the amount of light striking the film. They affect all colors equally.

Neutral density filters are manufactured in many densities. Each density represents a percentage of light transmission, ranging from the 80 per cent light transmission of ND 0.1 to the 0.001 per cent light transmission of ND 4.0. For all practical purposes the densities above ND 1.0 are of little use to the architectural photographer. An easy way to calculate ND filters is to remember that ND 0.3 transmits 50 per cent of the light and requires one additional f/stop opening to keep the exposure the same; ND 0.6 trans-mits 25 per cent and requires two additional f/stop openings; ND 0.9 requires three additional f/stops; and numbers in between increase or decrease exposure by $\frac{1}{3}$ of a stop.

EQUAL DENSITY FILTERS

Equal density filters, like neutral density filters, can be used either for black-and-white photography or for color work. Equal density filters are center-biased filters, designed to be used with wide-angle lenses where the light fall-off can be significant toward the edge of the image circle. Under normal conditions this fall-off is not noticeable, but when an extremely contrasty negative is desired, or when the lens is used at its maximum covering ability, the effect of exposure diminution toward the edges of the negative may be apparent. To compensate for this effect, an equal density filter is used in front of the lens. This filter, which is darker in the center than at the edges, is designed to compensate for variations in the intensity of light

reaching the film by transmitting less light in the center than at the edges. Note: It is advisable not to expose photographs taken on a wide-angle lens for high contrast unless an equal density filter is used.

ULTRAVIOLET AND INFRARED FILTERS

Ultraviolet and infrared filters are used primarily in aerial or telephoto shots where bluish atmospheric haze must be reduced or eliminated. Special effects can be produced with infrared isolating filters in combination with color compensating or even contrast filters on infrared film.

POLARIZING FILTERS

Polarizing filters work on an entirely different principle than other filters, because they affect light transmission not by absorption but by directing the angle of penetration. Polarizing filters, therefore, can be used effectively in black-and-white as well as color photography. Their primary use is to reduce surface glare and increase color saturation. The degree of glare reduction is determined by the angle of the light source and the camera angle. The greatest reduction of unwanted reflections occurs when the angle of light penetration is about 30°. No reduction of glare is possible when the angle of reflection approaches 90°. Polarizing filters are used, for example, to darken a blue sky in color photography, to cut down surface reflections from windows so that an interior can be photographed through the windows, or to intensify the color of any painted surface that reflects glare.

CADET CORPS BUILDING, Bronx, N.Y. EDGAR TAFEL, Architect.

The photo on the opposite page is an example of the use of a polarizing filter to cut down the surface glare on the furniture and glass of the showcase.

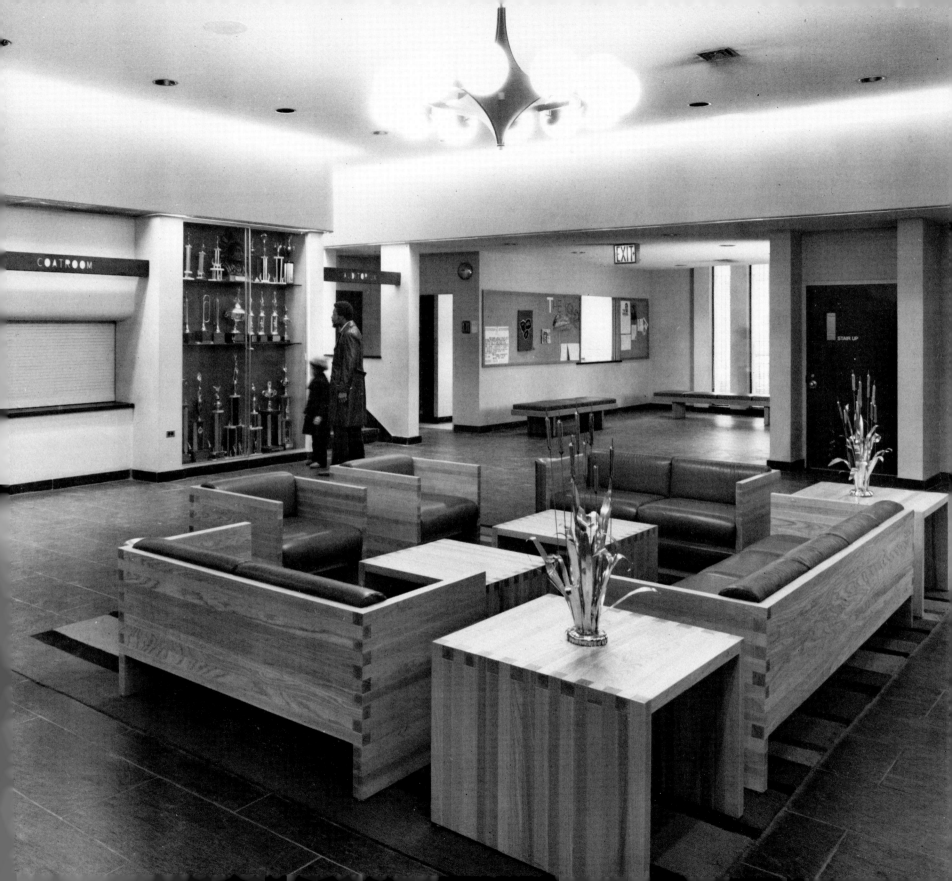

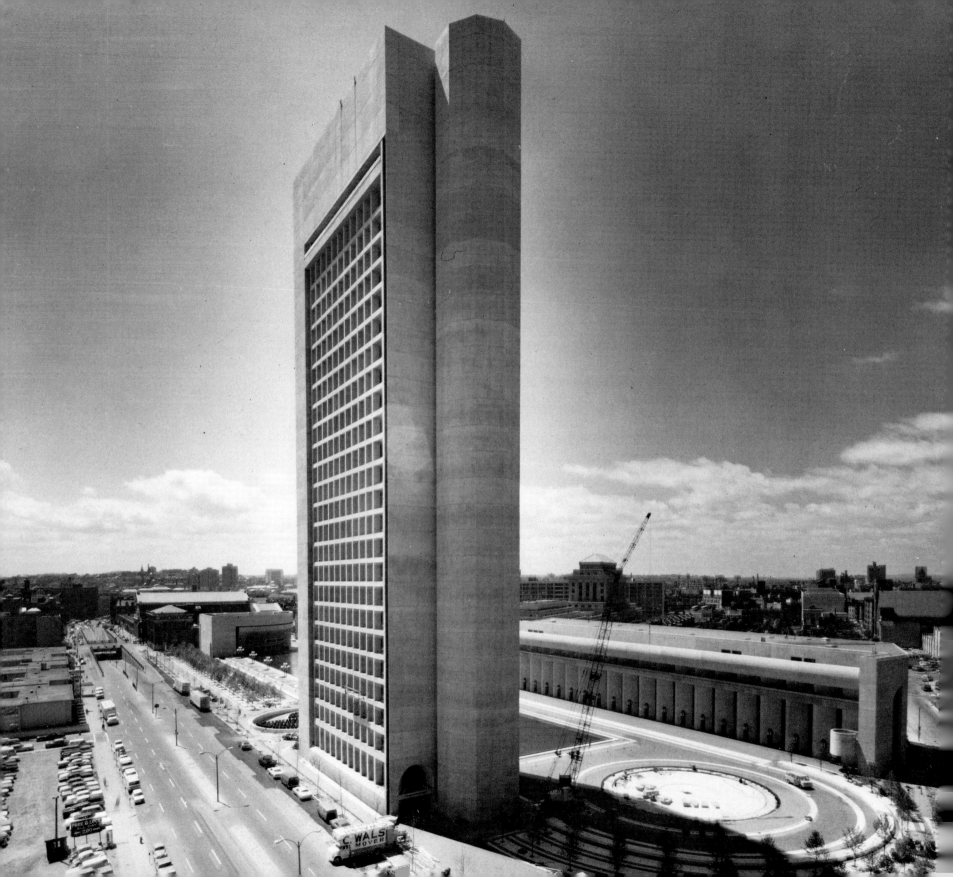

CHRISTIAN SCIENCE CENTER,
Boston, Mass.
I.M. PEI & PARTNERS, Architects.

In the photograph opposite, a yellow filter was used to separate the tones between the building and sky without dropping out tone completely from the very blue sky.

COLOR CONVERSION FILTERS

Color conversion filters are designed to change the color temperature of light striking the film so that a film balanced for one type of illumination can be used in another type of illumination. These filters make it possible to use one type of film under a variety of conditions both indoors and outdoors.

Daylight films are balanced for direct sunlight during midday—roughly 10:00 AM to 2:00 PM, depending on the time of year and the geographic latitude. Tungsten films are balanced for a specific color temperature, which is described in units Kelvin. Type A film, which is now seldom used, is balanced for 3400 K; Type B film, commonly known as tungsten film, is balanced for 3200 K. Although no true Kelvin number can be assigned to natural daylight, we usually consider daylight film as being balanced for 5500 K.

When we speak of converting a daylight-balanced film for use indoors, we mean that we must raise the color temperature of the light source with an appropriate filter, which is usually placed over the camera lens but in special cases may be placed in front of the light source itself, so that the Kelvin number of the light striking the film approximates that of daylight. For example, a Wratten #80A filter is commonly used to convert 3200 K (studio) lights for use with daylight films. If a tungsten-type film balanced for 3200 K is used outdoors, a Wratten #85B filter is generally used to lower the color temperature of the natural light. When conversion filters are not used, tungsten film exposed to daylight produces excessively blue photographs, and daylight film exposed to normal studio sources of artificial light produces excessively red photographs.

LIGHT BALANCING FILTERS

Light balancing filters differ from conversion filters in that they effect subtle or distinct changes in color balance, thus enabling the photographer to achieve the best possible reproduction of the apparent colors of his subject. They can also be used to manipulate colors creatively to help set a mood or emphasize some special characteristic of the subject.

Light balancing filters come in two series; reddish filters numbered 81A, B, C, or D (in Kodak's nomenclature), and bluish filters numbered 82A, B, or C. They can be used either singly or in combination.

Note: Filter nomenclature varies among manufacturers. In this book, Kodak nomenclature is used. Equally fine filters are made by a number of companies, and you can check with these manufacturers for lists giving exact nomenclature and applications. Many companies also provide lists showing the equivalent Kodak filters.

The following is a list of some common situations in which you may find light balancing filters useful. However, the suggestions are merely intended as guideposts and should not be used on important jobs without prior experimentation.

**For use with
Daylight type film:**

1. Morning and afternoon warm light: Use the bluish 82C filter and increase exposure by ⅔ stop.

2. Hazy but bright sky around noon time: Use the bluish 82A filter and increase exposure by ⅓ stop.

3. Light from a heavily overcast sky: Use the reddish 81C filter and increase exposure by ½ stop.

4. Interior spaces illuminated only by reflected blue skylight coming through windows: Use two 81X filters and increase exposure 1 to 1½ stops.

For use with tungsten (Type B) film:

1. Light from 100-watt, general-purpose household lamps: Use a bluish 82C plus an 80 filter and increase exposure by 1 stop.
2. Light from clear flashbulbs: Use an 82C plus and 81A filter and increase exposure by 1 stop.

For really controlled results with light balancing filters, use a color temperature meter. A good approximation of color temperature can also be made using a chart such as the one reproduced here.

COLOR COMPENSATING FILTERS

Color compensating filters are used to change the overall color cast of a transparency or negative. They are available in six colors—red, blue, green, yellow, cyan, and magenta—and are also available in various densities. They can be used either singly or in combination to make up for specific spectral deficiencies in a light source, such as those found in fluorescent lights, and to cor-rect for variations from one emulsion batch to another. They are also recommended for certain films when exposures are very long or very short. Each manufacturer publishes data on the appropriate color compensating filters to use with his films.

THE LENS SHADE

The use of a lens shade to cut out unwanted side or top light should not be minimized. Each lens should be shielded in some way from any direct light source shining into it, causing glare or fogging of the image. For smaller cameras, particularly 35mm SLR cameras, mounting the lens shade over the lens is the only way to accomplish the shielding of unwanted light. For larger cameras, a matte box is a welcome accessory. The matte box is either a ridged, black, cardboard device or an adjustable bellows that fits over the lens. It serves as a shade for many different focal-length lenses. Some matte-box devices are equipped with a filter holder built into the side of the box.

The basic standard for selecting either a lens shade or matte box is that it be big enough to shield residual light without interfering with the image. Unfortunately, most lens shades are too narrow and shallow (particularly with a wide-angle lens) to do much good. With large-format cameras the matte box is the best solution.

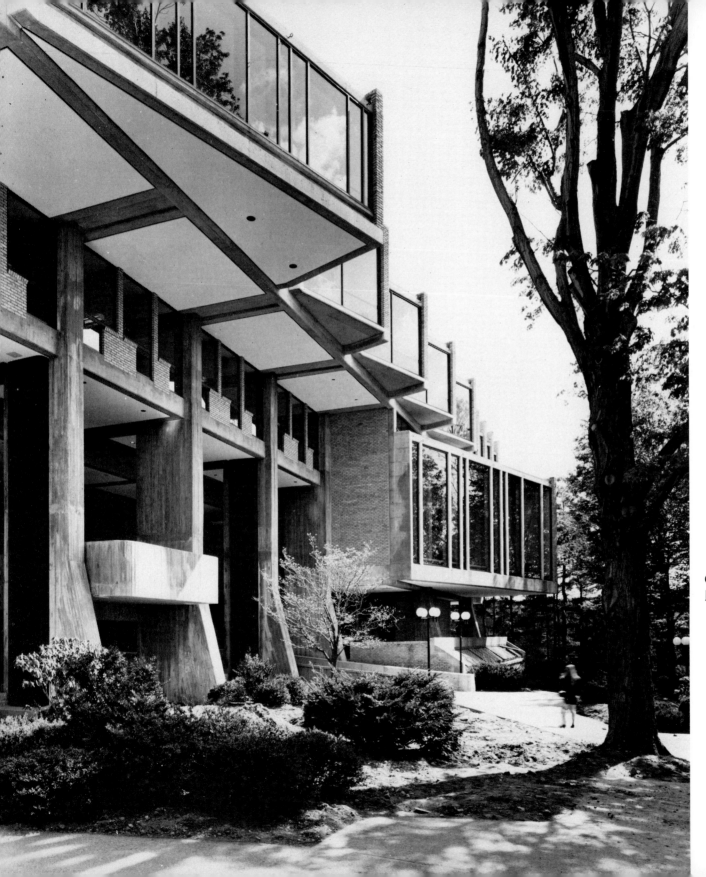

3

GODDARD LIBRARY, Worcester, Mass.
JOHN M. JOHANSEN, Architect.

Film And Negative

The purpose of this chapter is to give the beginner a working knowledge of the principles of film selection and development. The more the photographer knows about the entire photographic process, the greater will be his ability to think and see in photographic terms.

Most architectural assignments require photo coverage in both black-and-white and color. An immense variety of film types and brands is available, and it is part of the photographer's work to choose photosensitive materials suitable to the job at hand and see to it that they are handled correctly. The beginning photographer sometimes finds this particular aspect of his work bewildering, since there are a great many apparently suitable films available. Although a theoretical analysis of film characteristics helps, only practice and careful, controlled work with a specific film will give the photographer a useful, working knowledge of what he can do with it. To acquire this kind of knowledge, the beginner is advised to

pick a particular film stock and use it until he is completely familiar with its characteristics. To aid him in this choice, some specific brand recommendations are made later in the chapter.

The emphasis in this chapter is on black-and-white film developing and printing, because I feel that the craft of architectural photography can only be practiced successfully when the photographer has a complete working knowledge of all aspects of the photographic process. Unlike black-and-white film, for example, color film is usually developed by a custom photofinisher. Also, choice of color film is usually a matter of the individual's color preferences. Quality control in the manufacture of today's color film is such that the difference between various brands is generally experienced as a definite color bias—the tendency toward muted earth colors in some Agfa films, for example, or the bluish shadows rendered by Ektachrome, or the vivid colors of GAF films. These films of course differ in speed and other general characteristics, but none

is more "natural" than another. Choosing the right black-and-white film, however, requires a working knowledge of the films, rather than just a personal preference.

FILM CHARACTERISTICS

So far as practical architectural photography is concerned, the most important characteristics of a film are speed, grain, and color sensitivity. In addition, each manufacturer recommends specific time-temperature-developer combinations for each of its films and supplies graphs based on the amount of light required to effect a chemical change in the photosensitive emulsion, when the film is developed for a specific time and temperature in a selected developer.

FILM SPEED

The ASA rating, or speed, of a film is based on the amount of light it takes to produce an image when the film is given a standard

development. The ASA scale is arithmetic, meaning that a doubling of the ASA number indicates a doubling of the film's sensitivity to light. Another popular scale, used primarily in Europe, is the DIN rating, a logarithmic scale in which an increase of three indicates a doubling of the film speed. The calculator dials of most exposure meters are arranged so that either ASA or DIN numbers can be used. Practically speaking, it makes no difference which system you use, since either system will indicate identical exposures (f/stop-shutter-speed combinations) for any given scene.

Speed numbers are not absolute, however, and the effective speed of a film can be altered by exposure and development. Such alterations are useful under certain conditions, which are discussed later. And both exposure and development must be carefully controlled if these alterations are to be of practical use to the architectural photographer, who must be able to produce consistent results.

FINE ARTS BUILDING, Interior Hallway,
State University of New York
at Geneseo.
MYLLER, SNIBBE, TAFEL, Architects.

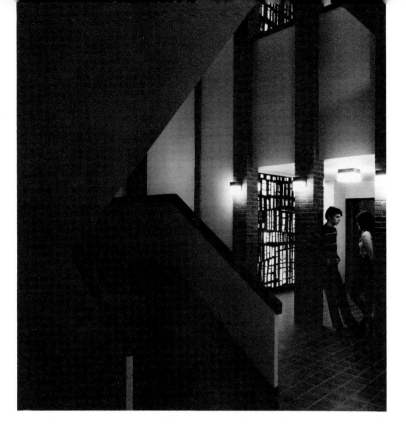

The top picture was exposed for the
brightest areas of the subject and de-
veloped normally. Most of the detail in
the shadows is lost. The second print
was made on the same grade of paper
but the negative was exposed for the
lowest light level in the shadows behind
the stairs. The development was carried
out in a compensating developer.

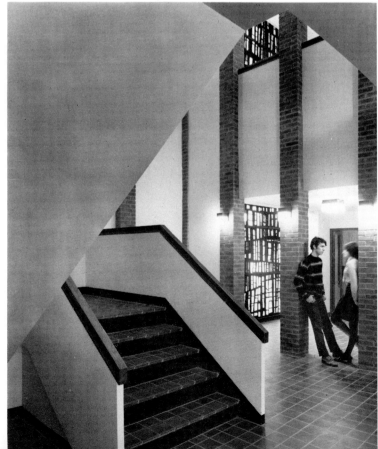

91

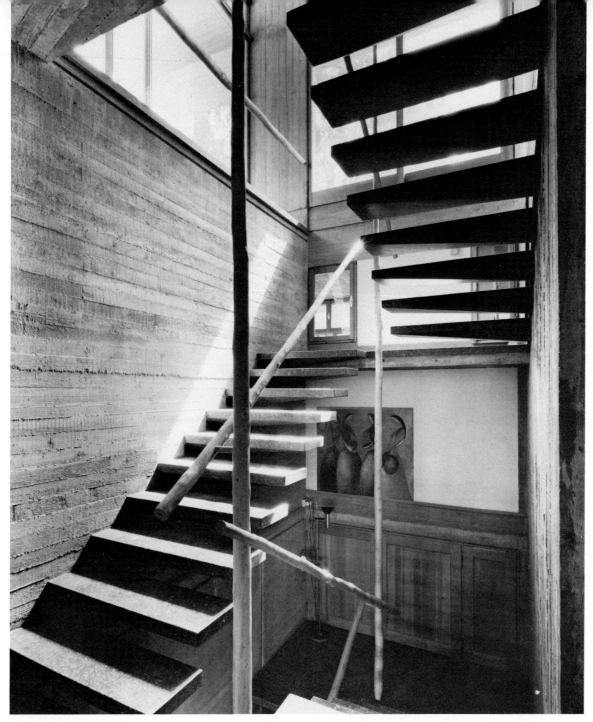

A full-scale negative was made using Ilford HP4, 4″ x 5″ film, overexposed greatly and developed for half the recommended time in D-76. HP4 film has a speed similar to Tri-X. In making this print, some dodging was necessary to hold full detail in the lowest part of the stairs.

RESIDENCE of the architect
NEOPTOLOMOS MICHAELIDIES,
Nicosia, Cyprus.

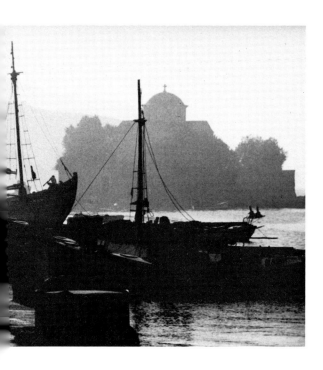

GRAIN

All films, when developed initially, are made up of tiny particles of metallic silver that can be clearly seen only under a microscope. Where heavy concentrations of these particles group themselves together, they form a grain pattern visible to the naked eye, especially when large prints are made. Color films also have a grain pattern, although in this case the metallic silver image is replaced by dyes during the development process

Prior to exposure, fast films have a thick emulsion containing silver-halide crystals ranging in size from large to small. The larger particles are more likely to be struck by light than the smaller ones. The larger particles are also more light-sensitive than the smaller ones, which accounts for the high speed, but they also tend to form a more obvious grain structure as they clump together during development to form the silver image. Slow films have thin emulsions containing small silver-halide crystals. This usually results in higher resolution and edge sharpness and leads to a better rendering of fine details. Slow films, however, have considerably less latitude than fast films; the limits of over- and underexposure are much narrower, which makes correct exposure a necessity. Fast films provide lower contrast and a greater margin for exposure error.

93

COLOR SENSITIVITY

Most black-and-white films used in architectural photography are panchromatic. This means that they respond to the visible spectrum of light in approximately the same way the eye does as far as the relative brilliance of various colors is concerned. Some special-purpose films discussed in the next section are designed to respond only to selected regions of the spectrum.

Color films are also designed to respond to the full visible spectrum. Their response is carefully controlled during manufacture so that they will produce optimum color rendition under specified conditions, such as midday sunlight or tungsten studio light.

BLACK-AND-WHITE FILMS

Black-and-white film can be grouped into four general categories, each of which may find some application in architectural photography. The first three are panchromatic and consist of thin-emulsion, fine-grain films, medium-speed, general-purpose films, and high-speed, limited-purpose films. The fourth group consists of special-purpose films that are occasionally useful.

Thin-emulsion films are particularly useful for 35mm photography and in cases where high definition or big enlargements are required. When used with a compensating developer, these films yield a wide range of tonal gradations. They are considered the best films to use when architectural exteriors are photographed in good light. Among the more commonly used of these slow, fine-grain films, with ASA ratings from 16 to 64, are the following: Agfa Isopan IFF, roll and 35mm film; Agfa Isopan 15, sheet film; DuPont Cronar Commercial S, sheet film; Ilford Pan F, 35mm film; Kodak Panatomic-X, 35mm, roll, and sheet flim; and Perutz Perpantic 17, 35mm film.

Medium-speed, general-purpose films ranging in speed from ASA 80-400 can yield fine grain when handled carefully. In this group are found such films as Agfa Isochrome 25, sheet film;

GAF Versapan, 35mm, roll, and sheet film; Ilford FP4, 35mm, roll, and sheet film; Kodak Plus-X, 35mm, roll, and sheet film; and Kodak Tri-X, 35mm, roll, and sheet film.

High-speed films are generally coarse-grain and are most effective in low-contrast situations where their great latitude can be put to maximum use. They are unsuited for outdoor, sunlight photography, and unless special effects are needed, their coarse grain and poor resolution characteristics make them useless for architectural photography. Among these films are Agfa Isopan Record, 35mm and roll film with an ASA of 1250 to 3200 depending on development, and Kodak 2475 Recording film with an ASA of 1000 to 3200. The high-speed Polaroid films, numbers 47, 57, and 107, with a 3000 ASA rating do not belong in this category because the diffusion-transfer process produces extremely fine grain; and, Polaroid photographs are not normally enlarged.

SPECIAL-PURPOSE FILMS

Special-purpose films are designed for specific uses, such as aerial photography or copy work, and are occasionally used by architectural photographers.

Infrared films are used primarily for aerial photography or photography through extremely long telephoto lenses because of the haze-penetrating effect of infrared radiation. Since these films are also sensitive to blue, they must be used with a deep red filter to be effective. In color work, infrared films can be used with various filters to achieve startling results.

Orthochromatic films tend to increase atmospheric haze if used outdoors because they are sensitive only to ultraviolet blue, and green. Thin-emulsion, fine-grain films are useful in black-and-white copy work to increase the contrast of panchromatic film negatives and blue prints, and to reduce the stain when copying older, yellowing photographs.

Blue-sensitive film, among which are the high-contrast copy

films, are particularly suited to making line copies of black-and-white renderings because they register few or no middle tones, especially when used with appropriate high-contrast developers.

POLAROID LAND FILMS

The films manufactured for the 4" x 5" Polaroid Land film holders (Nos. 545 or 500) are available in four different types: high-contrast copy film for reproduction of line copy or half tones (ASA 200); No. 55 P/N film, which produces both a black-and-white print and a permanent negative (ASA 50); No. 57 high-speed panchromatic film (ASA 3000); No. 58 color film (ASA 75), Types 51, 52, and 57, produces a print in 15 seconds.

Type 55 P/N requires a 20-second development and the negative requires a further bathing in a solution of sodium sulfite followed by normal washing in water. No. 58 color film produces a high-quality color print in 60 seconds. Further information on Polaroid films can be obtained by writing directly to the Polaroid Corporation, Cambridge, Massachusetts, 02139.

CHOICE OF FILM

A successful architectural photograph has the following characteristics: (1) high resolution of detail with all of the subject sharply delineated; (2) medium to fine grain, even in large blowups; (3) medium contrast with a wide tonal range and detail in the shadow areas.

When you work with a 35mm camera, you need a thin-emulsion, fine-grain film to produce prints that meet the above criteria. Moreover, you need to choose the correct developer and develop the film using a meticulous darkroom technique. Several films are commonly available for use in this case, although some are more readily available than others, depending on the manufacturer's distribution arrangements. Agfa, Ilford, and Kodak all manufacture excellent products, and I recommend using one of these as a starting point. Personally, I like Ilford Pan F or FP4 combined with a slow-working developer such as Edwal Super-20 for 35mm work.

This shot was exposed for the shadows and developed for the highlights. On the following page, the left shot was exposed for the window lights and the right, for the shadow detail.

HAGIA SOPHIA, Dome,
Istanbul, Turkey.

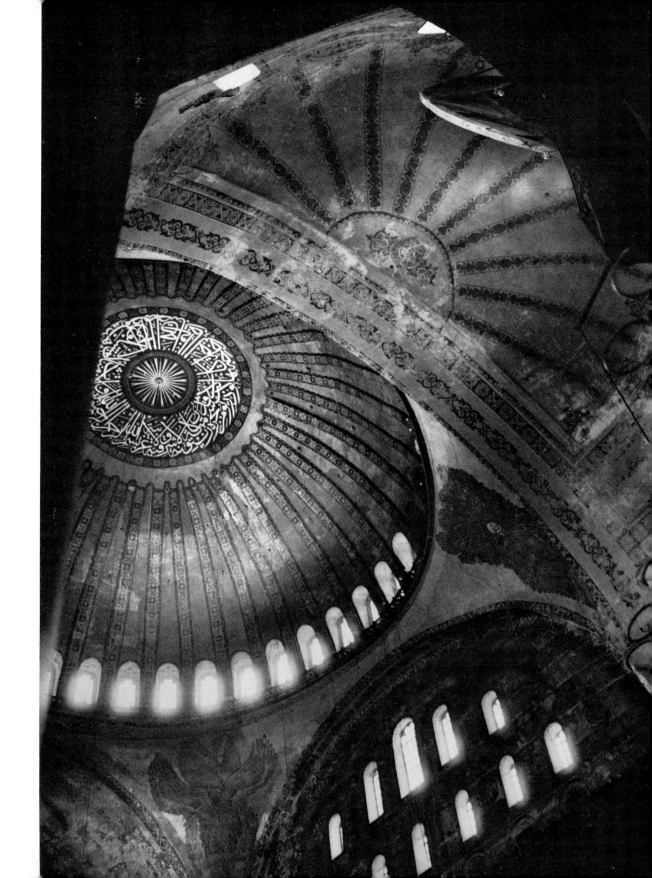

CONTROL OF THE CHARACTERISTIC CURVE

The characteristic curve of a film is a graph that shows the behavior of a film under specified exposure and development conditions. This curve is supplied by manufacturers to indicate the be-

havior of their emulsions under standardized conditions. However, the standards are useful primarily to high-volume photofinishers, who possess equipment to check their results against these curves, and to motion-picture film processors, who must maintain equal density from take to take. Architectural photography is a much more individual-

ized profession, and the results required are anything but average.

Fortunately, by altering exposure and development conditions, it is possible to change the characteristic curve of a film. And while it is totally unnecessary to graph the new curves, the results of certain changes are quite obvious to the experienced photographer. A faster film, say Kodak

Plus-X, Ilford FP4, Kodak Tri-X, or Ilford HP4, responds quite well to manipulation of development times, and is particularly recommended for interior photography. If any of these films is exposed at ¼ of its rated ASA and developed for ½ of the recommended time with constant agitation in a standard developer such as Kodak D-76 or ID 11, a long, full, softly-graduated tone scale will result in the negative: Highlights will not block up, and shadow detail will be printable. In principle, this effect will occur with any developer-film combination, although slow-working, low-energy developers will effect this to a greater degree than high-energy developers.

CHOOSING A DEVELOPER

The variety of developers marketed today makes the choice of one developer difficult, especially for the beginner. The best choice depends on film, format, and subject matter.

Developers can be roughly broken down into five basic categories: high-acutance developers, such as Rodinal, Edwal Super 12, and FR X-33C; M.Q. borax developers, such as Kodak D-76 and Ilford ID 11; speed-increasing developers, such as Ilford Mocrophen and Ethol UFG; speed-reducing, compensating developers, such as FR X-22, Ethol TEC, Edwal Minicol II, Kodak D-23 and D-25, and Gevaert G.215; and high-contrast developers such as Ansco 90, Kodak D-11, and Kodak D-19. All of these developers, with the exception of D-23 and D-25, come in ready-to-mix cans or bottles and can be diluted with water and used as a one-shot (one-time use only) developer, or can be reused when mixed with replenisher at proper intervals. Exact dilutions, recommended time/temperature combinations, and directions for replenishment are supplied by the manufacturer.

When you first pick a developer, it is better to start with a standard, easy-to-prepare developer with moderate to fine-grain characteristics. I personally find Kodak D-76 used full strength without replenishment an excellent all-purpose developer for formats larger than 35mm, especially for 4" x 5" negatives. When D-76 is used at a 1:1 dilution as a one-shot developer with medium-speed 35mm films such as Plus-X or FP4, the resulting negatives retain their fine-grain characteristics and do not get overly contrasty.

Tri-X film, because it has the greatest exposure latitude, can be used in a wide variety of situations, although it is best suited for the reduction of contrast in architectural photography.

For architectural details, static situations, or small-format architectural photographs, I recommend using a slow, fine-grain film in conjunction with a high-acutance, compensating developer.

By carefully manipulating film, exposure, developer, and development time and temperature, complete contrast control is possible. Many professional photographers, one of the most articulate among them being Ansel Adams, profess the idea that contrast should be controlled in the negative and that only minor adjustments should be made during the printing process. I am in agreement with Adams when he says that a successful photograph is the result of pre-visualization of the final print. In other words, before the film is even exposed, the photographer must formulate in his mind an image of what the subject is to look like in its final printed form.

DEVELOPMENT PROCEDURES

Consistent, predictable results, the stock-in-trade of the professional, come about in part through standardization of development procedures. For this standardization to come about, the professional must first know the layout of his darkroom as well as a good typist knows the layout of a typewriter keyboard; and the darkroom layout should be just as efficient, for its purposes, as the layout of the keyboard.

Use a table, counter, or other dry area for loading and unloading film; lay out development tanks and bottled solutions in a separate area, preferably in a sink or on a table. By keeping the two areas separated, you prevent contamination of unprocessed film. There should be sufficient room between the two areas to facilitate movement in the dark. Lay out your work table and sink in a way that is comfortable for you. Once you have found a layout that suits you, stick to it. You can avoid a great deal of confusion if

your layout is the same every time you work, since to function efficiently in the dark you must know exactly where your materials and chemicals are in relationship to one another. There is nothing more maddening than feeling around in the dark for a misplaced reel, or being confused about the order of your chemical layout.

EQUIPMENT FOR DEVELOPING

The table for your dry area should be large enough to hold a camera or a stack of film holders in the center, development reels or film hangers to the right, and the film holders or reels that you are loading. Keep the tabletop clean, dust-free, and uncluttered. Give yourself enough elbow room so that you can turn around easily.

Several types of reels are available for 35mm, 120, 220, and 70mm films. I have found that the stainless-steel reel is easiest to work with and keep clean, although initially some practice is needed to learn to load it. For example, the key to loading a Nikor reel is to keep the hand holding the film stationary and do all the work of rolling the film onto the reel with the hand holding the reel.

Two types of development tanks are widely used by professionals: square, hard-rubber tanks and cylindrical, stainless-steel tanks. The cylindrical steel tanks, are obtainable both with or without "daylight" tops, which allow for processing with the room lights on once the film is loaded and the top secured. They have a diameter slightly larger than the reel and are available in various depths so that you can develop up to an entire stack of reels at once. These tanks are most convenient when you use a one-shot developer, or want to use a developer other than your standard one. I find that a large, one-quarter-gallon cylindrical stainless-steel tank is useful for this purpose. Personally, I prefer three-gallon, hard-rubber tanks with a lighttight lid for developing 4" x 5" film and 120/220 roll film. A stock solution, such as D-76, full strength, can be kept in this type of tank. The large

amount of solution permits good circulation of the developer as the film is agitated. The large size also makes it possible to develop a great many rolls or sheets of film at once, an important advantage when time is limited. For special developers, I like the 1½-gallon, hard-rubber, square tank.

If your development tanks are large enough, you can develop several reels at one time by placing the reels on stainless-steel rods, which facilitate moving the reels into and out of the tank and make agitation easier when you are using large, one-gallon or three-gallon tanks.

FILM HANGERS

Several types of hangers are available for 4″ x 5″ sheet film. Made in both plastic and stainless steel, the most popular types are single-sheet holders and large, 8″ x 10″ hangers that hold four sheets of 4″ x 5″ film. The 8″ x 10″ hangers must be used with a three-gallon tank as a smaller tank will not accommodate them.

The proper procedure when working with film hangers is to stack the 4″ x 5″ film holders on the center of your table and put the empty hangers on one side of the holders, leaving empty space on the other side for loaded hangers. When you have loaded a hanger, move it to the opposite side of the table and stack it vertically. If you stack the loaded hangers one in front of the other, use a small box of film in front of the stack to keep it firmly in place. The developing procedure must be carried out in total darkness, so load only as many hangers as your tank will accept. A small, 1½-gallon tank will hold 10 sheets of film at one time; a 3-gallon tank will hold 24 sheets of film. Once you have a stack of film ready for development, pick up the whole stack with one hand and hold it in position with the other hand. In this way you can place the entire stack in the developer at the same time.

Two additional pieces of equipment are necessary for the controlled development of film: first, a large timer with a luminous dial and minute and second hands that can be easily read in the dark,

second, a thermometer, because all solutions should be held at approximately the same temperature. It is preferable to use a thermometer that can be hung on the side of the developer tank.

STEPS IN DEVELOPING

There are seven steps in the development of black-and-white negatives: (1) unloading the film from the camera or film holder and loading it onto reels or hangers; (2) placing the loaded reels or hangers in the pre-filled developing tank; (3) agitating the film and removing it from the developer; (4) placing the reels or hangers in the stop bath; (5) placing the reels or hangers in a fixer; (6) washing the film; (7) drying the film.

STEP ONE

Step One has been covered in the section above on equipment; the remaining steps are outlined in this section, along with some tricks that I have found make the process go more smoothly.

STEP TWO

Place the film in the developer and set the timer. When you have loaded your film on reels, this is a very straightforward procedure; the reels are simply stacked on a stainless-steel rod and dropped into the tank. Of course, there must be enough developer in the tank to cover the top reel. When you use 4" x 5" sheet-film holders, the procedure is more exacting because extra care must be taken to avoid scratching the film in the hangers. I find it best to hold the hangers firmly together with one hand on top of the stack and the other hand against the side of the stack.

STEP THREE

Because the more exposed areas in the negative exhaust developer in their proximity more quickly than the less exposed areas, a negative that is not agitated properly so that it is constantly exposed to fresh developer will be low in contrast and stands a good chance of being unevenly developed. Uneven de-

velopment, or streaking, is especialy apparent in larger negatives when they are developed in hangers in a large tank. To avoid uneven development, a standard agitation pattern must be used.

Two methods of agitation are commonly employed; first, the systematic moving of the negative in the solution by hand; second, movement of the solution by intermittent bursts of nitrogen gas coming up from the bottom of the tank. The latter method is used extensively in color processing and in automated, deep-tank processors, but it is expensive and beyond the reach—or needs—of most beginning professionals. In fact, when given a choice between the two methods, I prefer agitation by hand, because greater control is possible.

The pattern of agitation adopted depends on the qualities you want in the finished negative and on the development time. As a general rule of thumb, the more agitation, the higher the negative contrast with standard processing. However, when short development times of less than five minutes are used, vigorous and constant agitation throughout the development time is recommended for the production of standard negatives. With times greater than five minutes, the usual pattern adopted is constant agitation for the first minute and thereafter agitation for 20 seconds at one-minute intervals. To insure evenness of development, strict adherence to the pattern is necessary; a few jiggles here and there during development is not enough. As in all stages of the photographic process, discipline and regular procedures are necessary if predictable results are to be achieved.

To agitate film on reels, you need only grasp the rod on which the reels are placed and lift it up and down, tapping it on the bottom of the tank each time. To agitate film in sealed, cylindrical tanks, pick up the tank, turn it firmly upside down, then firmly right it and set it back on the counter. In either case, the method should be slow and deliberate; shaking the tank as though you were mixing a martini will cause bubbles to form along the surface of the film and can result in uneven development.

Agitation of sheet film in hangers is a more exacting procedure; each step should be carried out precisely and in sequence. First, immerse the loaded film hangers in the developer and set the timer. Next, using both hands, take a firm hold on the stack of film holders and lift it out of the developer. Turn the entire stack of hangers to one side and tap it lightly against the side of the tank. Re-immerse the hangers in the developer and take the entire stack out again, this time turning it to the other side and again lightly tapping it against the side of the tank. This should free the film of any air bubbles. Continue this pattern for one minute, or, if the tank is sufficiently large, simply turn the stack of hangers around in the developer, moving it from side to side for the first minute. After the first minute stop agitation, and at one-minute intervals thereafter repeat the agitation procedure for 20 seconds, returning the film to the developer to sit for another minute each time.

About five or ten seconds before the required development time is reached, take the film reels or hangers out of the developer and tap them lightly on the side of the tank to facilitate drainage. Next immerse them in the stop bath. Agitation in both the stop bath and the fixer should proceed in the same manner as in the developer.

STEP FOUR

The acid stop bath is an intermediate stop used to neutralize the alkalinity of the carried-over developer so that the fixer remains acid. Some workers feel that the stop bath is unnecessary, and in fact, for fast development in high-energy developers, its use is not recommended. Direct immersion in a fresh fixing solution after development will immediately stop the development process and begin the fixing process. If you do choose to eliminate the stop bath, use a quick-fix solution or a two-part standard fixer. In the latter case, always mix a fresh fixing bath for the final fixing step, and use the old fixer as a stop bath.

STEP FIVE

The exposed silver halides are reduced to metallic silver by the developer, but unexposed silver halides still remain in the emulsion and these are light sensitive. The fixing solution removes these unexposed areas so that the film can be exposed to light without further chemical change. Thus the image is "fixed." Another term for fixer is "hypo," a misnomer for one of the components of a standard fixing bath. The principal ingredient in a standard fixer is sodium thiosulfate, which accomplishes the reduction of unexposed silver halides; however, in modern fixing baths, other ingredients are usually added. Sodium bisulfite or boric acid is often used to maintain the acidity of the formula; finally, a hardener such as potassium alum is often used to harden the emulsion. A hardening fixer is particularly recommended when the temperature of the bath is above 75°F. This type of fixer can help prevent frilling of the emulsion and scratches.

STEP SIX

After proper fixing the negative will no longer respond to light, but it will retain a certain amount of chemical sludge deposited during chemical processing. The residues that are potentially most damaging are those retained from the fixing solution, especially the complex silver-salt deposit, which can cause staining and eventual deterioration of the emulsion. These residues must be removed by washing the film in clean, running water.

One of the most useful aids to washing is the hypo eliminator. Hypo clearing baths are designed to reduce washing time and ensure a greater degree of permanence. They are sold by a number of manufacturers. I use Perma-Wash, an easy-to-use, reliable product when the diluted solution is mixed fresh for each batch of negatives. According to the manufacturers of Perma-Wash, if you wash film in running water for one minute, then immerse your films in Perma-Wash solution for another minute, and then

give the film a final clean-water wash for one minute, films will have a 50-year permanency. When used according to these instructions, one gallon of Perma-Wash solution will suffice for 100 8″ x 10″ film sheets.

Whether or not you choose to use a hypo clearing bath, the key to good washing is the quality of the final water wash. Chemical sludge, rust, and heavy particles found in normal water supplies can damage negatives if they are present in sufficient quantities. Investing in an inexpensive water filter removes such residue and prevents a great deal of worry.

STEP SEVEN

The final step in the controlled processing of film is correct drying. For the professional, who must have readily printable negatives, the most important aspect of drying is finding a place that is free from dust. Once the film is washed, treat the film in a wetting agent such as Kodak Foto-Flo. For best results, mix the Foto-Flo in distilled water, which has

no residues that can be deposited on the film. The wetting agent cuts down on the possibility of foreign particles remaining on the emulsion surface, reduces surface tension that causes drying marks, and helps eliminate small scratches. Moreover, wetting agents contain a static eliminator that tends to repel dust particles.

There are two basic ways to apply a wetting agent: First, the film can be immersed in the agent, and then hung up to dry. Second, the film can be hung up to dry first. Then two pieces of clean cotton saturated with wetting agent can be used to gently squeegee both sides of the film until the film is thoroughly coated by the agent. The advantage of this technique is that it is easy and minimizes drying spots; the cotton, however, should be surgical quality, clean and dust-free.

Temperature and humidity in the room where film is dried is important. For best results, the temperature should not exceed 85°F and the relative humidity should be between 40 and 50 per cent. Simply hanging films up in

a dust-free dark room is generally sufficient. Drying in a heated cabinet can produce water marks, excessive curling, and even reticulation, cracking of the emulsion, on roll film.

FILING NEGATIVES

Once film is dry it can be stored in glassine envelopes. Both 120/220 and 70mm films can be cut in strips of three or four frames; 35mm can be cut in strips of five or six frames. For all these films I prefer to use the larger glassine envelopes designed for 70mm film. I store 4″ x 5″ negatives in 5″ x 7″ envelopes. Prolonged contact with the adhesives at the edge of the envelope can cause staining, and so by storing negatives in larger envelopes, the chance of the negatives coming in contact with these adhesives is avoided.

I like to put several negatives or strips of negatives in each envelope, the exact number needed to fill an 8″ x 10″ piece of printing paper. Each envelope is given a number, which is also written with indelible ink on the edge of the negatives. The number of the envelope also corresponds with the number placed on the contact sheet. In this way, negatives are organized as soon as they are developed, which prevents confusion and loss of time later.

THE PARTHENON, Athens, Greece.

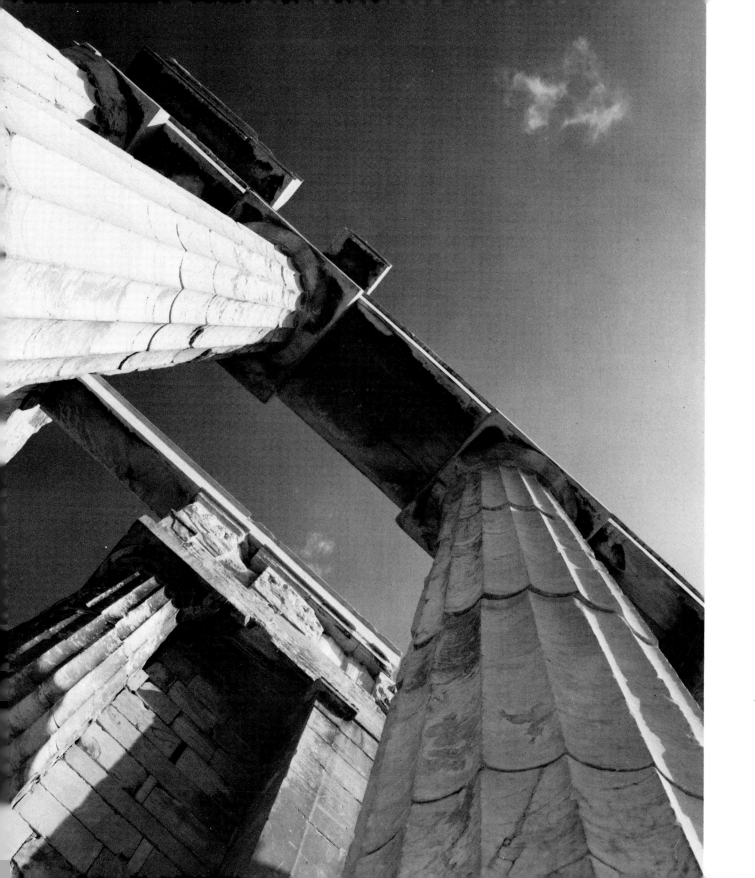

4

The Printing Process

Once the negative is developed, the third and final step in the photographic process can begin: print making. The photo that began as an image in the mind and then was made permanent in the negative must now be transferred to photosensitive paper. To do this the photographer must re-visualize his original image and create the final statement in the photographic print.

Although the learning process necessary to become a fast and efficient printer is a long and painstaking one, I feel there is no better way to fully learn the art of photography, because printing reveals all the mistakes that were made when the picture was taken in the first place. We often learn more from our failures than from our successes, particularly if we can look at those failures objectively. Learning and using the printing process is the best way I know to gain that objectivity.

To start our discussion of photographic printing: The following equipment checklist can be useful for those of you who are outfitting a darkroom. You will need

This is an obvious example of the use of potassium ferricyanide to bleach out part of the sky. I like this print because it adds a surreal quality to an otherwise static shot.

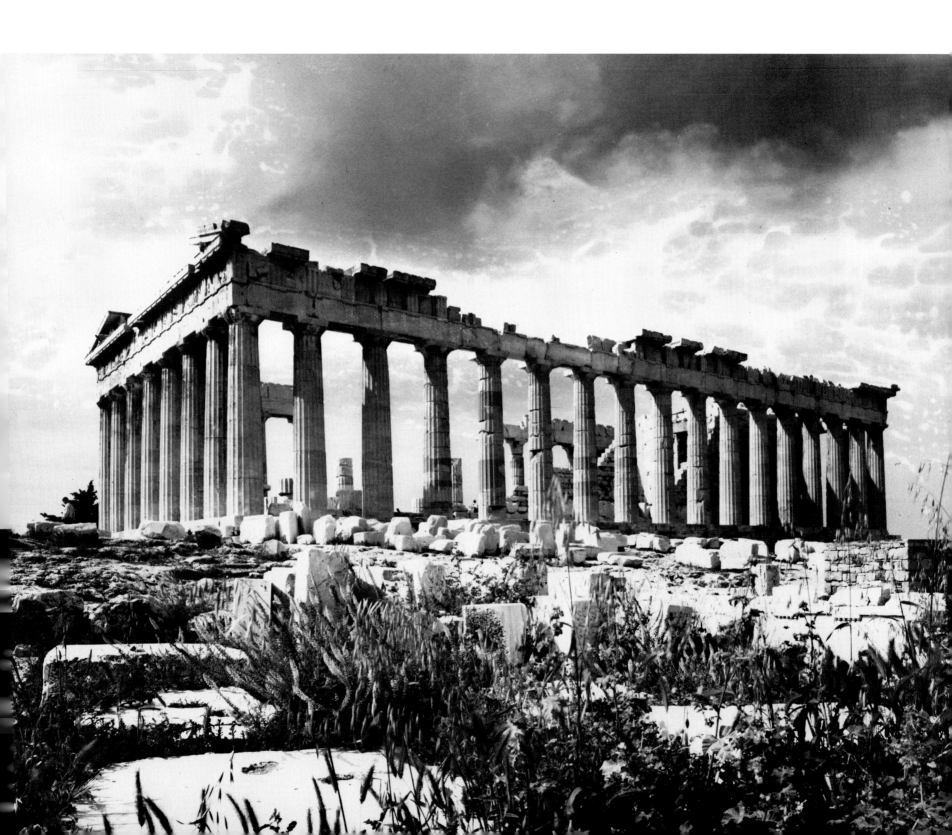

the following: (1) a bathroom, kitchen or any other room that can be made lighttight, (although one with available running water is preferable); (2) an enlarger with lenses appropriate to your negative size; (3) a timer to regulate the enlarger lamp; (4) a contact printer or printing frame for proofing negatives; (5) an easel to hold printing paper firmly in place; (6) trays to contain processing solutions; (7) a sink or table to hold trays and a table to hold the enlarger; (8) a thermometer to monitor solution temperature; (9) a clock to time prints; (10) a safelight (one or more) with filter appropriate to the printing paper in use; (11) a print washer or a large tray with provision for circulation of water. Other equipment, useful but not absolutely necessary includes: (1) a siphon; (2) metal or plastic tongs for handling prints in solution; (3) magnifier to check grain focus to assure maximum image sharpness when the enlarger is focused; (4) a glass negative carrier to hold film firmly in place and prevent buckling from the heat of the enlarger; (5) filter holders and filters, if you print with variable contrast papers; (6) dodging devices for holding back exposure in small areas of the print; (7) squeegees for wiping excess water from prints prior to drying; (8) a system for drying prints; (9) brown bottles for chemical storage; (10) spotting brushes and spotting colors for retouching prints; (11) a paper trimmer; and (12) a dry-mounting press, along with mounting boards and dry-mounting tissue.

A number of specialized techniques can be used to make a good architectural print; but to use these effectively, the basic print-making procedure must be thoroughly mastered. As in any other phase of the photographic process, consistent, predictable results come about only through meticulous attention to basic details. These basics are discussed below, step by step.

The use of ferricyanide bleach is not obvious at all in the print. It was used to lighten the name and the main entrance way. The statue to the left of the library was also lightly bleached.

SILAS BRONSON LIBRARY, Waterbury, Conn. JOSEPH STEIN & ASSOCIATES, Architects.

The four photographic prints on these pages represent four stages in the development of the final print. The picture was taken late in the day with the building in shadow and the sun setting behind it. The exposure attempted to compensate for the low light level but the result was a flat and uninteresting picture. The art of selective printing was employed to enhance the interest and excitement of the photo concept.

The first print (top left) represents the correct exposure for the building values.

The second print (bottom left) is to determine the amount of exposure to render the sky the proper selective tone.

The third print (top right) is a multiple exposure in which the base exposure was for the building and a second exposure was made to burn in the sky and foreground. The print is unsuccessful because the sky is not rendered dark enough and the building received too much exposure. Only the foreground road received the proper tonal rendition.

The fourth print (bottom right) is the final solution to this difficult printing job.

This series is meant to show the great control that can be exercised over the final print if you have patience and a will to experiment.

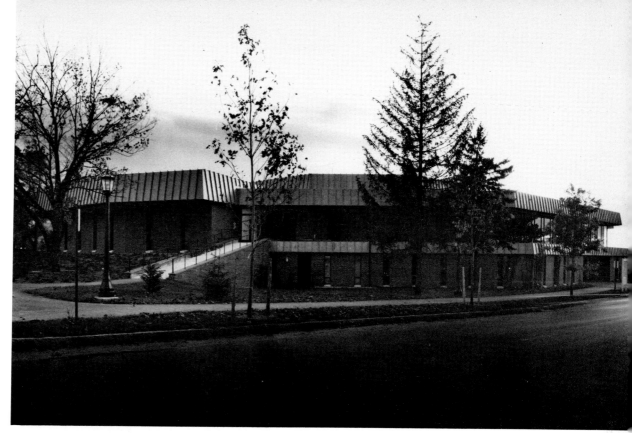

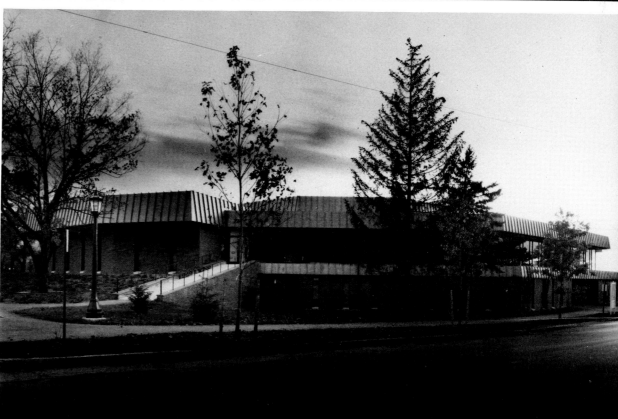

LECTURE HALL, State University of
New York at Geneseo.
MYLLER, SNIBBE, TAFEL, Architects.

STEP 1

Preparing the darkroom. Make sure outside light is blocked from windows and doors. All work areas and equipment should be clean and dust-free. Lay out trays for developer, stop bath, fixer, and wash on a table or sink. Prepare chemicals and check their temperature: Ideal temperatures range from 60°F to 75°F. Lower temperatures require a much longer development time and higher temperatures can change the quality of the image. Turn on the safelights—one should be over the developing tray, another placed so that it illuminates the entire room. Then select your negative, dust it with an anti-static brush or cloth, and place it in the negative carrier of your enlarger.

STEP 2

Cropping and focusing. Turn off the white room light and turn on the enlarger lamp. With a spare sheet of printing paper in the easel, adjust the height of the enlarger lamphouse so that you get the composition you want.

Focus critically, using either a grain-focusing device or careful observation with the lens wide open. Next, open up the aperture of the enlarging lens all the way. Then adjust the f/stop of the enlarging lens, closing it down about two stops to assure critical focus, and turn off the enlarger lamp.

STEP 3

Testing exposure. Experience minimizes the need for this step, since careful exposure and development result in negatives of fairly uniform density that have approximately the same printing characteristics. An experienced printer can judge exposure time to within critical tolerances simply by looking at the image on the enlarging easel.

If you do have any uncertainties about exposure, you can conserve paper by cutting a sheet of printing paper into strips and making trial exposures on these. Just set the automatic timer for the estimated exposure, place the test strip on the easel, and activate the timer.

STEP 4

Processing the print. Place the print or test strip into the developer with a sliding motion so that the entire exposed surface is covered quickly and evenly. Agitate the paper with print tongs or by rocking the tray and develop fully, usually for about two minutes. Remove the developed print from the developer, place it in fresh stop bath, and agitate. After one minute in the stop bath, remove the print, drain it, and place it in the fixer. Agitate for about one minute, after which time the print will be insensitive to white light, although full fixation may require anywhere from three to ten minutes, depending on the type of fixer used.

STEP 5

Inspection. Turn on the white light and examine the test strip or print for contrast range and exposure. If the print is too dark, use a shorter exposure; too light, use a longer exposure. Unless printing time becomes excessively long, vary time rather than

f/stops, since this cuts down on variables and helps in the creation of a predictable system of exposure.

If the print is correctly exposed but too flat (lack of deep blacks or brilliant highlights) or too contrasty (insufficient tonal gradation to show all detail), use a different contrast grade of printing paper. If you do change contrast grades, you may also have to adjust exposure. Each manufacturer supplies data on the percentage of exposure change needed when changing from one grade to the next.

STEP 6

Full-sheet text printing. Once the proper exposure and contrast grade of paper have been determined, either by experience or through testing, a full sheet of printing paper should be exposed and developed. The resulting print may be the final print, or it may serve to indicate the selected areas where changes have to be made through dodging or burning-in, techniques that are treated in more detail later in this chapter.

STEP 7

Washing the prints. The final wash of a photographic print is a critical step in the chain of procedures that begins with the pre-visualized photograph. Photographic paper absorbs residue from the fixer to a greater extent than film, and therefore a longer washing time is needed to completely free the print of all unwanted chemicals. The use of a hypo clearing bath is recommended to cut down washing time, although if such a bath is used, the print must still be washed in constantly changing water for at least ten minutes, particularly if several prints are being washed at one time.

I can't stress too strongly the importance of proper washing of both negatives and prints. Many inexperienced workers feel that washing is an unimportant job that can be done in an unconsidered way. Washing and drying prints is a time-consuming, non-creative process, but it is a highly important one, especially for the architectural photographer, whose prints will often be used for record-keeping purposes and may have historical value. Thorough washing is the only way to insure permanence. The investment in an automatic circular washer and dryer makes this last step less painful.

STEP 8

Drying. This can be done in a number of ways, including exposure to air, pressing in some type of blotter book or roll, or drying in a heated drum or flat-top dryer. Fastest, of course, is the heated dryer. In any case, soaking the prints in a print flattener and anti-static solution prior to drying is a useful, though optional, step. For maximum gloss, use a ferrotype plate in conjunction with a heated dryer. Just place the print face (emulsion side) down on the shiny, polished surface. Squeegee water off the back of the print and lay the plate on a flat surface or place it in a flat-top dryer. If you use the revolving drum-type dryer, the surface of the drum, which should be kept clean at all times, acts as a ferrotype plate. When dry, the print will pop off of its own accord.

If time is not important, blotter books or rolls can be used for drying prints or they can be laid out face up on screens to dry in the air. Prints dried in these ways will have a flat, semi-matte surface, even though the printing paper is the glossy type.

STEP 9

Presentation. Once the print is dried, final presentation must be considered. The edges of the print can be trimmed, or the print can be mounted on cardboard, masonite, foam, or other flat material with a dry-mounting press. Pinholes or dust spots on the final print can be removed by mixing a retouching solution and spotting it on the print with a fine brush.

Printing procedures, like developing procedures, should be carried out with a deliberate consistency. Each photographer designs the layout of his darkroom to suit his personal methods and available space, but once a method is settled on, it should be followed in the same way every time. The fewer the variables, the greater the certainty of consistent, predictable results.

PRINT PAPERS

As is the case with films, a wide variety of papers and paper developers is available, although in this case the demands of architectural photography narrow down the choice considerably. For example, the papers of a single manufacturer may range in surface texture and sheen from silk- or pebble-textured matte surfaces, through smooth semi-matte, to smooth glossy, with dozens of variations in between. But in architectural photography, where maximum rendition of detail is normal, the standard paper for enlargements up to 16" x 20" is a smooth-surface, glossy paper.

Printing papers used by the architectural photographer break down into two basic categories: slow-speed contact papers and high-speed projection papers.

119

CONTACT PAPERS

These papers can be used when a print is made directly from a negative at a 1:1 ratio. The negative is placed on the paper, emulsion facing emulsion, a sheet of heavy, clear glass is placed over the film to hold it firmly in place, and a strong light is turned on to make the exposure. The assembly for holding the negative/paper sandwich is usually a contact-printing frame with some means of putting pressure on the paper and film to hold them flat.

Older, relatively insensitive types of contact paper could be used in a semi-dark room, loaded into a frame with the negative, covered with glass, and taken out to the sun for exposure. This is the way the early 19th-century photographic prints were made, and many of the famous 20th-century photographers, Edward Weston, for example, continued to use large-format, 8" x 10" or 11" x 14" cameras and almost never used an enlarger. They felt the integrity of the image diminished when another optical step was introduced. Now, of course,

with the use of small-format cameras—and for the older photographers small-format meant any format 4″ x 5″ or smaller—the contact print is primarily used for record making, not exhibition, and projection papers are used for contacting as well.

The one advantage contact papers have over projection papers is that they allow a greater control of print tone by manipulation of the developer formula. Both these papers are made by most manufacturers of printing papers, but I have found that Ilford, Kodak, and Agfa papers are the most widely available.

ENLARGING OR

PROJECTION PAPERS

Enlarging or projection papers are fast, sensitive-emulsion papers designed to be used with low-intensity illumination. Because they are the most widely used type of printing paper, manufacturers supply such papers in various weights (though the most common are single and double weight), in various speeds, contrast grades, surface textures, image tones, and finishes. As mentioned above, contrast and detail in both highlights and shadows must be maintained in architectural photography, and for this purpose a smooth-surface paper with a brown or blue-black image tone and a semi- or full-gloss surface is best. These papers have light-reflecting properties that permit the viewer of a print to discern finer gradations of tone, especially in the shadow areas where the blacks are denser and the tonal differentiation is finer than on other types of paper. Note, however, that for extremely large blow-ups or mural photographs, a non-glossy (matte) surface is preferable because it cuts down on surface reflections.

Each manufacturer provides information on the papers he makes and provides samples of what each type looks like with an image printed on it. If you study these samples carefully, you can quickly judge whether a given paper has the desired characteristics for a particular job.

CONTRAST CONTROL

Both projection and contact papers are manufactured in various contrast grades to match the printing characteristics of various negatives. Generally, numbers 1 and 2 are low-contrast papers, 4 to 6 high-contrast, and number 3 the normal paper, although in some cases number 2 may be considered normal.

Appropriate developers for each type of paper are recommended by the manufacturers, although there are some developers that can be used as a standard for many different paper types. Edwal T.S.T. is one such developer. It comes in liquid form and can be mixed to various dilutions, thus helping to control to some extent the final print tone. Kodak Dektol, Ilford ID-20, and DuPont 55-D are other standard developers that provide some tone and contrast control, depending on the amount of dilution.

VILLAGE OF THERA, Island of Santorini, Greece.

122

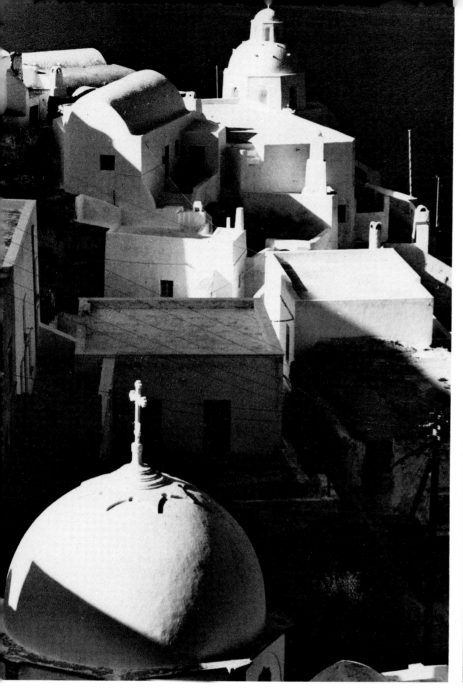

This series of three prints shows the results of three different grades of paper used with the same negative. The higher the paper grade the greater the separation of tones. The first print on a No. 1 paper (opposite page) is flat but has a full range of tones from very white to very dark. The third print on a No. 4 paper (right) has very few middle tones. Detail is lacking although the print has an interesting graphic effect.

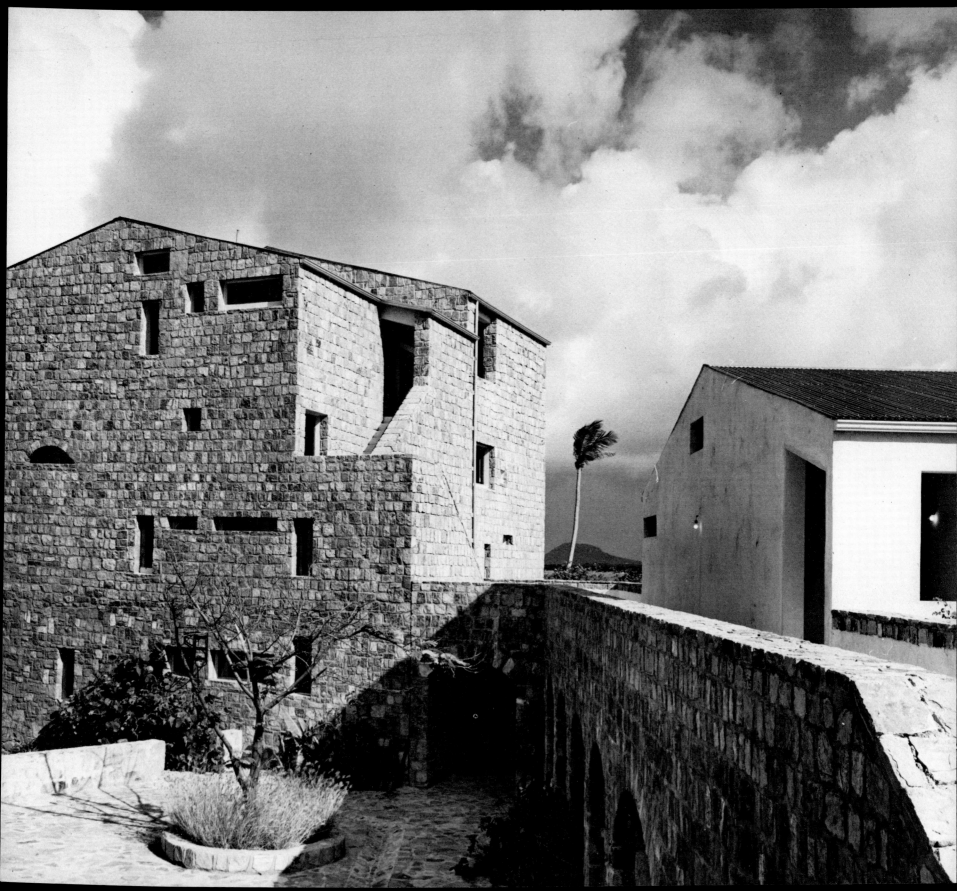

The choice of a suitable paper-developer combination can alter the total appearance of the finished photographic image and thus enhance the photographer's ability to control the final effect of his print.

SELECTIVE PRINTING

The concept of dodging (selectively holding back exposure to areas of the negative), and burning-in other areas (applying more exposure to other parts of the negative), is best shown by the accompanying set of illustrations.

The top print at the right shows the area under the bridge in deep shadow. The bottom print shows what happens when too much dodging is done—the area is too light and looks unnatural. The final print (opposite page) has been dodged just enough to retain detail and a natural appearance to the print.

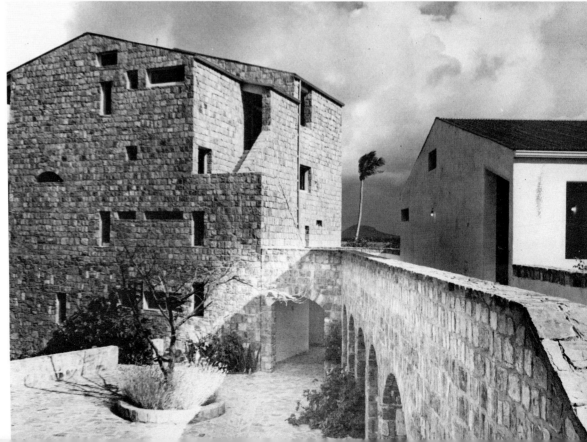

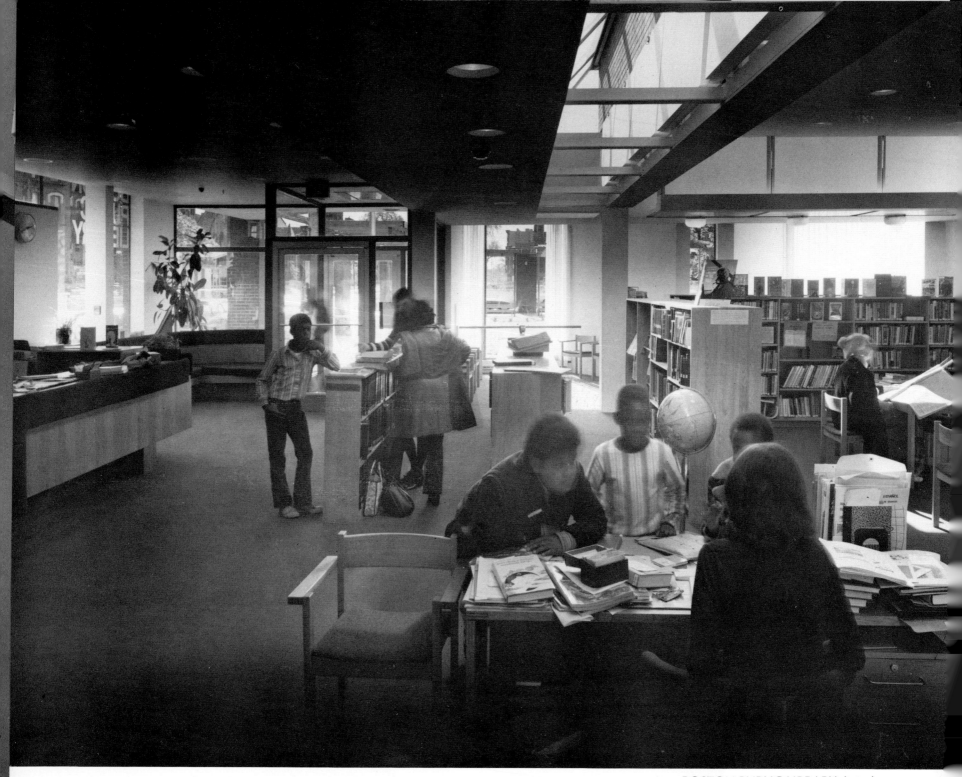

BOSTON PUBLIC LIBRARY, Interior.

The two facing illustrations show the technique of selective burning-in an area of the print to call attention to the center of interest. In the case of the print at the left, the foreground and ceiling were darkened to emphasize the light streaming in through the skylight and the people standing underneath. In the case of the print at the right, the foreground was burned into black to clean up the appearance of a street in poor repair. The background sky was burned-in to bring out some of the clouds, adding emphasis to the building design.

I.C.I. BUILDING, Stamford, Conn.
HANFORD YANG, Architect.

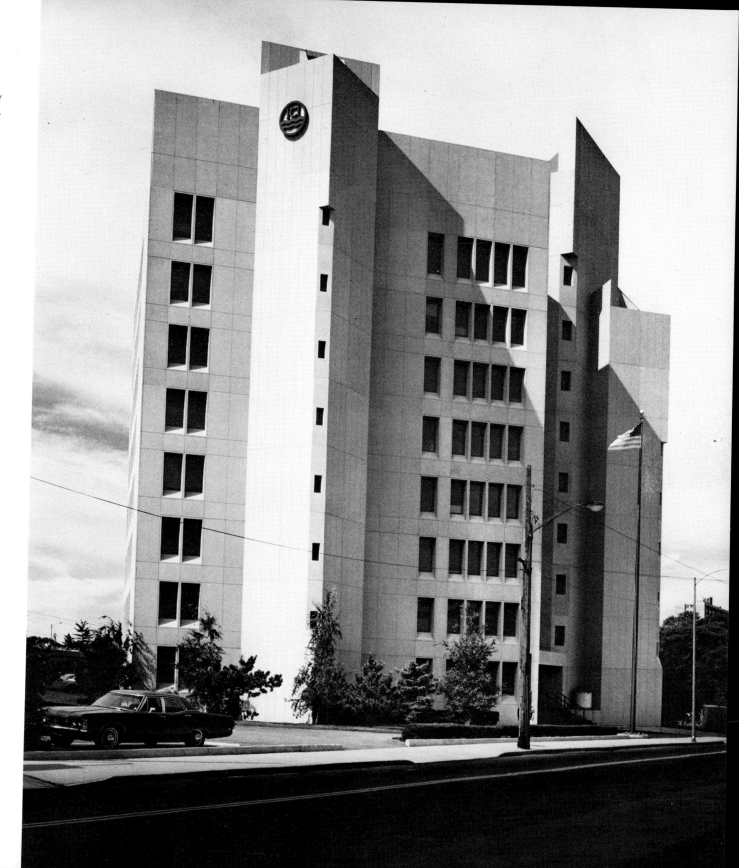

RESIDENCE, under construction.
SYM VAN DER RYN, Architect-Builder.

To emphasize the fact that special consideration of the materials was essential to the design of this unique house, it was necessary to use different contrast filters to bring out the various elements of the photographic composition.

OTHER CONTROLS

With variable-contrast filters it is possible to give the print an overall desired contrast, holding back deep shadow areas, or thin areas, of a negative, and switching to another higher-contrast filter to give the shadow detail another exposure.

Contrast and development in selected areas of the print can be controlled by preparing a beaker of hot water or hot, concentrated developer and applying this solution with a piece of cotton to a selected area of the print while it is in the developer; development in that area is speeded up.

Potassium ferricyanide mixed in a weak solution can be applied to lighten overexposed areas of a print or the overall print. Small areas can be lightened by dipping a cotton swab in the weak ferricyanide solution and applying it to the desired area while the print is in the fixer. If larger areas are to be bleached, it is advisable to wash the print thoroughly in running water after fixing, bleach the

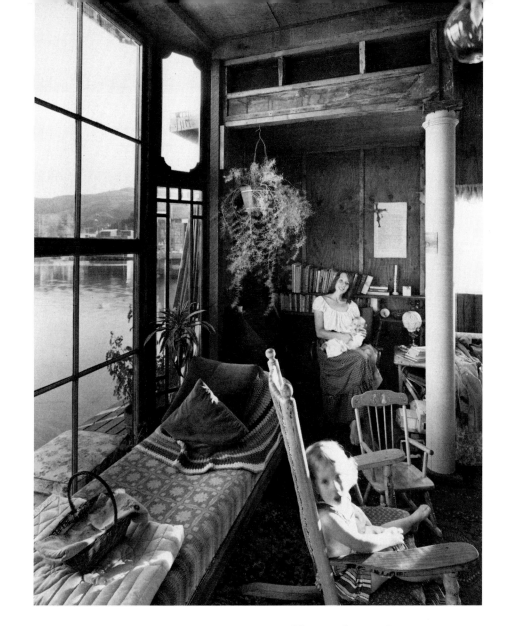

entire print or larger area, and then return the print to the fixing bath. The bleached print should then be treated in the same manner as a recently developed print.

The mother and child were in deep shadow. The first print exposure was made to render the high tone readable while the darker areas were held back by dodging. A second exposure was made with a #3½ filter on Kodak Polycontrast Rapid Paper to give appropriate detail to the area in which the mother and child are sitting.

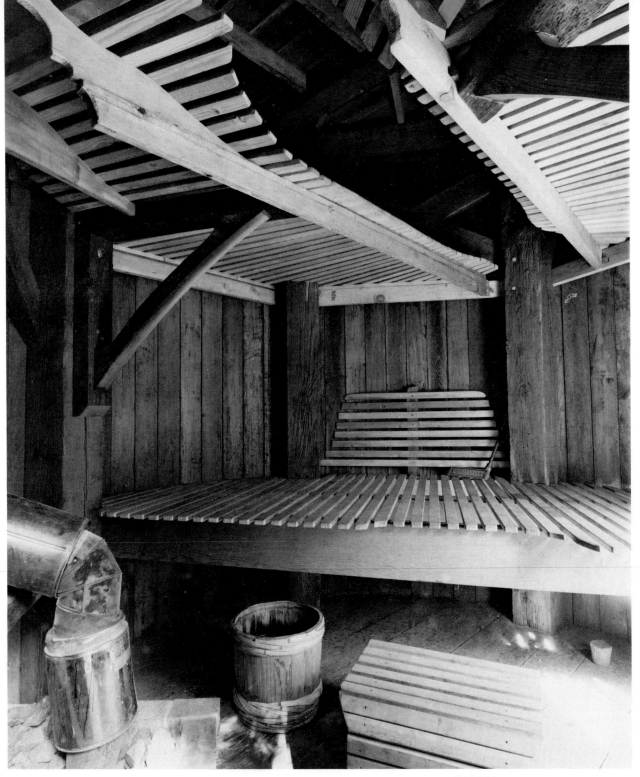

SAUNA.
SYM VAN DER RYN, Designer.

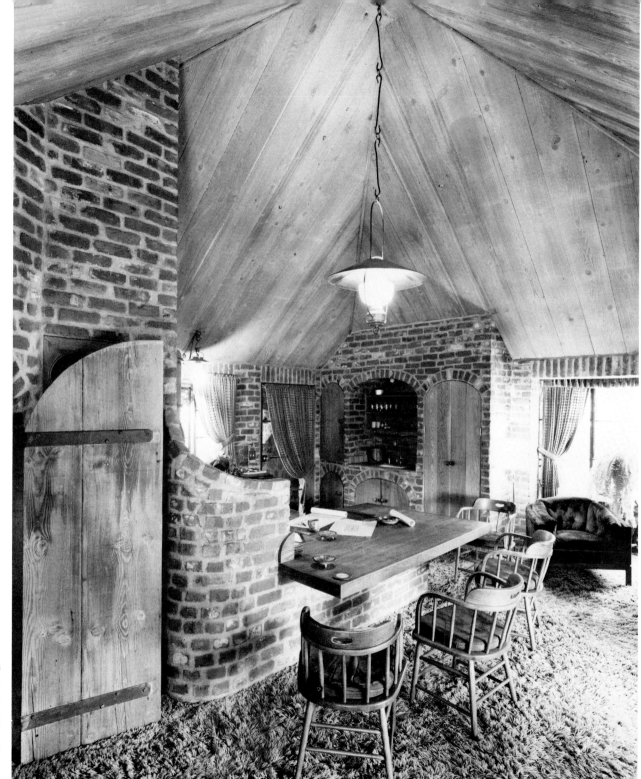

Both prints on these facing pages were enhanced by selective contrast control. Although the negatives had a full tonal scale, a small extremely bright area of window exposure had to be burned-in to give an even appearance to the prints.

OFFICE OF CHARLES DELK
ASSOCIATES, Walnut Creek, California.
CHARLES DELK ASSOCIATES, Architects.

CHOICE OF ENLARGERS

Another method of controlling contrast in the print is by printing the same negative on different types of enlargers.

A condenser enlarger will yield a higher contrast print than a diffusion enlarger because it uses a lens or series of lenses to collect light from the lamphouse and direct that light evenly onto the negative. A diffusion enlarger, on the other hand, does not use a condenser lens but rather a ground-glass system between the light source and the negative. The ground-glass diffuses the light, scattering it from all angles over the negative surface. The lowering of image brightness, and the absorption by the negative of this scattered, non-directed light, result in a loss of contrast. The degree of absorption will depend on the density and size of the negative.

One of the major problems with the diffusion type of enlarger, besides loss of image brightness, is uneven distribution of light, particularly noticeable in large-format negatives (4" x 5",

5" x 7", and 8" x 10"). When the light source is a single bulb, the image projected will have a 'hot spot' in the center. That is, the center of the negative will receive more light than the edges. Careful dodging of the center or burning-in of the edges can compensate for this effect. To avoid this center bias of most condenser enlargers, a cold light source is employed by many manufacturers: Instead of a single bulb or series of bulbs a circular fluorescent light is used in the lamphouse. Fluorescent light is diffuse by nature and insures a soft, even illumination of the negative. Omega manufactures an interchangeable cold-light head for use with its 4" x 5" condenser enlarger.

A cold-light diffusion system is the best available means for softening the image. Such an enlarger is particularly desirable in printing very contrasty negatives or in printing negatives that have been scratched or retouched. (If such negatives are enlarged with a condenser enlarger every scratch or brush stroke will show up in the print.)

RUBENSTEIN HOUSE
LILA SCHNEIDER, Interior Designer.

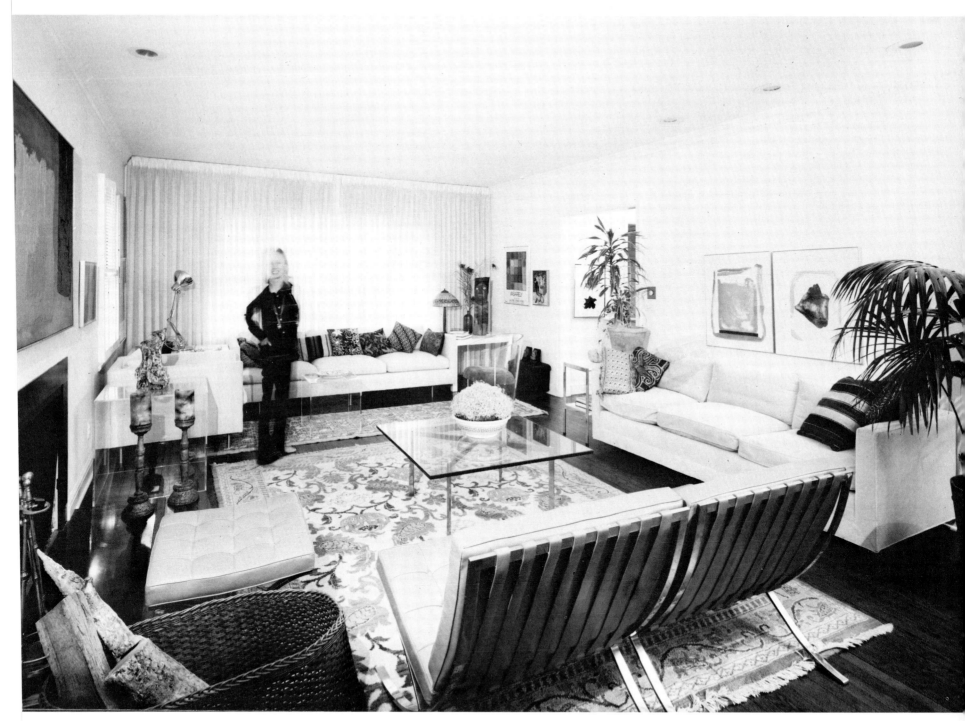

This print was made possible by the use of a cold-light diffusion enlarger. No
additional light was used in photographing this house.

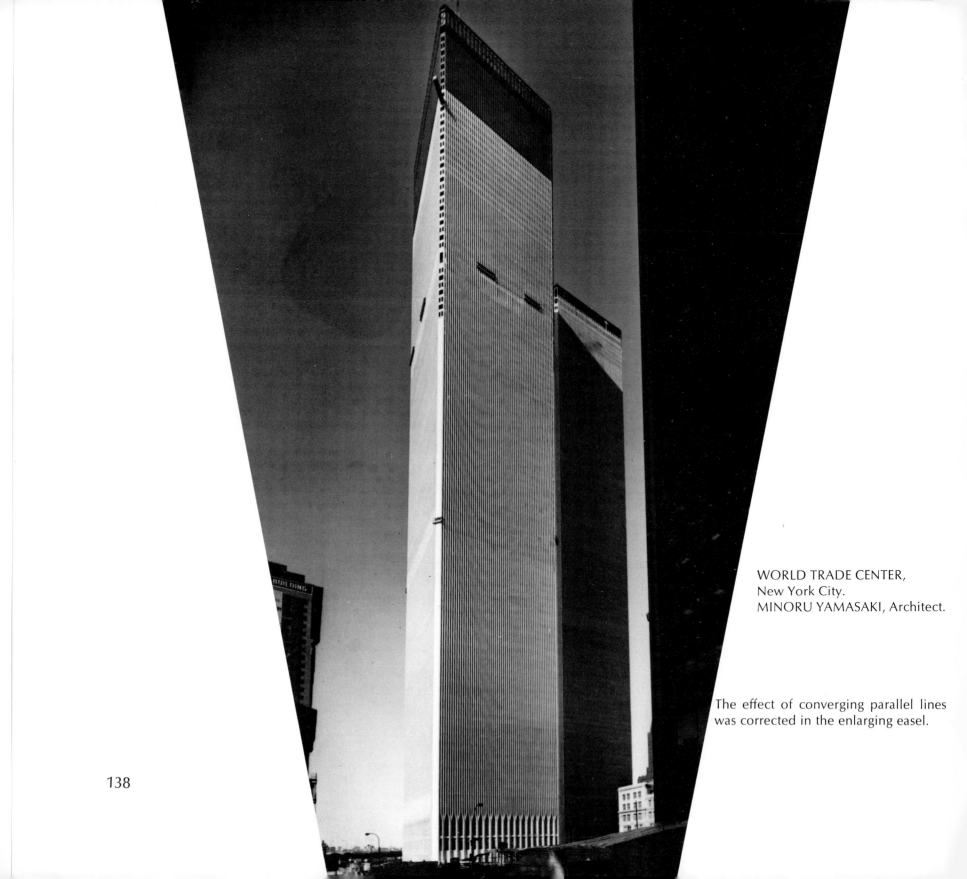

WORLD TRADE CENTER,
New York City.
MINORU YAMASAKI, Architect.

The effect of converging parallel lines
was corrected in the enlarging easel.

PERSPECTIVE CORRECTION

We have learned earlier that perspective control, or rather control over the relationship of the film plane and building plane to render vertical and horizontal lines in a building perpendicular, is accomplished by swing and tilts of the camera back. A similar method of perspective control is possible in printing with an enlarger-easel combination.

When photographing a tall building with a non-adjustable-back camera or through a lens with insufficient angle of view, it is often necessary to tilt the camera upwards to include an entire building. If the resulting effect of the building lines converging is undesirable it can be corrected to some extent in the darkroom. By tilting the easel in the opposite direction of the converging lines in the negative, compensation is made and parallel lines can be rendered parallel once again.

Some enlargers, particularly the Beseler CB-7 condenser enlarger, have built-in tilt axes of both the negative holder and lens board. If this type of enlarger is used in combination with a tilting easel, virtually any type of correction is possible.

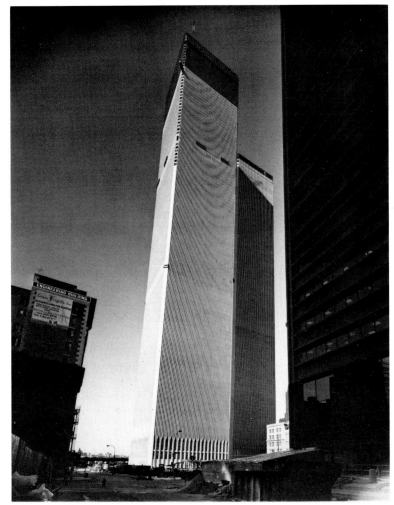

The same negative used for the picture on the opposite page is printed here without correction for parallel distortion.

This spread illustrates another control at the disposal of the architectural photographer. By carefully joining together a series of pictures taken at the same distance from the subject, it is possible to produce an elevation of an entire city block.

USDAM DAY CAMP
CONKLIN AND ROSSANT, Architects.

Below, two photographs were joined together in the center. A tree appearing dark in the middle makes detection impossible. Keeping the camera in the same position but rotating it creates an angle of view of 160 degrees. When doing a panoramic shot it is important to keep the tripod perfectly level.

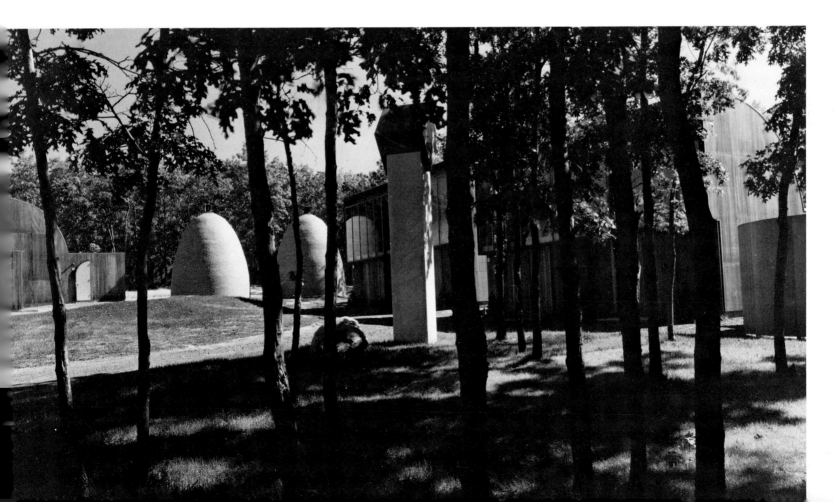

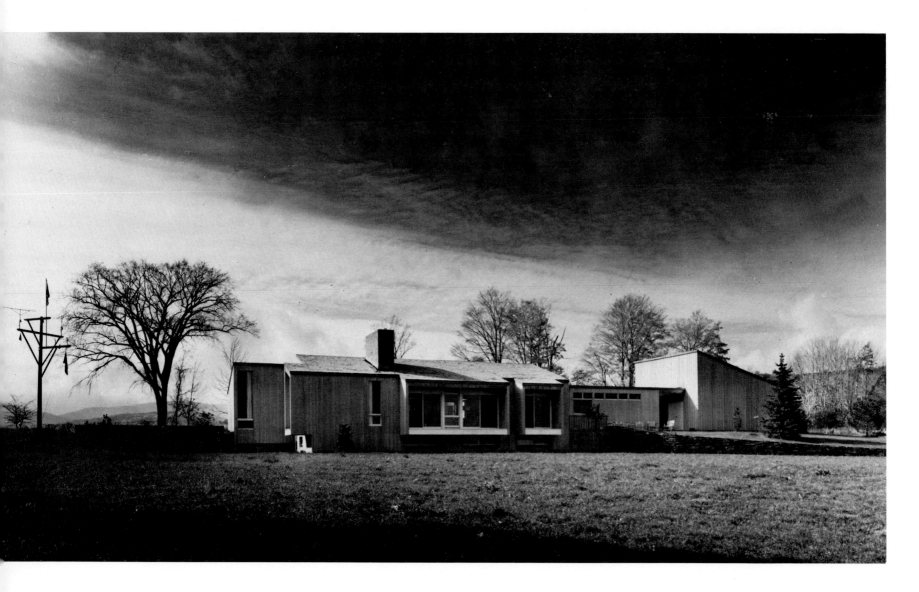

Both prints exhibit selective printing control.

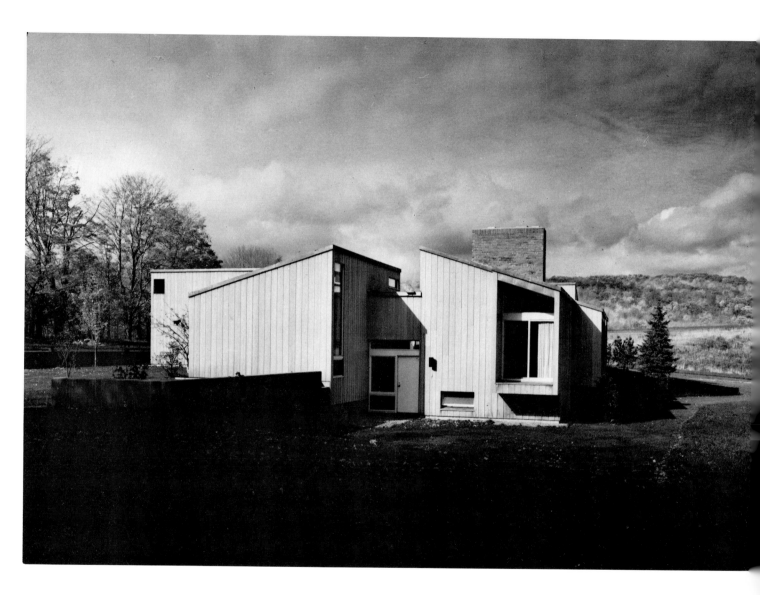

KEEP HOUSE, Two views.
DAVID TODD ASSOCIATES, Architects.
PAUL BASILE, Design Associate.

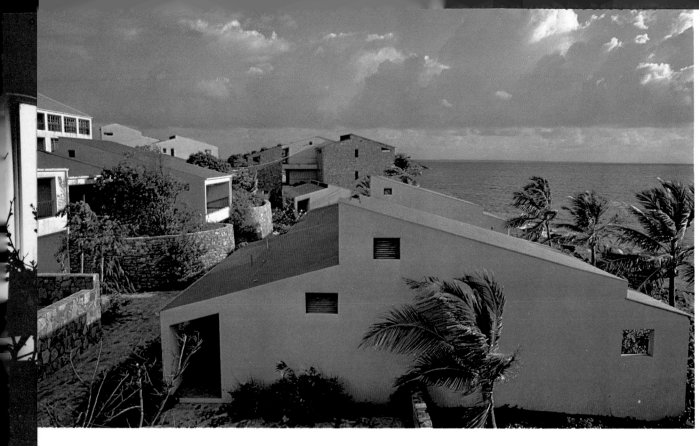

LA BELLE CREOLE.
DAVID TODD ASSOCIATES,
Architects.

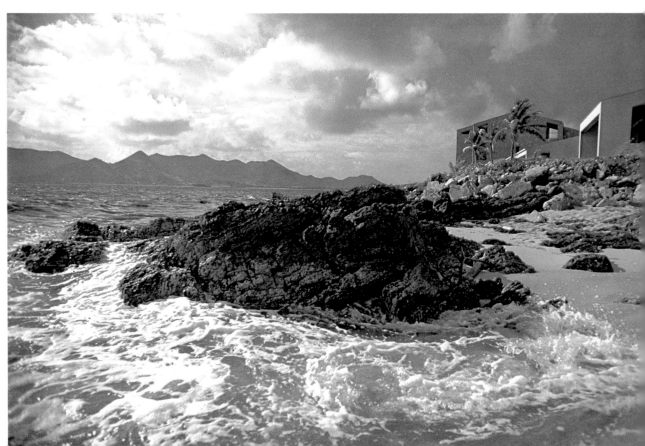

JOHN HANCOCK BUILDING, Chicago, Ill.
SKIDMORE, OWINGS & MERRILL, Architects.

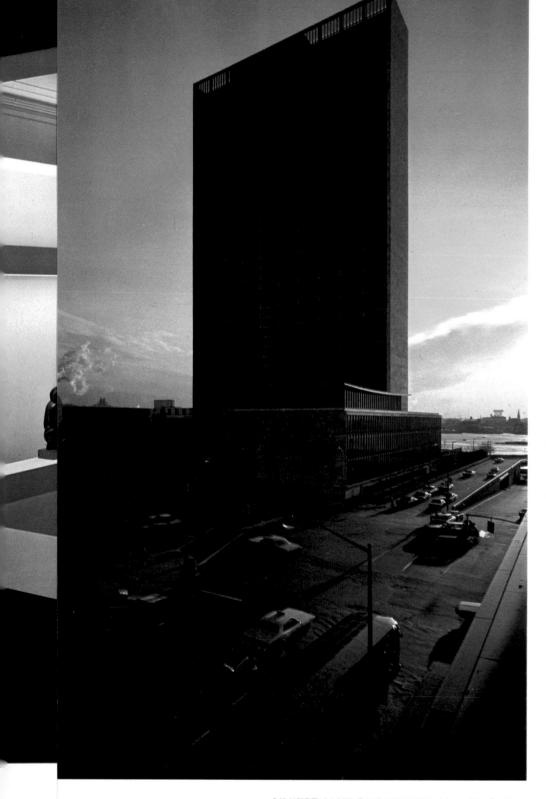
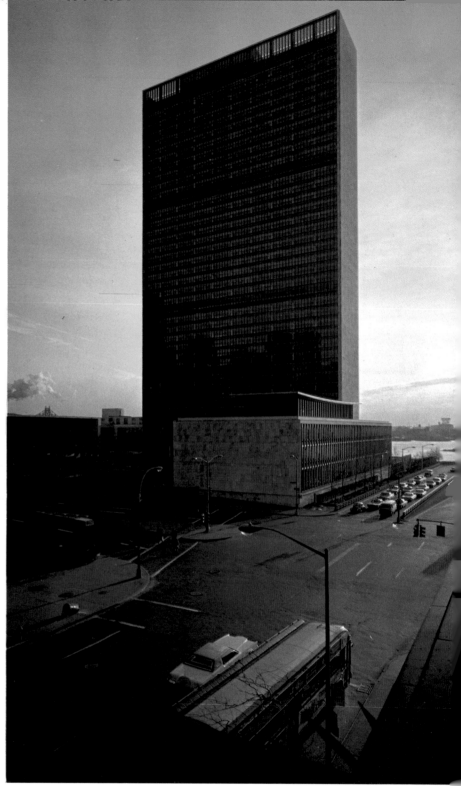

UNITED NATIONS TOWER, New York City.
HARRISON AND ABRAMOVITZ, Architects.

The left picture was taken at sunrise, the right picture a half-hour later. The de
reddish tone has changed to a softer yellow tone. No filters were used.

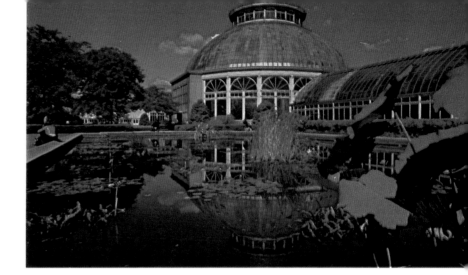

Striking color changes are created by using yellow, red, and blue filters, respectively, with infrared color film. Extensive experimentation is necessary, however, to achieve correct exposure and predictable color changes.

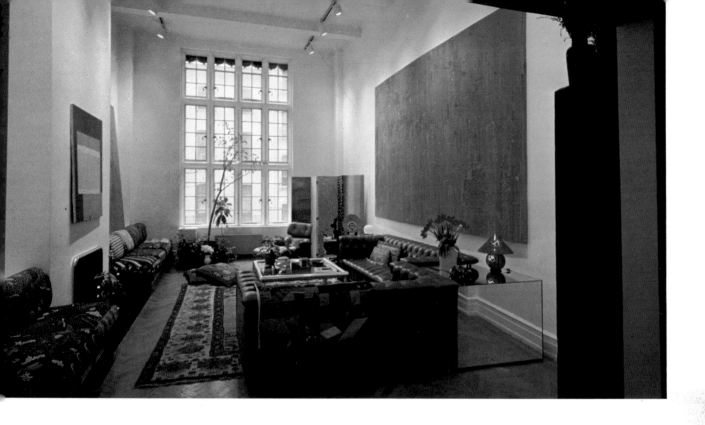

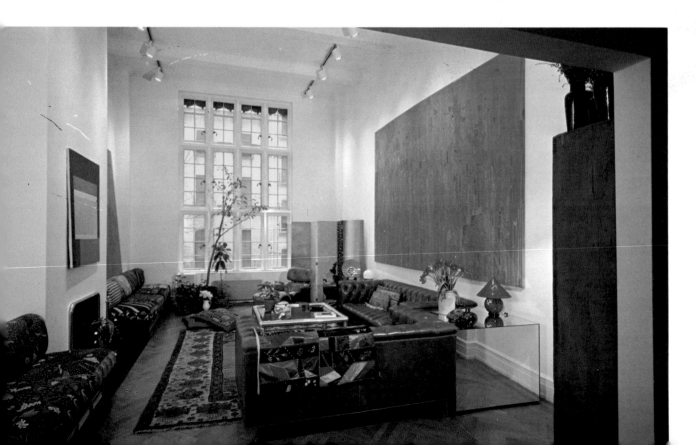

RUBENSTEIN APARTMENT,
Planned Office Interiors.

LILA SCHNEIDER, Designer.

An example of filtration in indoor photography. The top picture was shot without a filter; it is dominated by a reddish tone. The bottom picture was taken through a bluish filter to correct for this. Both pictures were taken on Ektachrome Film Type B using the same light source.

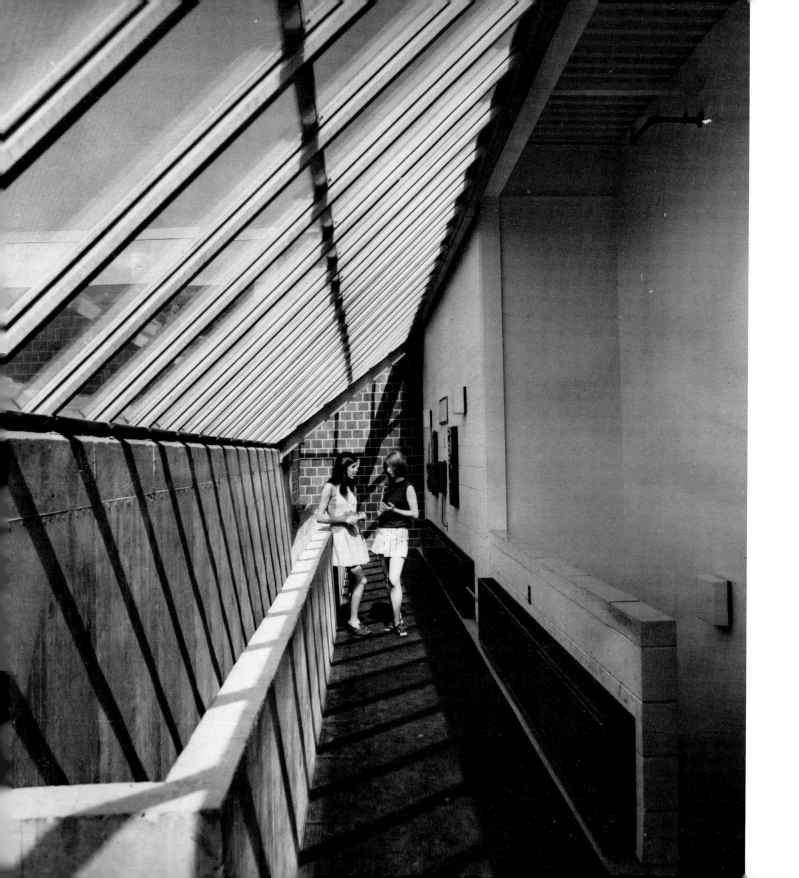

5

Photographic Communication

Now that we have looked at the various types of assignments, the methods and equipment for handling those assignments, and other general problems of photographic interpretation, we must turn the discussion to the elements within a photographic image that make communication possible.

To simplify this discussion, the contents of photographic communication will be broken down into three categories: (1) symbols that indicate size and depth in a photograph; (2) picture composition; and (3) image perspective. I have left the category of perspective until last, because a discussion of this complex subject must follow an understanding of the first two categories.

SYMBOLS THAT INDICATE SIZE AND DEPTH IN A PHOTOGRAPH

The most difficult aspect of reality to communicate photographically is the actual size of a three-dimensional subject. Unless we photograph an object,

This picture is without a scale indicator. Its design is rendered timeless and abstract.

JOHN HANCOCK MUTUAL LIFE BUILDING, Chicago.
SKIDMORE, OWINGS & MERRILL, Architects.

the face of a cube for example, from a straight-on, frontal position and then enlarge the image to a 1:1 scale, the subject will appear at some fraction of its actual size. When there is more than one cube to be photographed, or when the cube is turned so that more than one side is visible, we have greater difficulty in representing actual size photographically. Furthermore, size becomes more ambiguous when an object is photographed against an undefined background.

The apparent size of an object will be determined by its distance from the lens and its degree of enlargement on the print. If we photograph two cubes, for example, and place them so that one is twice as far from the camera as the other, and make an enlargement that renders the more distant cube life size (1:1) in the print, the near cube will appear twice life size.

A camera records the size of objects in direct proportion to the focal length of its lens. Lenses are ground so exactly that if we know the focal length of the lens used and the distance between the object and lens, we can determine by careful measurement of the image on the negative the height and width of the actual object.

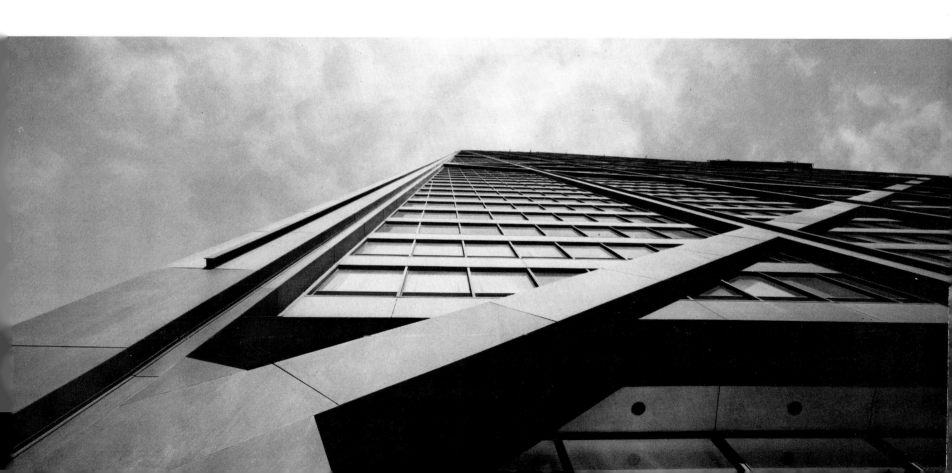

There is a branch of science that uses two photographs to measure three dimensions—height, width, and depth. By computing measurements made from two photographs that were taken from two cameras with the same focal length lens, an accurate evaluation of the relative proportions of objects can then be made. Stereo photogrammetry is most commonly applied in aerial map making. A stereoplotter, which is an elaborate device for bringing objects in depth to a common scale, is then used so that contour lines can be drawn to indicate height differentials.

The important point here is that the correct interpretation of stereo photographs depends on the establishment of a reference plane or known scale indicator from which all other measurements can be made. Furthermore, all objects must be brought to a common scale and measured in relationship to the reference plane, before the images can be correctly interpreted and contour lines drawn.

In essence, we do the same thing when we view the world around us. When we view a three-dimensional object we scan it with two eyes and record multiple impressions. So that we can judge the size of an object accurately, our eyes combine these images in an incredibly rapid, unconscious process, and our minds bring all objects to a common scale for size comparisons. This is called "perceptual size scaling."

In his book **The Intelligent Eye,** R. L. Gregory suggests that the process involves a mental image that is not directly related to the optical image produced in the eye and that perception is a kind of problem solving that depends on educated guesses. He states that the perceptual system is a "look-up" system in which sensory information is used to build gradually, and to select from, an internal repertory of perceptual hypotheses "which is the nearest we ever get to reality."

Another view of the John Hancock Building shows it in relationship to the smaller buildings of Chicago. Seen this way, the building looks enormous. It is 96 stories high.

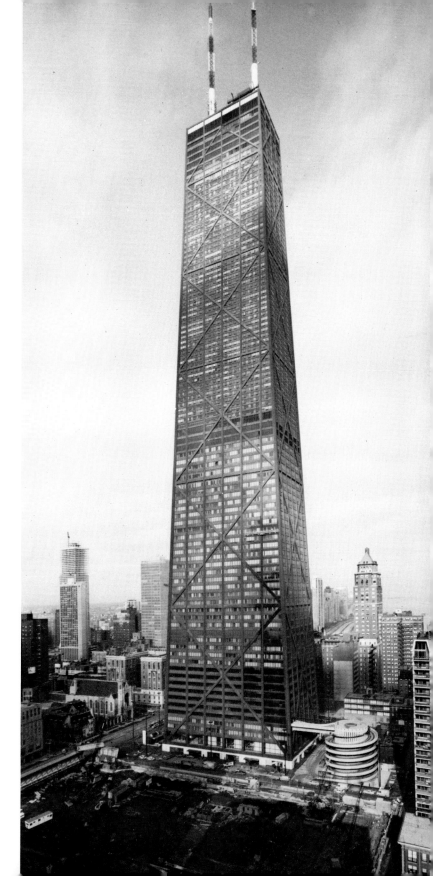

SCALE INDICATORS

The architectural photograph is designed to inform the viewer, and if it is to perform this function, it must include certain types of information that make human understanding of the image possible. There are two factors that make object-size evaluations possible in a photograph: picture scale and perceptual-size-scale indicators.

Picture scale: The print can be enlarged so that, from a predetermined viewing distance, objects in the photograph will appear normal. Picture scale sets the conditions for proper judgment of the relative sizes of objects when it approximately mirrors human perspective. In practice, however, indicators that permit perceptual-size scaling are more important.

Perceptual-size scaling: Judgments about size, position in space, and depth of unknown objects are made by comparing them to a recognizable object in the photograph, such as a person, automobile, bicycle, and so on. If inappropriate scale indicators are used, perception is distorted, and the photograph becomes ambiguous and sometimes misleading, as you can see by the accompanying photographs. Adequate and non-ambiguous indicators are necessary if we are to communicate the correct impression of size and distance between objects.

Scale is indicated by the placement of the bicycle in the foreground.

GRADUATE DORMS,
Princeton University.
RICHARD SNIBBE, Architect.

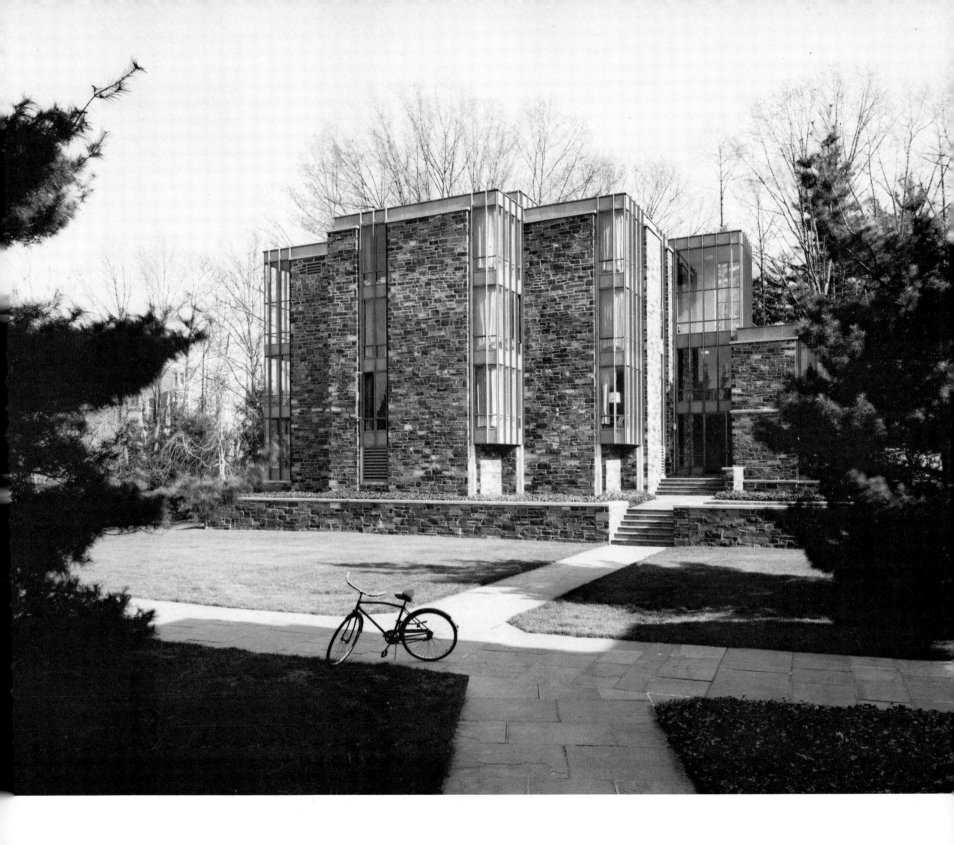

Not only must an appropriate scale indicator be included in the photograph to evaluate the size of the building but that indicator must be placed in the proper relationship. The top illustration of the Vivian Beaumont Theatre in Lincoln Center is without a scale indicator. The building looks larger than it really is. Placing the girl too close to the camera as in the bottom illustration makes the building look small by comparison. The final resolution (opposite page) conveys the appropriate size impression.

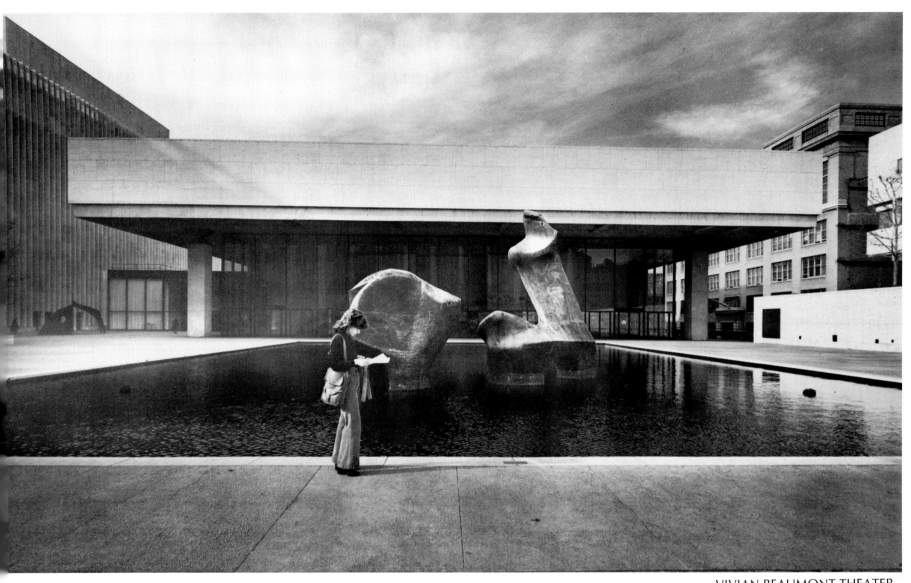

VIVIAN BEAUMONT THEATER,
Lincoln Center, N.Y.

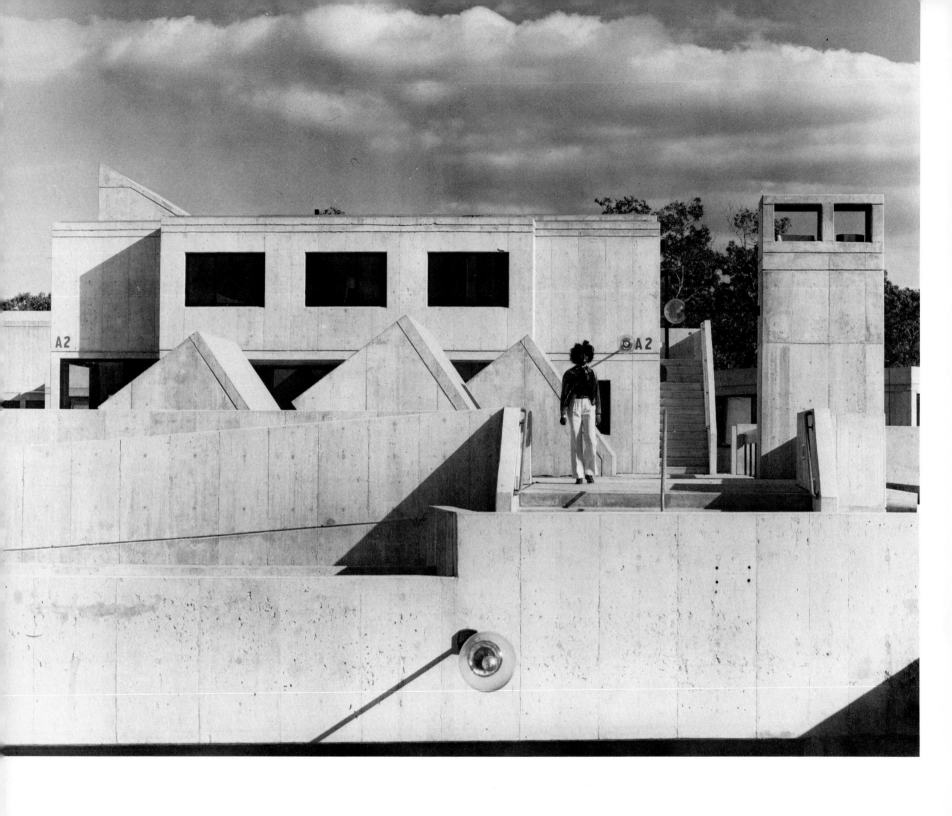

COMPLEX A, State University of
New York at Old Westbury.
ALEXANDER KOUZMANOFF,
VICTOR CHRIST-JANER, JOHN M. JOHANSEN,
Architects.

The use of the telephoto lens and the fig-
ure of the black girl give a most accur-
ate impression of the size relationships.

The blurred figure in the doorway adds
just the right amount of reality to this
otherwise abstract night shot.

STORYK RESIDENCE, Woodstock, N.Y.
JOHN STORYK, Architect.

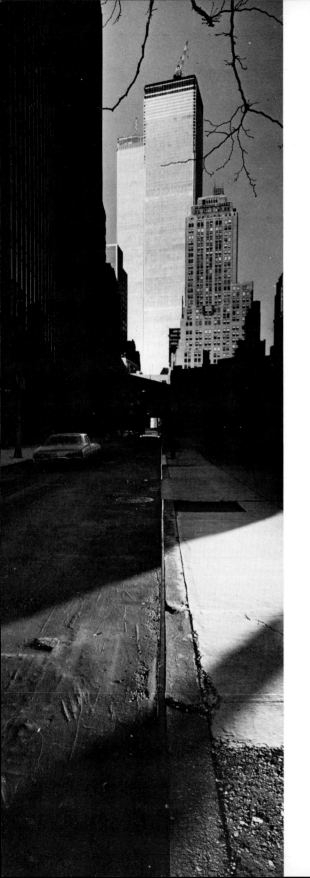

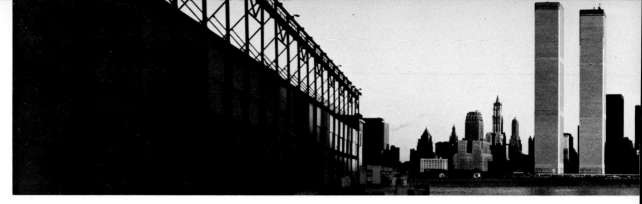

Three views and four prints of the World Trade Center illustrate how appropriately size is or is not communicated. The picture at the far left shows the Center dwarfed by the surrounding buildings. The shot at the far right highlights the towers, making them look extremely tall. The top and bottom prints were made from the same negative (although cropped differently). Each print conveys a different impression of size because of its degree of enlargement.

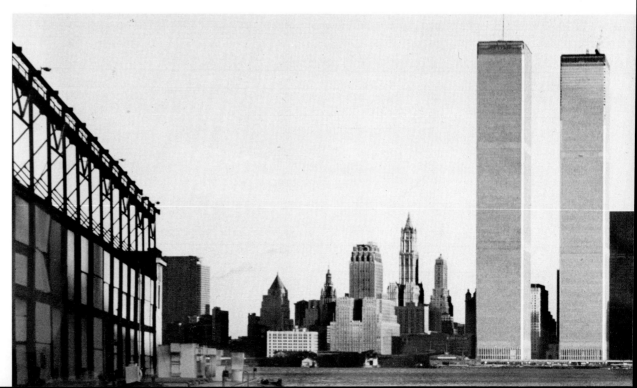

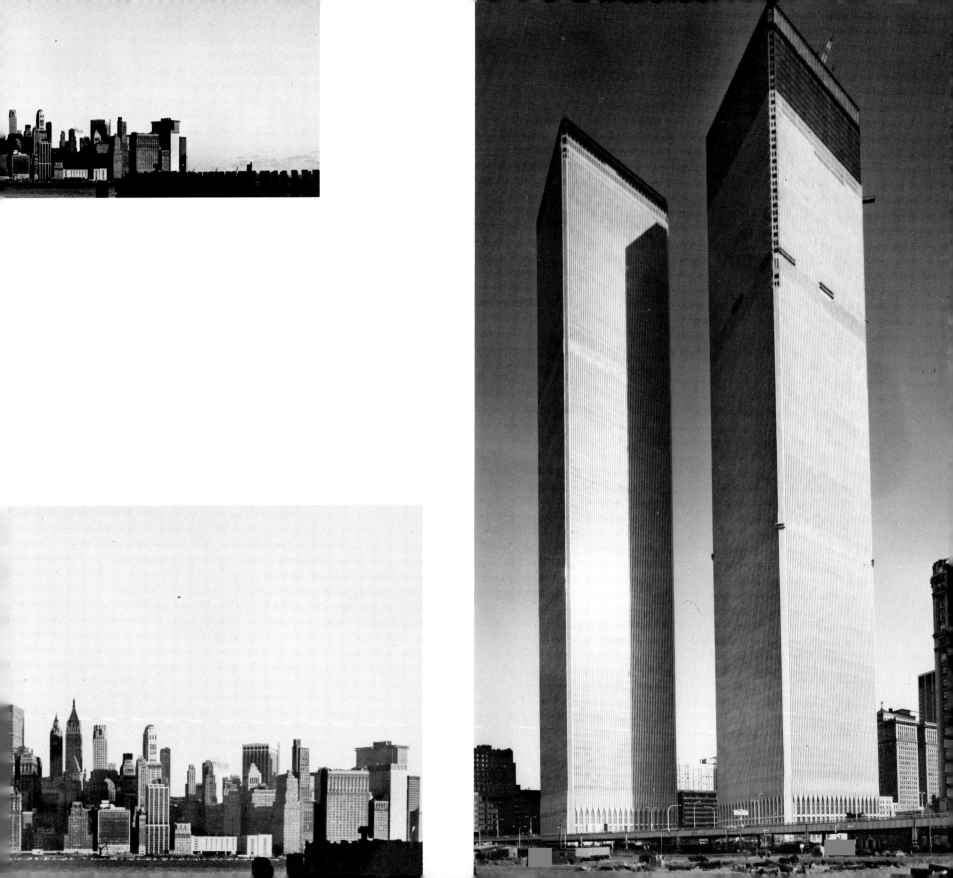

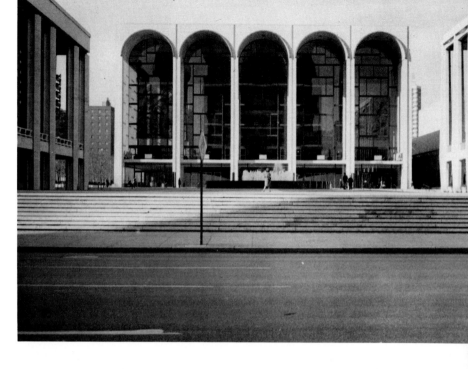

These three illustrations show the effect of varying the subject-to-camera distance.

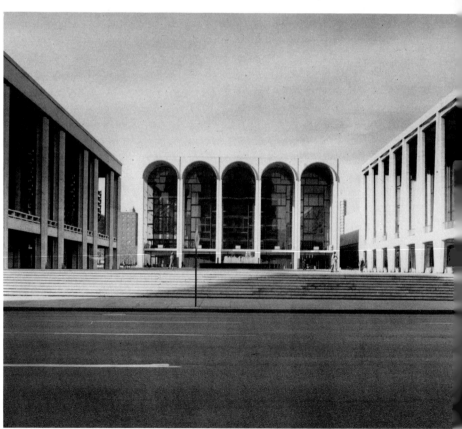

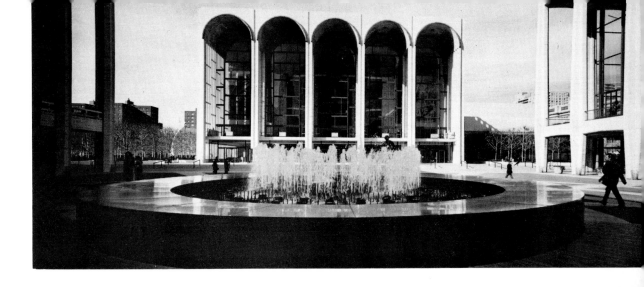

The three photographs on this page were made by using lenses of different focal lengths. The camera was not moved. The size of all the buildings in relationship to each other remains exactly the same. On the preceding page, as the point of view is altered the relationship of varying parts of the buildings are equally altered.

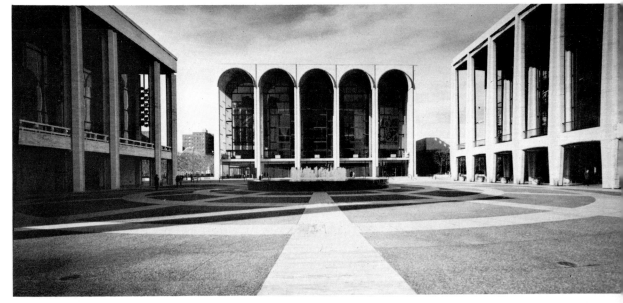

LINCOLN CENTER FOR THE
PERFORMING ARTS, New York City.

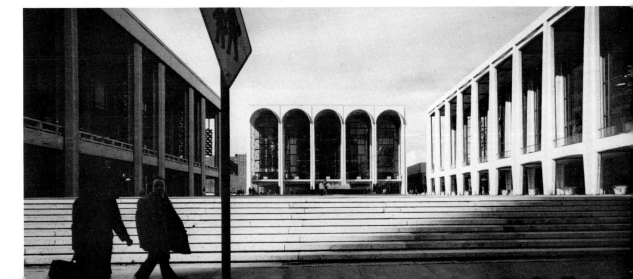

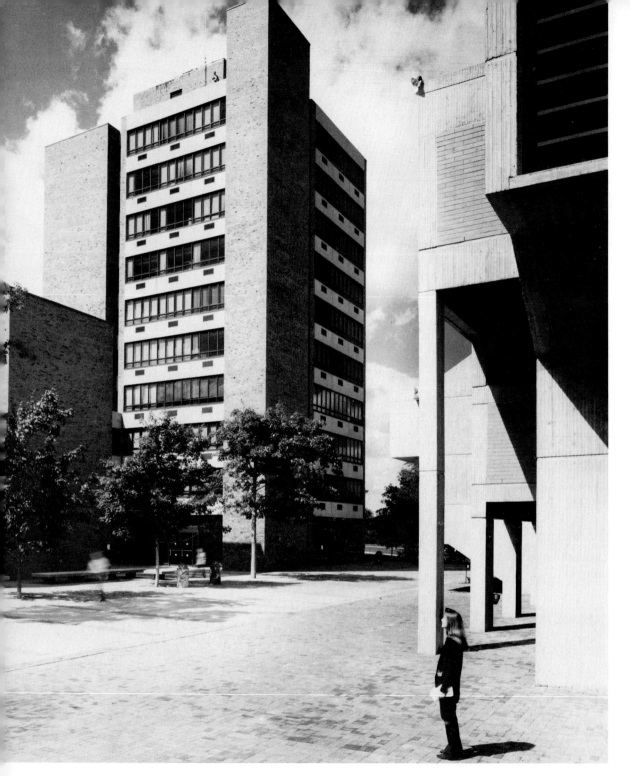

FACULTY OFFICE BUILDING, State University of New York at New Paltz

DAVID TODD ASSOCIATES, Architects.

DEPTH INDICATORS

A number of factors influences a viewer's ability to perceive depth in a photograph. The most important of these are perspective dimension, distribution of light and dark, foregrounds and backgrounds, framing, direction of light, color, framing, cropping, and shadows.

Perspective: Convergence of parallels and diminution, that is, the way in which more distant objects are rendered progressively smaller, are the most obvious depth indicators.

IMAGE PERSPECTIVE

Image perspective is difficult to discuss because it involves both the way a camera-lens system records objects (geometrical perspective) and the way the human eye-brain system recognizes objects (human perspective). A camera-lens system is mathematically predictable while the eye-brain system depends on many factors including the cultural experience of a specific individual. Actually, all discussion

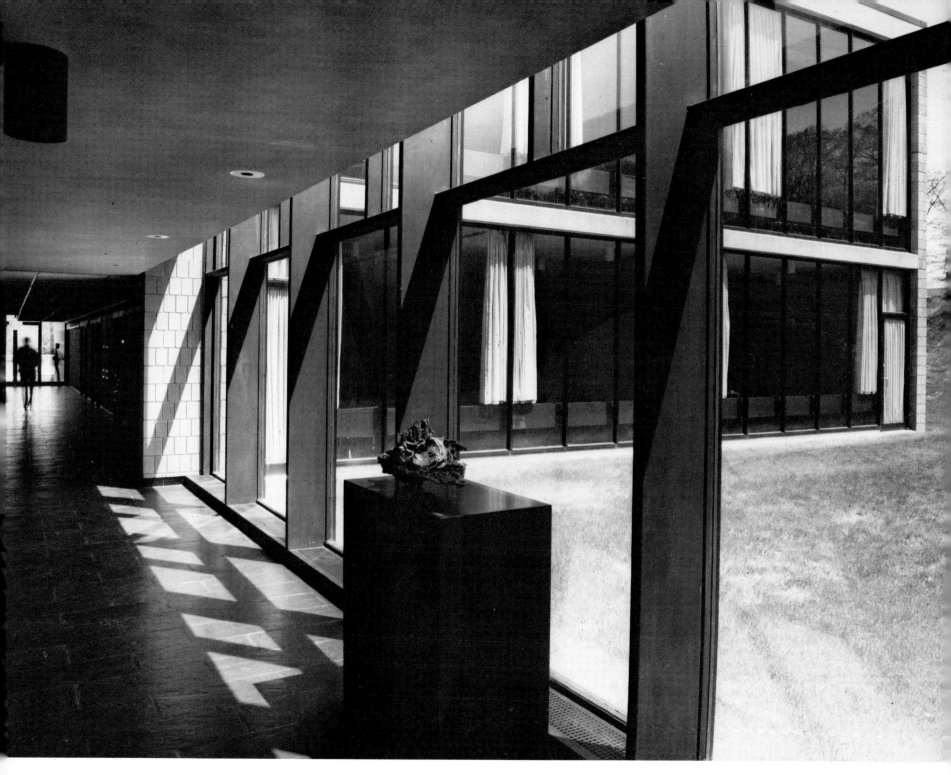

The strong receding lines of the window
and corridor convey a sense of depth.

YMYWHA, Essex County, New Jersey.
GRUZEN AND PARTNERS, Architects
in association with A. W. GELLER.

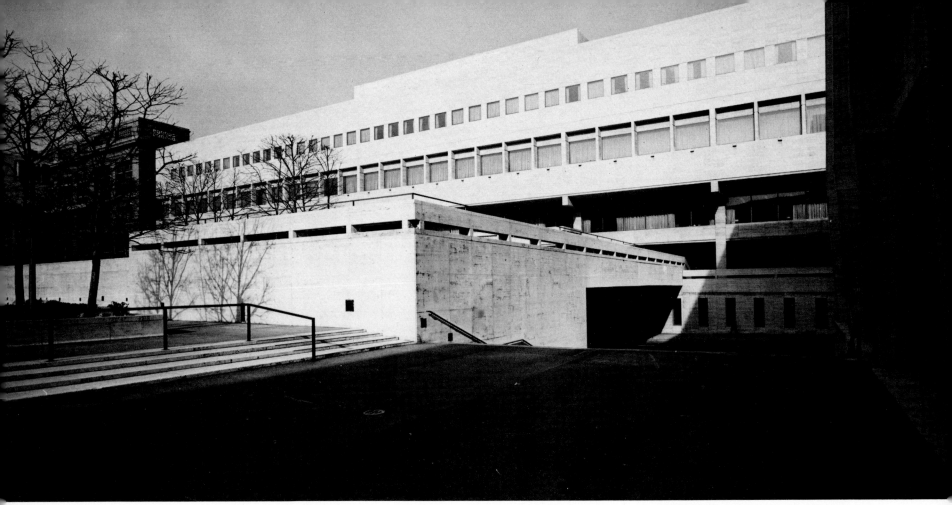

JULLIARD SCHOOL OF MUSIC,
Lincoln Center for the Performing Arts,
New York City.
BELLUSCHI, CALALANO, AND
WESTERMANN, Architects.

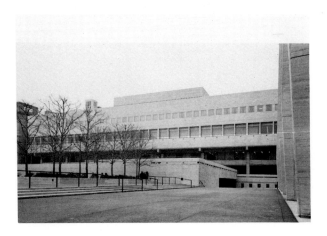

Light coming from the side, casting
expressive shadows, helps to convey a
greater sense of depth. Compare the
above photograph with the flat-lit pic-
ture of the same building to the left.

162

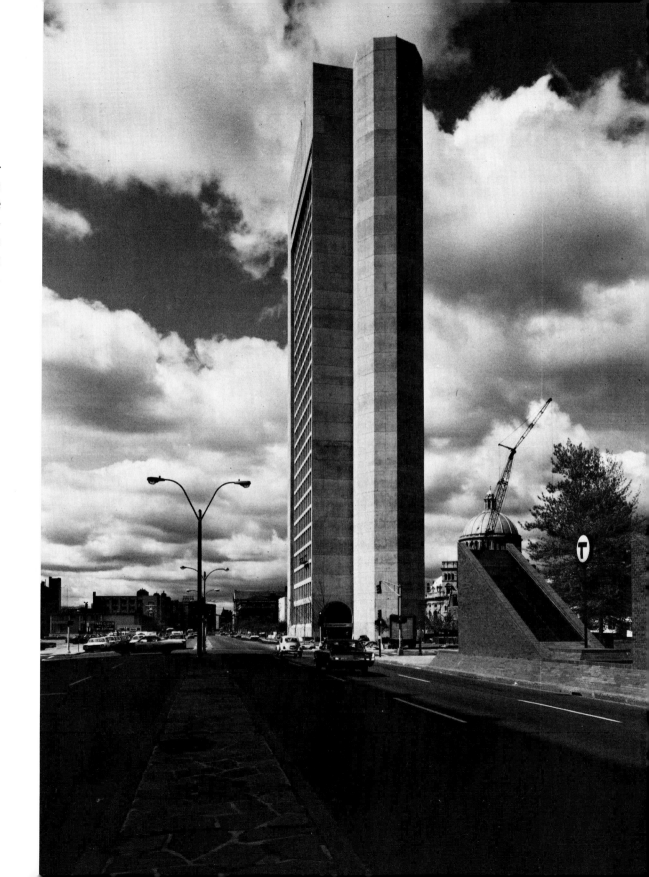

CHRISTIAN SCIENCE CENTER,
Office Tower, Boston, Mass.
I. M. PEI & PARTNERS, Architects.
ARALDO COSSUTTA, Partner in charge.

about communication must begin and end with the human factor. Just as there is no one interpretation to a given assignment there can be no single interpretation to a photographic image. Each image wil be re-interpreted by each individual.

Distribution of Light and Dark: In nature we perceive depth by the progressive lightening or darkening of distant objects. Depth can be indicated by either method. Objects appearing in foreground can be dark; those in the middle distance and background can progressively become lighter the farther away they are from the camera. In reverse, objects can appear light in the foreground and dark toward the horizon.

As a general rule, a large foreground gives a greater sense of depth to a photograph, particularly if the background is flat. A greater sense of depth is also communicated if the sky is filled with clouds. A preponderance of dark over light evokes a greater feeling of depth.

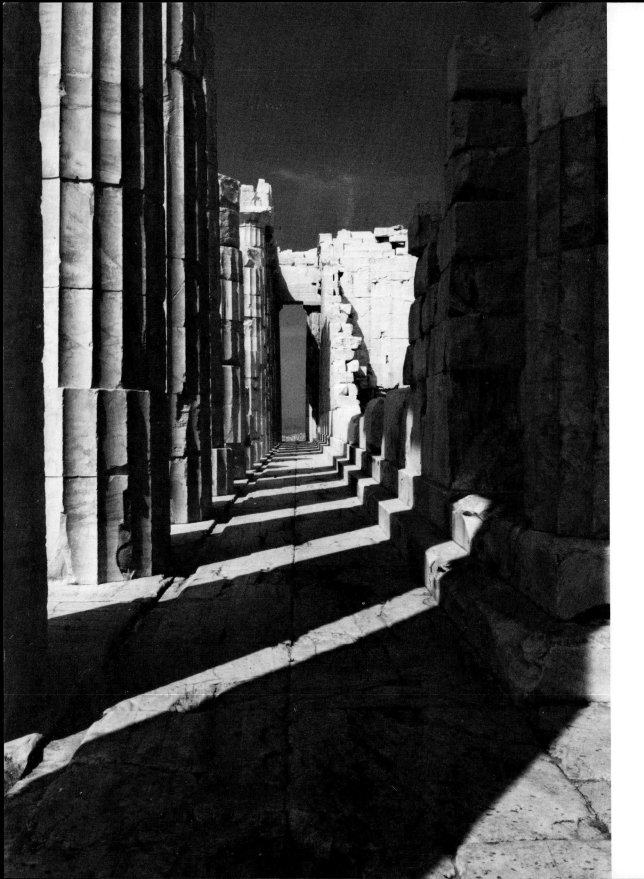

Direction of Light. A greater or lesser sense of depth is communicated by the appropriate choice of time of day, as the raking light of morning or afternoon creates dimension-rendering shadows.

The illustration to the left shows the Parthenon columns articulated by early morning light. A strong graphic effect as well as a sense of depth is communicated by the patterns created by the shadows.

THE PARTHENON, Athens, Greece.

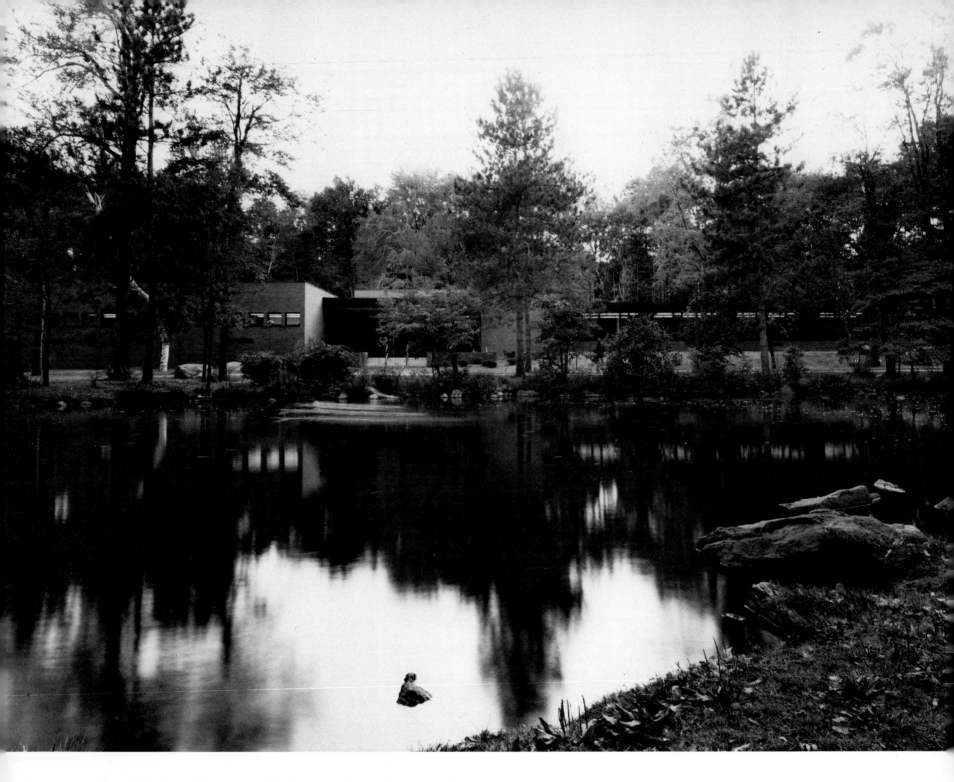

The utilization of foreground helps not only to show the environmental relationship of the building to size but is one of the best ways of communicating spatial dimensions.

TEMPLE OF APHAEA, Aegina, Greece.

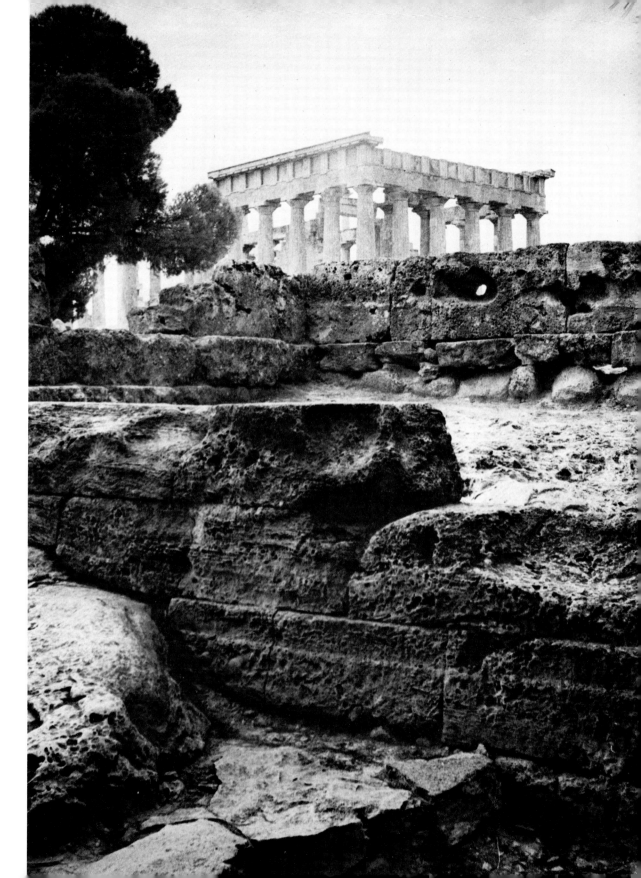

SCIENCE CLASSROOM BUILDING,
St. Margaret's School,
Waterbury, Conn.
JOSEPH STEIN & ASSOCIATES,
Architects.

FINE ARTS BUILDING, State University
of New York at Geneseo.
MYLLER, SNIBBE, TAFEL, Architects.

Both pictures express strong
compositional elements. The
one on the left directly expresses
motion with the blur, that on
the right implies motion arrested
by the fast shutter speed. Iron-
ically the static motion shot is a
more dynamic composition.

171

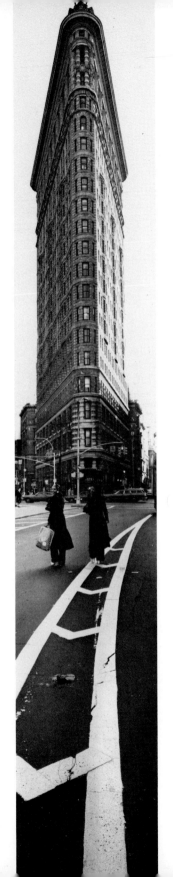

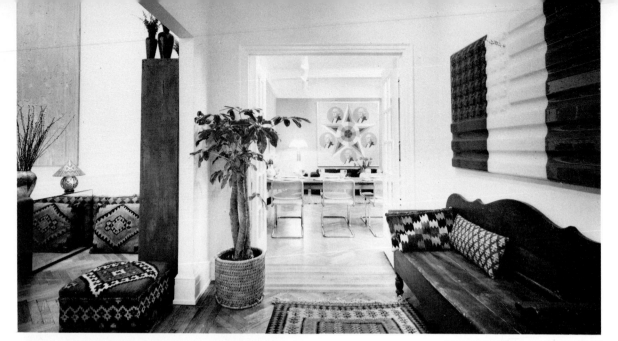

RUBENSTEIN APARTMENT.

CYPRUS CHURCH.
THEO DAVID, Architect.

FORMAT

Format refers both to the size and shape of the film used and/or the final print. A 35mm format, for instance, produces a rectangular image (35mm x 24mm). This elongated format tends to be dynamic, asymmetrical, and informal. It can be generally stated that a square format (2½″ x 2½″ for instance) will pro-

FLATIRON BUILDING, New York City.

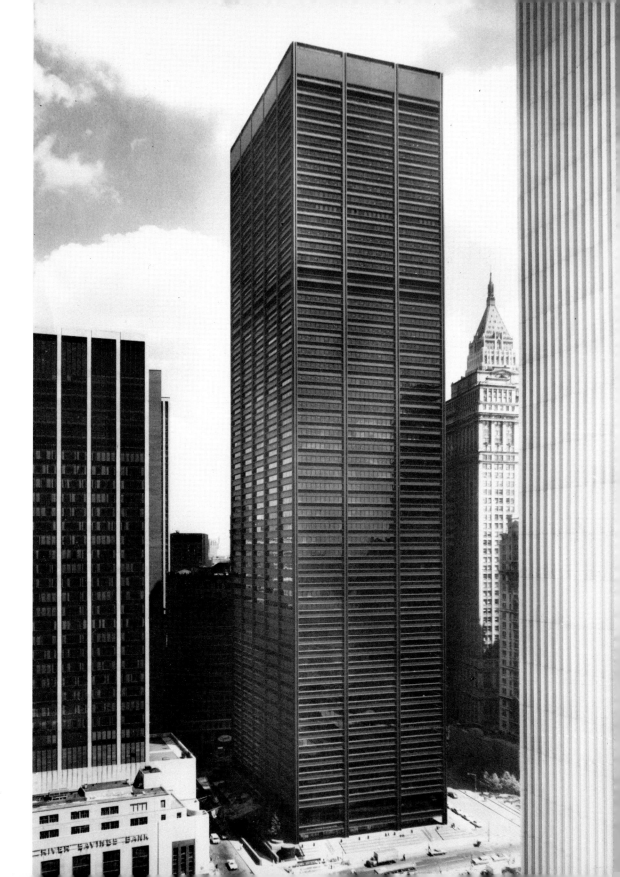

U.S. STEEL BUILDING, New York City.
SKIDMORE, OWINGS & MERRILL,
Architects.

mote a more static, geometrical, and formal compositional design. These words are of course imprecise and only meant as guidelines. They should not be construed as value judgments.

The choice of a format should depend on each situation and the inherent design patterns of the subject to be photographed.

COLOR MASS

Color: Color is a more complex element to control. In a landscape, the effect of color diminishes as distance increases, colors becoming muted as haze refracts the light.

Color mass in black-and-white photography affects the composition in terms of tonal balance only. In color photography, not only the specific colors but their intensity play a primary role in the picture design. Subtle monochromatic pictures will emphasize the line pattern of an architectural photograph, while vivid contrasting colors will express the grouping of important masses.

Differing formats require compositional adjustments, as demonstrated by this four-picture spread.

GEOMETRIC PERSPECTIVE

The discovery and application of geometric perspective is attributed to the Italian artists and architects of the early Renaissance. In their struggle to communicate complicated ideas about spatial relationships, they developed a method of drawing that conveyed a sense of depth and dimension, giving birth to perspective rendering.

However, true geometric perspective, as we render it today, was not used until the invention of an optical system that could project an image of a scene onto a canvas. This image, produced by a "camera obscura," an optical device for projecting an image of a scene onto a piece of paper or canvas, could be precisely traced, and the finished drawing or painting appeared to have all the qualities of what we now call "photographic reality," that is, geometric perspective.

A Method for Rendering Perspective: Antonio Canaletto (1697-1768), called the master of perspective drawing, used the "camera obscura" to make renderings of cityscapes and architecture. However, a simpler method of drawing in geometric perspective was described by Leonardo da Vinci (1452-1519), who observed that such a drawing could be achieved by placing a transparent pane of glass between the eye and the subject to be drawn. By using only one eye and keeping the glass in a fixed position, the artist can trace a subject on the glass, and that tracing will conform strictly to the laws of geometric perspective, provided that the position of both glass and eye remains fixed.

This is a worthwhile exercise for a photographer to perform, since it provides practice in the most basic aspect of photographic seeing without introducing a camera-lens system. Perspective in a photograph is simply the imaging on a plane (the film) of the proportional size of objects when viewed from a fixed point in space. To set up the conditions that will result in correct geometric perspective, you need only have a pane of

glass on which an image can be drawn, a single, fixed point from which that glass can be viewed, and a predetermined distance between the image plane and the viewpoint.

You can set up the basic conditions for perspective rendering as follows: Take a piece of cardboard, cut a hole in it large enough to allow one eye to see through it in comfort, and fix the card on a stand. This will set the point of view. Next, take a piece of glass, mount it in a frame, and fix it vertically in front of the eyepiece far enough away so that all the desired elements of the composition are included within the frame.

With the point of view and the viewing distance fixed, you can look through the eyepiece and trace, with a black grease pencil, the outlines of an object that appears to be on the surface of the glass. The finished tracing will be a rendering of the object in true geometric perspective. If you increase the distance between the glass and the eyepiece and make another tracing, this time with a red grease pencil, you will see that the object has increased in picture size although less of the overall subject is included in the picture frame. This change in scale of rendition illustrates what happens when we change from one focal-length lens to another.

From this simple experiment we can illustrate the three factors that control image perspective: angle of view, subject-lens distance, and focal length of lens.

Of the factors that control the overall appearance of a photograph, only the first two are a function of geometric perspective. The angle of view is the orientation of the camera-lens system to the subject, high or low angle, for example. Subject-lens distance determines how much of the subject will be included in the photographic frame. The focal length of the lens will not effect a change in geometric perspective as long as the point of view and the subject-lens distance remain the same. The focal length will, however, affect human perspective, because it determines the scale of rendition (linear size of objects imaged in the negative).

If we turn back to our demonstration with the eyepiece and glass picture frame we can demonstrate the effects of changes in point of view and subject-lens distance.

Keeping the glass picture frame fixed, move the eyepiece a few inches upward. Now, if you will trace the object as it appears on the glass, you will notice that it has moved upward in direct proportion to the new position of the eyepiece. (For this experiment, a round dish is best as a subject). If you compare the drawing with a drawing of the dish made before you moved the eyepiece, you will see that the shape of the circle has changed slightly. Now, if you will move the subject closer to the glass picture frame, keeping the eyepiece and glass in the same position, you will see that the object must be pictured as a larger object, and, because of its new position, its shape will have altered once again.

The following is a series of illustrations that demonstrates the change in geometric perspective when the camera-subject distance and the point of view are changed. Following this series is a series of illustrations of the same subject shot with lenses of various focal lengths, which demonstrate how human perspective is altered without changing geometric perspective. In practice, the experienced photographer is constantly working with both factors to communicate complex ideas and feelings about the spatial aspects of architecture.

DISTORTION

There is no such thing as distorted geometric perspective in photography unless the camera-lens system has an optical or mechanical defect. Any apparent distortion of perspective is the result of human perspective, that is, errors that result from poor judgment or preconceptions about how a photograph ought to look, or failure to find the appropriate distance and angle from which to view the photographic print.

Because of the extreme wide-angle perspective this building appears distorted. If, however, you move closer than normal to the page the building will appear in normal perspective.

SCIENCE BUILDING, State University of New York at New Paltz. DAVIS-BRODY, Architects.

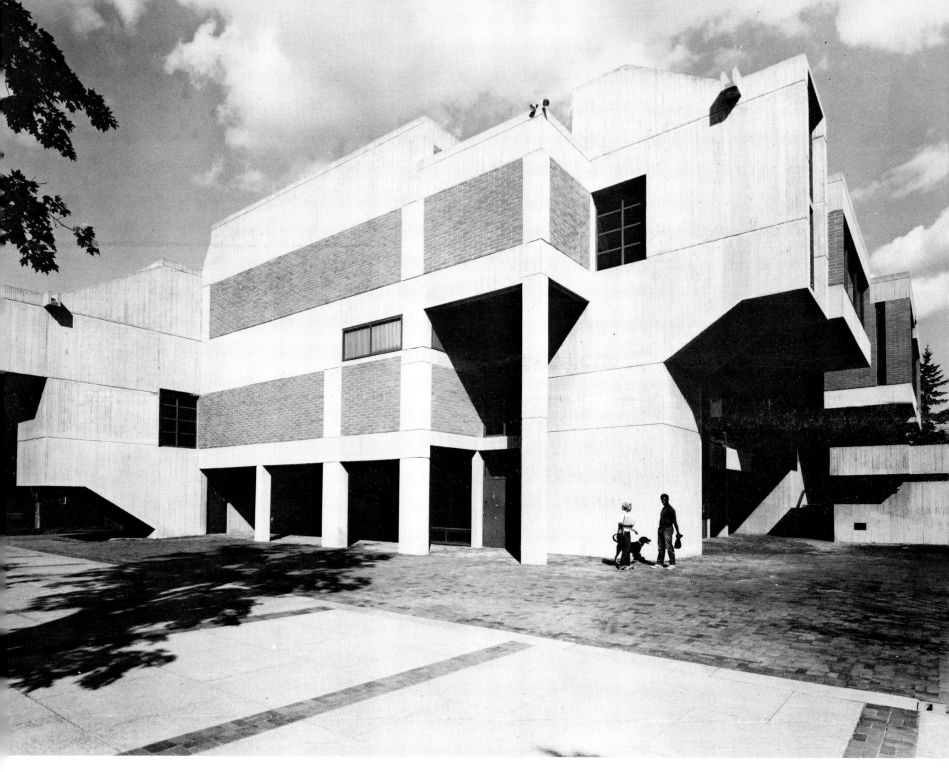

In the case of photographic images produced by wide-angle and telephoto lenses, the apparent exaggeration or compression of perspective can be minimized by finding the correct viewpoint from which to look at the print or slide. For example, if you take a photograph with a wide-angle lens, blow it up until it fills an entire wall, and walk toward it, you will eventually find a point of view from which the relative proportions of the objects within the scene appear normal. If you take a telephoto shot, enlarge it to an 8″ x 10″ print, hang it on a wall, and step far enough back, a similar effect will occur. At some point, the relative proportions of objects within the print will suddenly appear to be normal. In practice, of course, this is not done; instead we look at a photographic image from a comfortable viewing distance, usually about 10 to 15 inches for an 8″ x 10″ print, and interpret it from that point of view, without trying to duplicate the mechanical conditions that establish true geometric perspective. And because we do this, wide-angle and telephoto lenses give us images that differ from the way that subject is normally seen.

Many of the common ways of discussing the effects produced by these special lens-film combinations produce confusion simply because the terms used do not relate to geometric perspective but rather to human perspective. For example, just what is meant when someone talks about the exaggerated or compressed perspective given by a particular focal-length lens? Usually, it simply means that the lens used provides an image of the subject that does not correspond with the way we normally see things. These lenses do give true perspective, by definition, but they also provide a different, and very non-human, way of imaging the world onto a flat surface.

When we assume the usual 10- to 15-inch viewing distance, the exaggerated or compressed effects are due to picture scale. A very big enlargement of a wide-angle shot or a small print of a telephoto shot, viewed from the usual 10- to 15-inch distance, does appear normal.

I.C.I. BUILDING, Stamford, Conn.
HANFORD YANG, Architect.

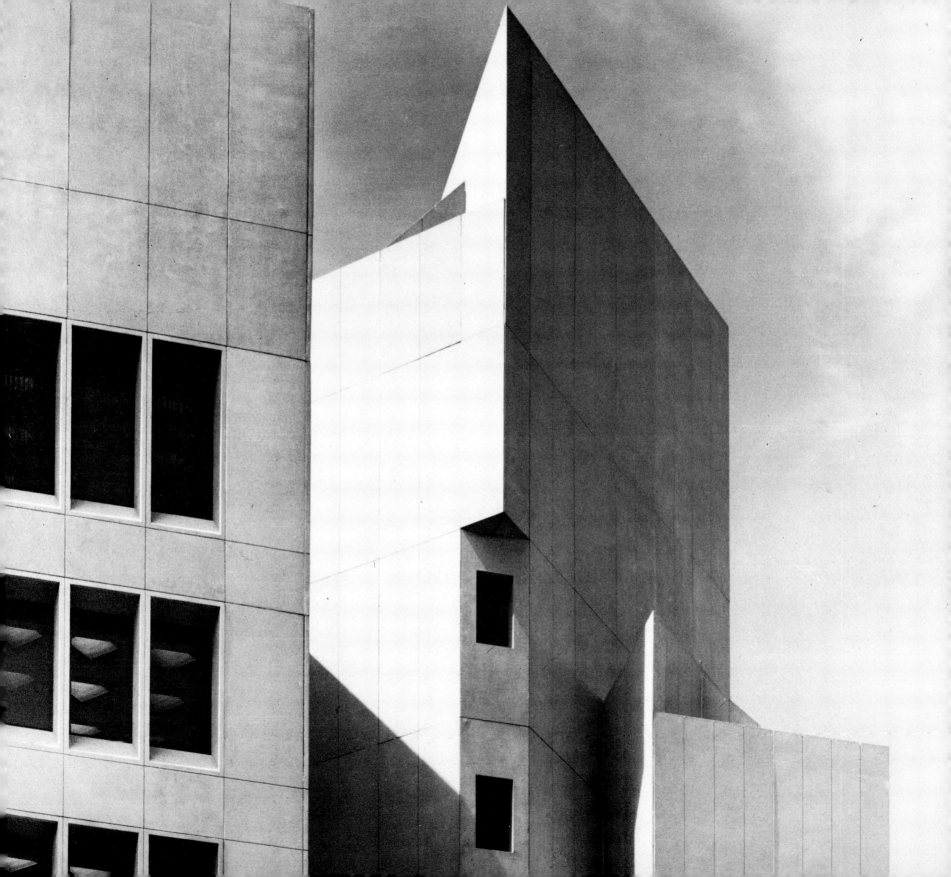

LIBRARY BUILDING RENOVATION.
BELFATTO AND PAVARINI, Architects.

CYLINDRICAL AND SPHERICAL PERSPECTIVE

Prints made from panoramic shots are in a slightly different class, since the image is in true perspective only when the plane on which the image is projected is curved. Since the ordinary print is flat, simply finding the correct viewing distance will not provide the appearance of normal per-

spective: The print itself must be curved.

The term perspective distortion can only be applied correctly to human perspective. The impression of distortion in photography is caused by the inability of the viewer to visualize or to understand the way a camera-lens system records objects. Images produced by a good camera-lens

system always record in true geometric perspective, and when distortion is created it is the result of an inappropriate picture size or inappropriate angle from which the photograph is viewed.

The cylindrical perspective of the Panon camera is illustrated above. On the opposite page is a picture taken with the Fisheye-Nikkor 7.5mm lens. This unusual view can only be achieved by the spherical perspective of this highly specialized lens.

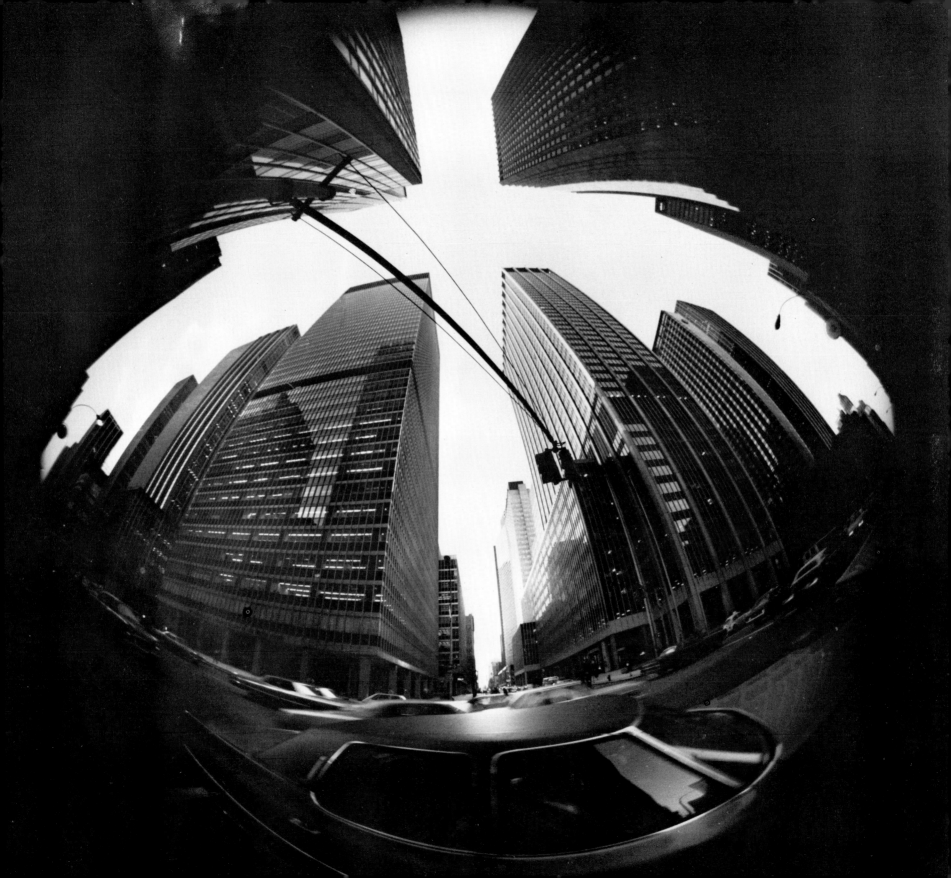

THE DETAIL SHOT

Photographs of architectural details are difficult because the photographer must select and isolate a significant detail to express the overall design. Specific detailing techniques often mark the design philosophy of a particular architect. Frank Lloyd Wright is a good example of an architect who spent a great deal of time and thought designing specific treatments of such details as doorways and window cornering. The composition of any detail shot is therefore highly critical.

THE CONSTRUCTION PHOTO

The construction photograph, if it is to communicate something of the finished architectural design from an incomplete building, must be tightly composed to utilize whatever dramatic elements are on hand to distract the eye from the sense of incompleteness.

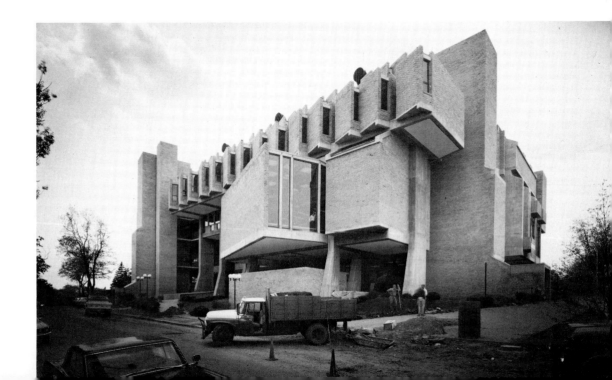

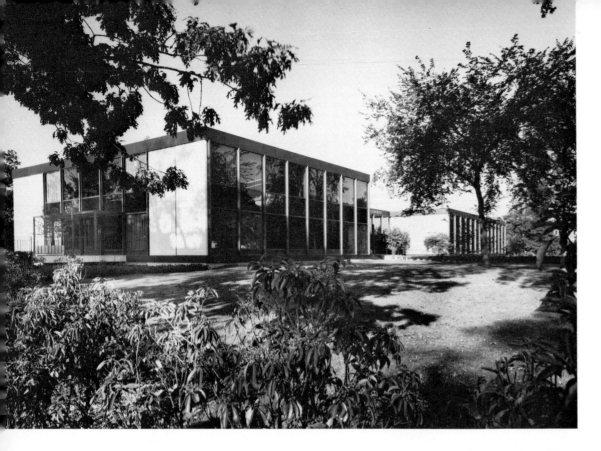

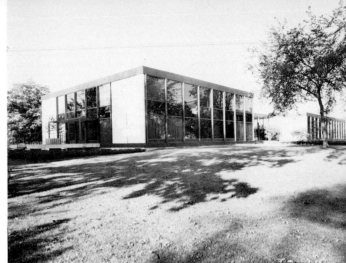

SILAS BRONSON LIBRARY.
JOSEPH STEIN AND ASSOCIATES,
Architects.

THE ENVIRONMENTAL SHOT

Photographing the environment of a building is not an easy task. Often when distinct elements of environmental beauty are shown, the building can be obscured. The best lens for showing an environment and not diminishing the size and importance of an architectural design is the telephoto lens. This lens is used all too rarely in architectural photography.

184

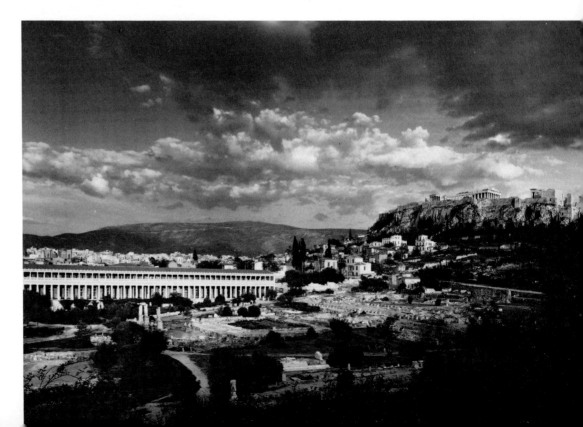

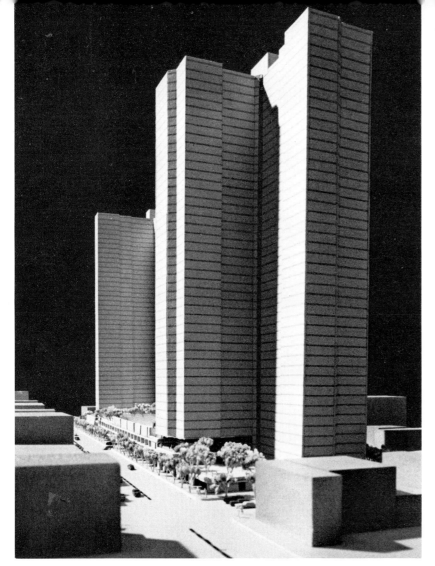

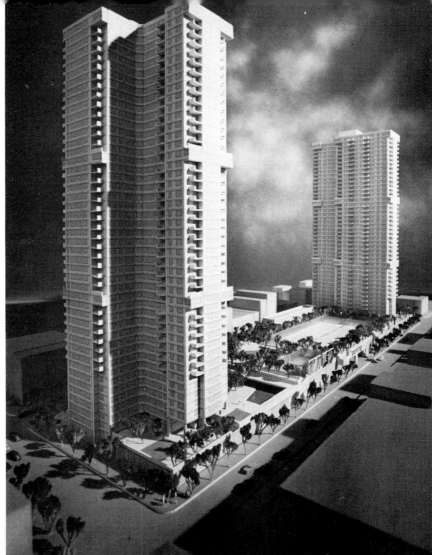

42nd STREET HOUSING, New York City.
DAVID TODD ASSOCIATES, Architects.
ROBERT CABRERA, Design Associate.

MODEL PHOTOGRAPHY

Two basic approaches to the photographing of an architectural model are generally used: abstract and realistic. The composition of a study model with a white or black background must concentrate specifically on the design elements of the building. It tends to be abstract. If the model is finished, it usually lends itself to a looser, more realistic, documentary approach, and the composition can even be enhanced with the addition of a painted background to show the model in its environment.

185

INTERIOR PHOTOGRAPHY

The key to successful interior photography rests on three main factors: the position of the camera, the correct use of additional artificial light, and the placement of the furniture.

The camera placement is the prime consideration as it estab-lishes the perimeters of the composition.

Lighting design is of particular importance when photographing an area that has low-level illumination. The job of the photographer is then to bring up the overall light of the interior so that he can record detail in all the significant areas of his composition but still retain a pleasing balance between the existing illumination and the additional lights.

In the arrangement of furniture, a slight shift of a piece will correct a disturbing compositional element. For other situations a major shifting around of all the furniture will be necessary to strengthen the composition of a particular angle of view. This is not a comment on the interior

186

designer; the original arrangement of furniture seen from another angle will look perfectly appropriate. Usually some degree of furniture shift will be necessary, and the photographer should not hesitate to move a piece of furniture if it will enhance his composition. When photographing interior spaces, it is wise to have either the architect or the interior designer on hand to approve the necessary handling of furniture and lighting.

LIBRARY, Interior, School of
International Affairs.
HARRISON & ABRAMOVITZ,
Architects.
J. LITTLEFIELD, Design Associate.

CYPRUS HOUSE, Interior.
NEOPTOLOMUS MICHAELIDIES,
Architect.

THE NIGHT SHOT

Handling composition in night photographs of a building depends mainly on the forms and patterns created by artificial light. In an overall photograph of a building in which some exterior detail not illuminated artificially must be shown, the photographer should rely on the darkening sky to provide additional light. The timing of this type of shot is of prime importance. The photograph must be exposed before all the light from the sky has disappeared, yet not before the light level of the sky has fallen slightly below the light level of the artificial illumination.

If the abstract forms and patterns of light are of sole importance, the photographer should wait until all light from the sky has disappeared.

YMYWHA, Essex County, New Jersey.
GRUZEN AND PARTNERS, Architects,
in association with A. W. GELLER.

STATUE OF LIBERTY, New York Harbor.
AUGUST BARTHOLDI, Designer.

THE AERIAL SHOT

Environmental elements are best shown with the greatest compositional control when shooting the photograph from the air. Particular problems such as vibration and atmospheric haze can be simply solved by fast shutter speeds and films, and appropriate filtration.

SUMMING UP

It should now be apparent that many decisions will confront the concerned photographer whose aim it is to represent his subject to the best of his creative and technical ability. Hopefully this book will help the reader to do this. Architectural photography is a challenging field not only because there are many technical problems that must be handled with subtlety but because the field has become static in many ways and is in need of new and fresh approaches.

Architectural photography serves a function, yet it is as much an interpretative art as any other branch of photography. To approach every assignment in the same way is to overlook the essential challenge of the art—that is, to search within the medium for a comprehensive solution to the specific problem on hand and embody that solution with feeling. The architectural photographer must know where he stands intellectually and emotionally if he is to succeed in his field.

POTENTIAL MARKETS

Here are some of the potential markets for photographs of any building:

1. All persons immediately involved with the project from a design or construction standpoint—architect, project captain, consulting engineer, lighting designer, interior designer, landscape architect, contractor.

2. Building owner, school administration, board of directors.

3. Manufacturers of building materials used, such as concrete blocks, lighting fixtures, ducting, elevators, roofing, heating equipment, air conditioning, and so on.

4. Furniture manufacturers.

A list of all persons involved can usually be obtained from the architectural firm responsible for the design. An introductory letter or phone call can be made to each prospective buyer and a set of contact prints of all photos taken can be sent out to those who express interest.

Selected Readings

1

Heyer, Paul, "Architects on Architecture." New York, Walker & Company, 1966.

Venturi, Robert, "Contradictions and Complexities of Architecture." New York, Museum of Modern Art, 1967.

———

2

Adams, Ansel, "Camera and Lens." Hastings-on-Hudson, Morgan and Morgan, 1970.

Feininger, Andreas, "The Color Photo Book." Englewood Cliffs, N.J., Prentice-Hall, 1969.

"Kodak Filters, For Scientific and Technical Use." Eastman Kodak Company, 1970.

———

3

Adams, Ansel, "The Negative." Hastings-on-Hudson, Morgan and Morgan, 1968.

———, "The Print." Hastings-on-Hudson, Morgan and Morgan, 1968.

Caroll, John, Ed., "Amphoto Lab Handbook." New York, Amphoto, 1971.

Feininger, Andreas, "The Complete Photographer." Englewood Cliffs, N.J., Prentice-Hall, 1965.

"Photo-Lab Index." Hastings-on-Hudson, Morgan and Morgan, 1973.

———

4

Adams, Ansel, "The Print." Hastings-on-Hudson, Morgan and Morgan, 1968.

———

5

Gregory, R. L., "Eye and Brain." New York, McGraw-Hill, World University Library, 1966.

———, "The Intelligent Eye." New York, McGraw-Hill, 1970.

Lootens, J. G., "Lootens on Photographic Enlarging and Print Quality," 7th ed. Garden City, N.Y., Amphoto, 1967.

COLOR TEMPERATURE GUIDE

To effect controlled results a color-temperature meter should be used or a reliable chart that gives the correct color temperature of different light sources.

Here are a few guide lines:	Color Temperature	Decamired Value
light source		
60-watt general purpose lamp	2800	36
100-watt general purpose lamp	2850	35
500-watt professional tungsten lamp	3200	31
650-quartz-halogen lamp	3200	31
500-watt photoflood	3400	29
clear flashbulbs	3800	26
daylight photoflood lamps	4800-5400	21-19
daylight flashbulbs	6000-6300	17-16
morning and afternoon sunlight	5000-5500	19
sunlight through thin overall haze	5700-5900	18
mean noon sunlight unobstructed by clouds	6000	17
light from a totally overcast but bright sky	6700-7000	15
blue skylight only (subject in shade)	10,000-12,000	9
clear blue northern skylight	15,000-27,000	6-4